33159590

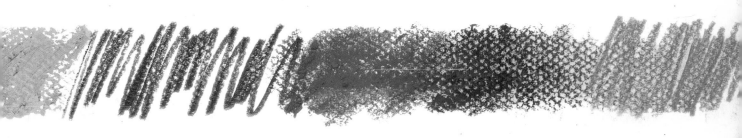

ALL ABOUT

techniques in

DRY MEDIA

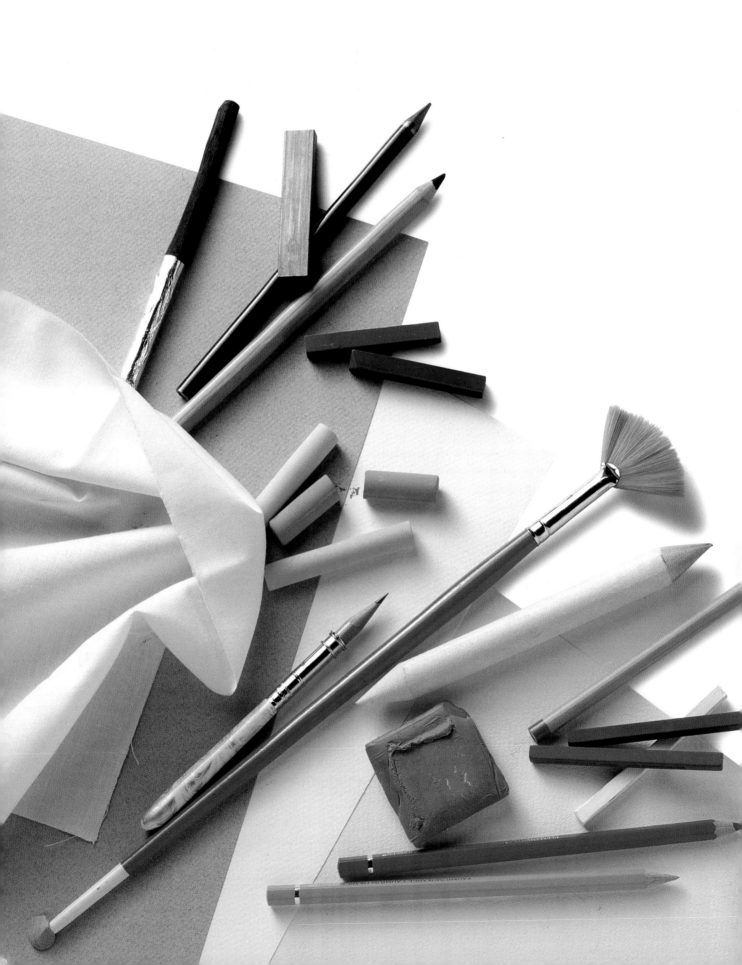

ALL ABOUT

techniques in

DRY MEDIA

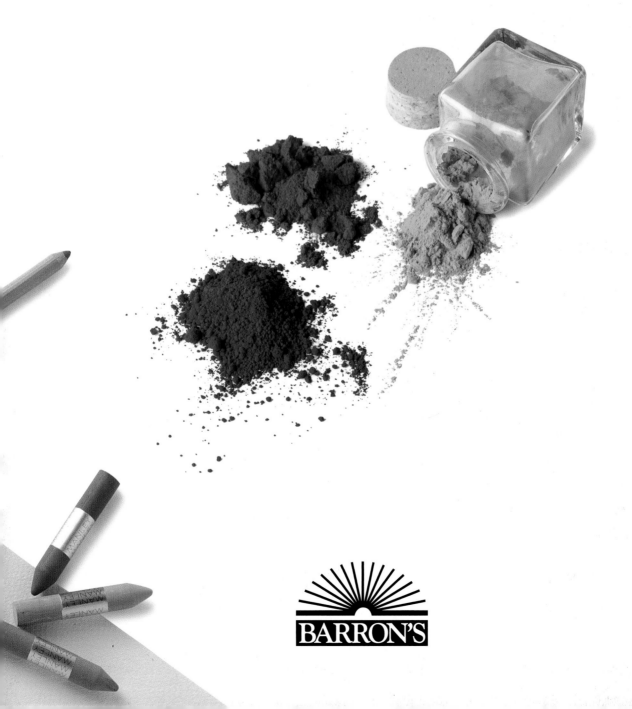

BARRON'S

Contents

This book contains all the information required to begin drawing with different media: charcoal and its derivatives, sanguine crayon, chalk, dry pastel, graphite, colored pencils, and oil-based crayons and pastels. All the media discussed can be used for drawing lines, shading (in the cases of charcoal and graphite), and coloring. They are applied to a support, usually paper, following a series of procedures that are referred to as dry techniques. And although they possess similar characteristics, their differences require different techniques and render results that are very different as well. The various media and effects, combined with the personal working style of each artist, all contribute to the wide range of expressive possibilities.

All the dry media will be covered in this book, each one requiring the development of good drawing skills and a mastery of color. The step-by-step exercises explain how to approach drawing a model, and presenting and evaluating the different media, while imparting a basic understanding of color theory.

The fact that so many different media are covered does not mean that this book is unfocused. To the contrary, it provides an overview of all that is essential for making progress in drawing and painting. Basing lessons on the observation of a model, this book analyzes each drawing and the light that illuminates it, teaching the reader to mentally situate the areas of light and shadow and to apply a range of tonal values and colors necessary for modeling the volumes. Dry media are ideal for realistic representations because during the learning phase the applications and techniques emphasize depth.

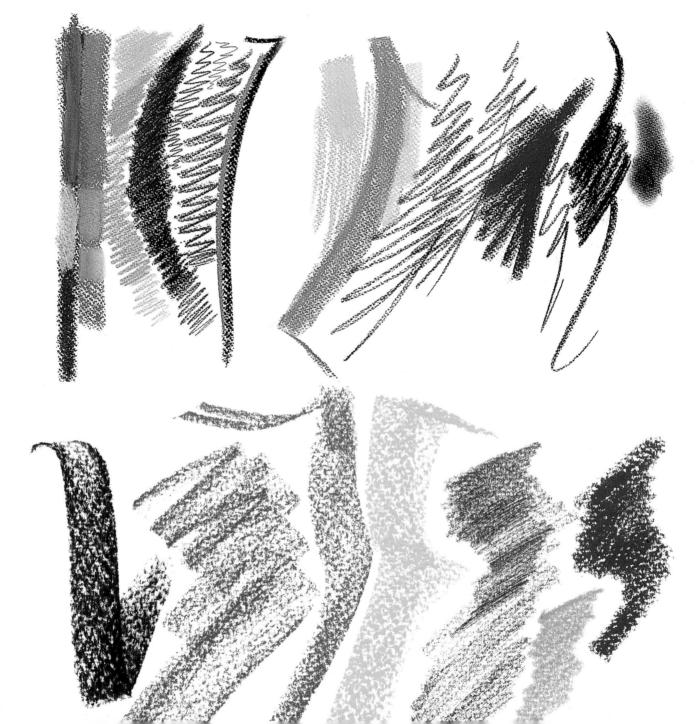

Dry Techniques

There are media that can be applied using dry techniques without the need for additives or complementary products, such as charcoal, sanguine crayon, chalk, and soft pastel. But graphite, colored pencils, wax crayons, and oil pastels are also considered to be oil-based media because of their grease, oil, or wax components. Techniques common to all of them include line, shading or coloring, gradating, blending, and rubbing. The effects and results produced by each of these techniques, and others that are not common to all, depend on the medium that is used. A general overview comparing work done with different media will make this quite clear.

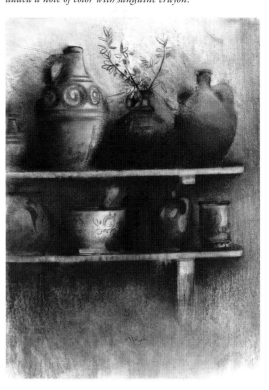

Francesc Crespo drew a large still life with charcoal and added a note of color with sanguine crayon.

SKETCHING MEDIA

It is obvious that a sketch can be made with the same medium that is going to be used to make the final drawing. However, it is not always done this way, since the characteristics of one medium make it ideal for use in the preliminary sketch for another medium. For example, the volatility of charcoal causes it to be one of the most used media for sketching.

Although a work of art can be done entirely in charcoal, sanguine crayon, chalk, pastel, graphite pencil, colored pencil, or oil pastel, these media are often used to create the preliminary sketch of a drawing or painting that is then done in another medium. Charcoal, chalk, and soft pastel are usually used to make sketches for oils and acrylics. Watercolors, on the other hand, require sketches done with graphite or colored pencils, even water-soluble ones. Oil pastel, which can be dissolved with turpentine or mineral spirits, can be used in the sketch for a painting that will be completed in oils. A line drawing is the usual technique for a sketch, the elements and main shapes representing the model being loosely drawn on the surface of the support.

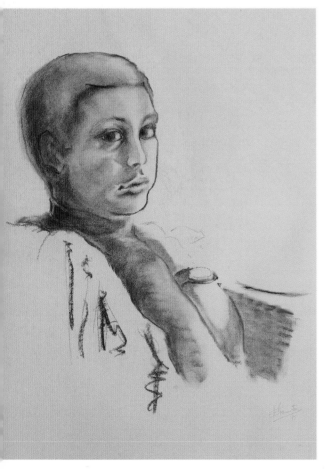

This is a character portrait, L'Arnau, done completely in charcoal by M. Braunstein using the basic techniques of line, gradation, and rubbing.

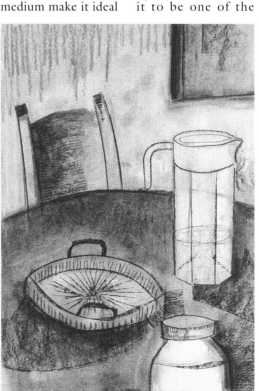

Gabriel Martín used charcoal and black chalk to create this Still Life.

PERFECT MEDIA FOR SKETCHING

Charcoal, sanguine crayon, chalk, pastel, graphite and colored pencils, and oil pastel can be used to make sketches using line, shadow, and color to indicate the light and shadow of the model. In addition, the techniques of gradating and some blending and rubbing can be applied to more developed sketches. The sketch can be achromatic (charcoal or graphite pencil), monochromatic (with one color of sanguine crayon, chalk, dry or oil pastel, or colored pencil), or done in several colors.

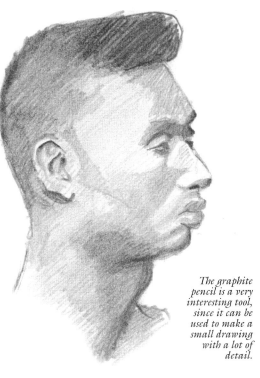

The graphite pencil is a very interesting tool, since it can be used to make a small drawing with a lot of detail.

DRY MEDIA ARE COMPATIBLE

White chalk is used to highlight a charcoal drawing. Sepia is used to darken sanguine crayon, and white chalk is used to lighten it. The historic technique *aux trois crayons* mixes charcoal, sanguine crayon, and white chalk, which can be used to achieve a perfect representation of volume. Charcoal and sanguine crayon are perfectly compatible with colored chalk and the soft pastels. The same is true of soft pastels and the colored chalks, which are nothing more than hard pastel.

Sanguine crayon, chalk, or pastel can be used over a sketch made with charcoal. In any case, it is always a good idea to draw lightly with the charcoal so the medium applied over it will not become dirty.

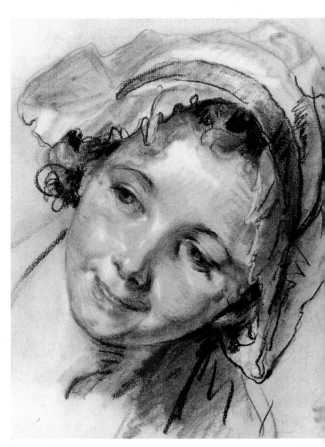

Head of a Girl, *by Jean Baptiste Greuze, illustrates the three pencil drawing techniques: charcoal pencil, sanguine pencil, and white chalk highlights.*

Portrait of a Figure *was done with silver point, a very old medium that cannot be corrected. Carlant drew on a smooth paper covered with a thin layer of dry gouache, using a silver point and a copper wire in a lead holder.*

DRY MEDIA AND OIL-BASED MEDIA

The techniques of blending and rubbing create a very similar effect with charcoal, sanguine crayon, chalk, and dry pastel, although the specific characteristics of each of these media and their derivatives do present some slight differences. Rubbing adds a special dimension to grease-based pastels, whether they are wax or oil, while the effects of blending and rubbing graphite or colored pencils greatly depend on the quality and hardness of the lead. With colored pencil, rubbing can even be done by drawing hatching or over areas of color. That is, the tool that applies the color does the rubbing, while with dry media this is usually done after the line or color is applied, with the fingers or a blending stick.

Practice will show that it is not always a good idea to use these techniques if you wish to avoid smudging the drawing.

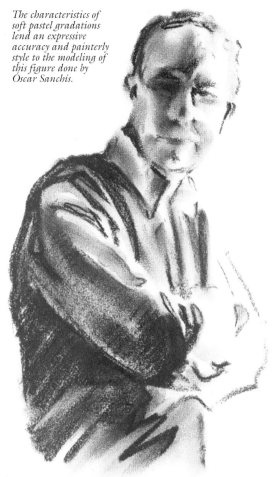

The characteristics of soft pastel gradations lend an expressive accuracy and painterly style to the modeling of this figure done by Óscar Sanchís.

It is possible to draw quick sketches on large sheets of paper with chalk. This way you learn to loosen the wrist and gain confidence in your freehand lines using very inexpensive materials. Drawing by M. Braunstein.

MODELING

Dry techniques allow perfect modeling of the forms in the representation of the subject thanks to the media's range of tone, color, and gradations. Achromatic or monochromatic tonal ranges can be created with any of the media that are covered in this book simply by applying more or less pressure to the drawing tool and observing the effect on the color of the support, which can be white or any color. In the case of the dry media (charcoal and sanguine crayon), the tonal ranges can be increased by using white chalk. Color and tonal ranges are achieved using chalk, dry and oil pastels, and colored pencils. Applying these ranges using the gradation technique will model the forms, and thus create the impression of three dimensions on the two-dimensional support.

Sanguine is useful for making quick sketches like this one by Óscar Sanchís. In this case, he resolves the drawing using figures and perspective.

THE MEDIA AND THEIR DERIVATIVES

A work in charcoal can be strengthened using a compressed charcoal stick or a charcoal pencil. These two derivatives of charcoal have characteristics that are somewhat different from vine charcoal. Compressed charcoal colors the support more and it is less volatile than vine charcoal. Charcoal pencil, on the other hand, because it is oilier, is the least volatile of the charcoal derivatives and the one that most darkens the support. It is not surprising that many artists, aware of these differences, use one or more of these forms in a single drawing to give it greater depth and introduce variations of texture.

Sanguine crayon and sanguine pencil do not differ as much as the charcoals. How-ever, it is easier to make hatching with the pencil, while the stick is ideal for laying down color in large areas.

The lead of pastel pencils is like a hard pastel and that of colored charcoal pencils is as hard as compressed charcoal. They are very useful media for introducing contrast or for making sharp outlines.

There are so many products and so many varieties of professional and student quality that it is a good idea to surrender to curiosity and make a systematic study of them. You may find it interesting to evaluate the characteristics of each product and to find out which media and techniques will be useful.

Óscar Sanchís used a technique of drawing opaque lines with soft pastel to create hatching and optical color mixes.

DRY TECHNIQUES AND INTERPRETATION

Interpretation is a part of all works of art. It could be the amount of synthesis or abstraction of the form or the color, or of both. With achromatic media like charcoal or graphite, or in monochromatic drawings, the interpretation consists of the artist's definition of the forms and the representation of light and shadow. With color media, the subjective abstraction can lead to areas of color or distorted forms.

In Field of Wild Poppies *M. Braunstein shows the possibilities of wax crayons using reserves, rubbing, and sgraffito.*

Here M. Braunstein used chalk on the rough side of brown wrapping paper. In The Pipe Corner *the strong colors and the contrasts between them stand out.*

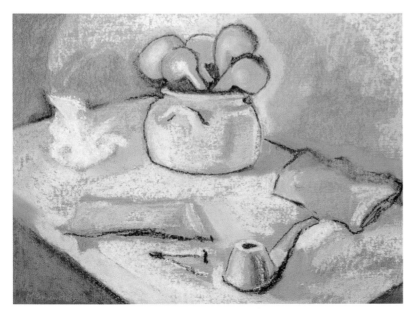

Charcoal

Charcoal is, without a doubt, the most traditional medium used for initiating a drawing. Furthermore, charcoal is the most universal drawing medium, whether used for simple sketches or complete works of art. Its line has a characteristic freshness, especially in large formats. Available as sticks, pencils, or powder, it enriches artwork with its contrasts in intensity of line, shadow, and texture.

Charcoal is available as vine charcoal sticks of different widths, in pencil form, in compressed sticks of natural and artificial charcoal, and as leads or cylindrical sticks.

ITS ORIGIN AND COMPOSITION

Charcoal is the oldest medium, used by humans in prehistoric times for their representations of the hunt and customs or for decoration. The smudge became very durable when mixed with some kind of grease. Today's charcoal is a vegetable carbon, and it is made from a complex burning process.

FORMS

Vine charcoal, compressed charcoal, charcoal pencil, and powdered charcoal are the different forms available. It is very useful to know the compositional characteristics of each one of these products, since the drawing depends on their effects.

VINE CHARCOAL

Vine charcoal is available as 5- to 6-inch (13–15-cm) long sticks, with a diameter ranging from as small as $3/32$ inch (2 mm) to almost $3/4$ inch (2 cm). Select the straightest sticks with the least number of knots. The most common are thin branches of willow, linden, and walnut. The carbonizing process must be very uniform to ensure a consistent hardness throughout the stick while maintaining the same quality for shading. The best known brands are Koh-i-Noor, Grumbacher, Lefranc, and Taker. The sticks are soft, medium, or hard, depending on their origin and the carbonizing process. The intensity of their "black" is less than that of charcoal pencils and compressed charcoal.

COMPRESSED CHARCOAL

Charcoal sticks, made by pressing charcoal powder in molds, are very regular cylinders with a consistent hardness. They are very useful because of their low cost and because they do not have inconvenient natural irregularities. Knots and imperfections cause vine charcoal sticks to break more easily when heavy pressure is applied while drawing. Some compressed charcoal sticks have a little clay as a binder, available in ¼-inch (7–8-mm) diameter cylinders, like those sold by Pitt and Faber-Castell. They are available in varying degrees of hardness, with the softest rendering a very intense black, and each has its own characteristics when it comes to coloring ability. Thus, they can be used for different purposes.

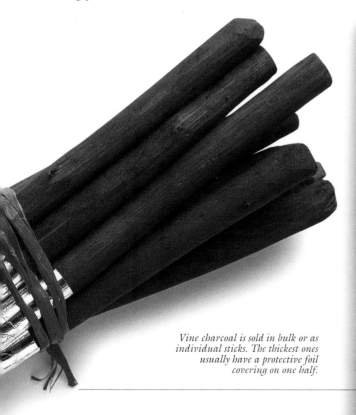

Vine charcoal is sold in bulk or as individual sticks. The thickest ones usually have a protective foil covering on one half.

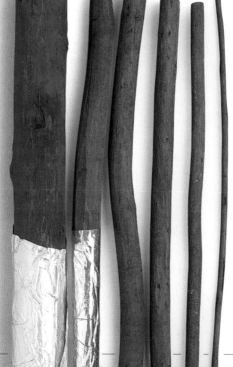

Vine charcoal sticks, besides being available in different widths, also have varying levels of hardness.

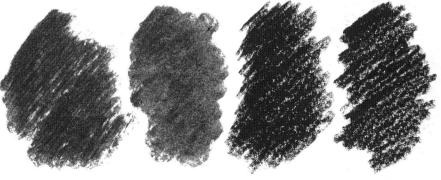

There are boxes that are sold with an assortment of charcoal products, although most artists prefer to assemble their own drawing box. Shown here are white chalk and sanguine sticks and pencils, since it is a common practice to make à trois crayons drawings.

Charcoal powder is another option.

CHARCOAL PENCIL AND LEADS

The charcoal pencil, a derivative of vine charcoal, is also known as the Conté pencil or crayon. It is a lead made from vegetable charcoal that contains binding agents, and it is protected by a wood case.

Conté pencils come in six grades of hardness, from soft through medium to hard. The leads have the same formula and work best when used with a lead holder. The Conté Pierre Noire pencil is the greasiest and most resistant to blending and rubbing.

CHARCOAL POWDER

Although a charcoal stick, compressed charcoal, or even a lead can be pulverized manually using a craft knife or sandpaper, the quality of the powder that is obtained will not be very consistent. Manufactured charcoal powder, on the other hand, is perfectly pulverized and works better for any blending that requires subtlety.

COLOR CHARCOAL

There are also color charcoal pencils. This is an interesting product, since it adds color to the volatile characteristics of the charcoal. It is very interesting to compare the results of color charcoal pencils with those of chalk and hard pastel pencils. The former can be blended and spread very easily; the latter have more coloring power and adhere better.

THE FRAGILITY OF VINE CHARCOAL

It is best to buy good vine charcoal, even though it is expensive; when drawing, you can depend on the quality and intensity of its line. Furthermore, because vine charcoal breaks so easily, it is a good idea to use the one that has the most consistent hardness. You can only draw well when you trust your tools.

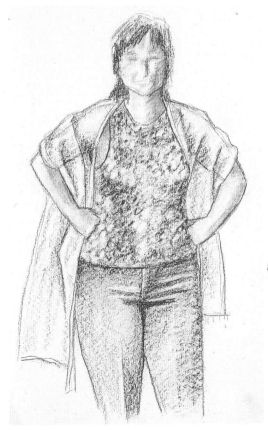

Esther Rodríguez drew Female Figure with Shawl *using a compressed charcoal pencil.*

The "blacks" of the charcoal derivatives share neither the same intensity nor the same finish.

Sanguine

In crayon or pencil form, sanguine is one of the very best media to use for modeling the figure. It has been used since about 1500, and it continues to be used today. In all the academies and schools of art it is the media that is typically used after having begun the drawing in vine charcoal. Sanguine has better covering power, and because it is less volatile than charcoal it requires more control of line and coloring to avoid mistakes and later corrections.

There are boxes with an assortment of sanguine crayons and pencils. White and black chalk are always included with them.

THE PENCIL AND THE LEAD

The sanguine pencil is made from a lead and a wood protector or case. The thicker lead is cylindrical and usually used with a lead holder. Sanguine does not need as much agglutinate as charcoal to strengthen the lead, although the Conté method requires some baking. The pencils are available in sanguine, sepia, and white.

There is also an oil-based sanguine pencil that should not be confused with the normal sanguine pencil. Its lines can be used as reserves that can later be colored with the dry version of the pencil.

COMPOSITION

Conventional sanguine comes in the form of a stick or crayon. It is composed of ferruginous clay or iron oxide or iron per-oxide, and it usually contains a small amount of chalk. When using sanguine, it is usual to carry a darker colored crayon, such as sepia. In fact, there is a range of chalk used with sanguine: white, two blacks, and sepia.

FORMS

Sanguine is available in crayon and pencil form and also as a cylindrical stick or lead. It is a good idea to practice and become familiar with all the variations and to use the appropriate one at the opportune time.

THE CRAYON

The sanguine crayon is a square stick about 3 inches (8 cm) long. Depending on the brand, the sides can be from $\frac{1}{5}$ to $\frac{1}{4}$ inch (5–7 mm). Its hardness and covering power vary according to its quality and the amount of time it is baked during the manufacturing process.

A range of sanguine colors is available in both crayon and pencil form. The white is used for highlighting and the black and sepia for shading and blocking-in drawings.

The square crayon is the most common form. But the length and girth of the crayon will vary depending on the brand.

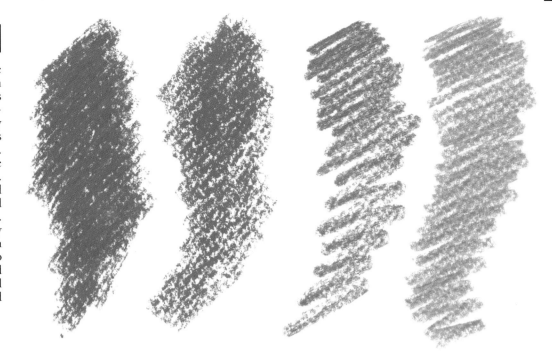

PIECES

As soon as one begins to draw with sanguine, it becomes apparent that the crayon breaks relatively easily, although it is harder than charcoal. Nevertheless, all the pieces can still be used. The side may be used to draw wide lines and to color large surfaces. There is also a very useful square crayon holder or extender to hold the pieces and ensure good control for accurate freehand drawing.

SANGUINE POWDER

One way of coloring with sanguine without leaving visible streaks is to apply it very carefully with the side of the crayon. But sanguine powder can also be used for this task. It is very easy to make this powder using a crayon and a craft knife. The powder is quite homogenous if the crayon is scraped lightly. Even the sanguine powder created when sharpening the point of a pencil can be used to introduce a little variety to the composition of the crayon powder. All the powder can also be sifted through a piece of woven fabric to eliminate the largest particles and get a very fine powder.

CHARACTERISTICS AND COLOR

The characteristics of each form of sanguine and the particular mark each makes on the support can be very instructional when all the properties are used in one drawing. For example, the crayon covers well and is difficult to erase if applied with much pressure. A crayon of a different hardness will have more or less intense color. Non-oil-based sanguine pencils are drier and harder than crayons and wear more slowly. Oil-based pencils, on the other hand, have little covering power.

The different applications of color vary from one brand to another, but the difference is especially pronounced between the crayon and the pencil, and with the oil-based pencil (from left to right: two crayons of different hardness, pencil, and oil-based pencil).

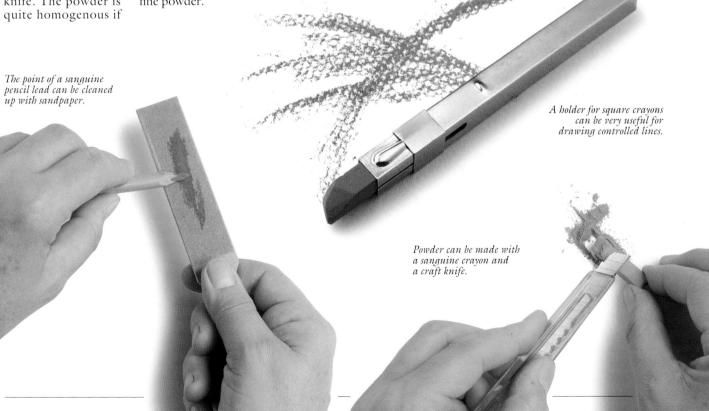

The point of a sanguine pencil lead can be cleaned up with sandpaper.

A holder for square crayons can be very useful for drawing controlled lines.

Powder can be made with a sanguine crayon and a craft knife.

Chalk

White chalk was first used to highlight charcoal and sanguine drawings. Black chalk was used as well, to darken sanguine without having to resort to charcoal. Later on, more colors of chalk were manufactured. Nowadays, chalk is often called hard pastel, but the number of available colors is never as large as that of the soft pastels.

Samples of the different pigments used to make color chalk.

The range of chalk colors is not as wide as that of soft pastels. However, a box of 24 sticks is enough to achieve good results when drawing and coloring.

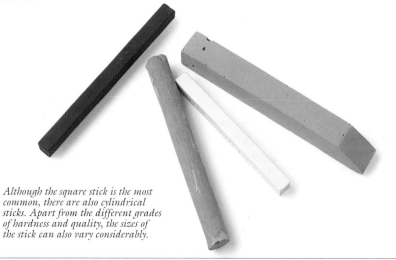

Although the square stick is the most common, there are also cylindrical sticks. Apart from the different grades of hardness and quality, the sizes of the stick can also vary considerably.

COMPOSITION

Chalk is a calcareous rock, white or gray, which was formed in layers during the Cretacious period. Contemporary recipes call for lightly cooking a paste that is left to dry in molds for square crayons. In the beginning, chalk was limited to white, black, sepia, and sanguine. Much later, more colors of chalk were created by adding pigments.

FORM

Chalk is normally available in square sticks that are at least 2½ inches (6.5 cm) long, and the sides vary from ⅕ inch (5 mm) to ¼ inch (7 mm) or even more. But there are so many products on the market that these dimensions are only references. There are also cylindrical sticks of chalk.

Thick cylindrical leads about ⅕ inch (5 mm) in diameter and with a point on one end are sold in all the traditional colors plus a few more. The leads are used with lead holders because they break easily when pressure is applied to them. They can be used directly for coloring lightly.

Chalk pencils are basically hard pastels. The lead is thinner than those manufactured without a wood case. It usually measures about ⅛ inch (3 or 4 mm) in diameter.

It is common practice to create two assortments of grays, one with cool tendencies and one with warm.

Because there is not as large a selection of color chalk as there is of soft pastels, it is worthwhile to create new colors by mixing the powder from two sticks of chalk. This powder may or may not be well mixed, however, and the color of the mark made from it may be homogenous or an optical mixture of the two colors used.

On an interesting note, it should be pointed out that it is possible to make a stick from powdered chalk by simply adding a binder and baking it in a home oven or a kiln.

Professional grade chalk, which can be purchased as individual sticks, is laid out for use according to personal preference. The black and white ones are usually set apart, and the warm and cool colors are clearly separated.

THE RANGE OF GRAYS

White and black constituted the simple range of colors in the beginning. Little by little, all the shades of gray were added to the assortment. Nowadays, there is a wide range of gray chalk of various tones and qualities. A drawing can be made with warm grays or cool grays, further contributing to the options of this simple color range.

BOXED OR INDIVIDUAL STICKS

Chalk is available in boxed assortments of 12, 24, or more colors. An assortment large enough for drawing without limitations should include at least 24 colors. Professional grade chalk is also sold as individual sticks. It is a good idea to create your own palette once you have begun to master drawing and painting.

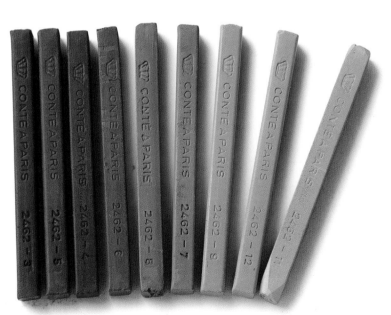

Without a doubt, the gray range is the most extensive. There are so many shades that they can be distinguished only by placing them next to each other.

Chalk colors are usually mixed on the paper by using one over the other. But it is also possible to make mixtures by scraping two or more colors, in this case blue and carmine, and mixing the powders, in this case making violet.

Pastel

Pastel can be used for drawing and painting at the same time. It is no surprise that so many prefer it. Before the advent of pastel in the seventeenth century, chalk was the medium habitually used to color drawings that were made with charcoal. However, after the development of pastel, it became the medium used for painting full-color masterpieces, and it is famous for its marvelous chiaroscuro.

STICK AND PENCIL

Pastels are sold in stick form. Generally, the soft and semisoft pastels are cylindrical, and the hard pastels are formed into square sticks.

The soft pastels are available in several sizes. The typical round stick is 2¾ inches (7 cm) long. Its diameter ranges from ⅜ to ½ inch (1–1.3 cm). Semisoft pastels are usually thinner than soft ones.

Extra thick soft pastels are made for coloring the surfaces of large supports. They are very useful for sketching and coloring samples for decorating or advertising. They measure about 1¼ inch (3.5 cm) in diameter.

The pastel pencil has a much thicker lead than a typical wax-based colored pencil. It measures at least ⅛ inch (3 mm) in diameter and has the same composition as hard pastels.

PASTEL COMPOSITION

The composition of a pastel basically consists of pigment for color and gum arabic as an agglutinate, or binding agent. Soft pastels are pigment with only a small amount of agglutinate, and are therefore very fragile and crumble quite easily.

Hard pastels and artist's chalk are manufactured from chalk, and they require a short baking time to make the stick harder. This is why the hard pastel sticks are thinner than the soft and semihard pastels. Because of their hardness they are also available as square sticks, so they can be used to draw very fine lines on the paper.

Boxes with a wide assortment of pastels arranged in protective trays are available in stores.

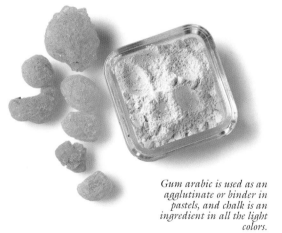

Gum arabic is used as an agglutinate or binder in pastels, and chalk is an ingredient in all the light colors.

A WIDE ASSORTMENT

The good professional brands of pastel offer a wide range of colors, especially in the soft pastels. This is because the ability to mix colors with pastels is limited to the use of dry techniques like blending or rubbing clean and directly applied colors. It is a good idea to have many colors from which to choose the most appropriate tones.

The large amount of pigment used in the manufacture of pastels explains their intense colors, especially the soft ones.

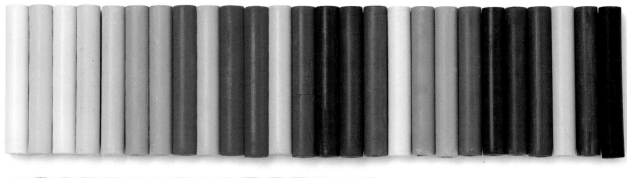

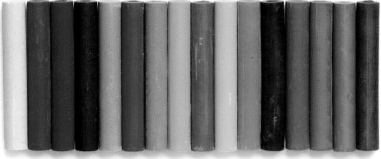

There is a very wide selection of pastel colors, so it is a good idea to begin with an assortment of 40 to 50 colors.

It can be useful to make your own pastel powder. Afterward, the different colored powders may be mixed well or left unmixed. Making your own powder is a good technique for creating colorful streaks.

PRACTICAL ADVICE

To keep pastel sticks in good condition, it is necessary to store them in compartments where they will not touch each other. They are basically sticks made of pigment, and the soft ones crumble quite easily. Whenever two sticks come into contact, they smudge each other with their respective colors. To avoid this, they are kept in separate compartments. If it turns out that a stick has been smudged by another color, it can be wiped off with a clean cotton cloth.

PROTECTIVE COVER

Not all brands of pastel sell their sticks with a protective wrapper, but it is a common practice. This protective wrapper fulfills several functions. For one, it keeps the stick from getting dirty. It also allows the pastel to be used without smudging the artist's fingers. And finally, the wrapper helps to bind the pastel dust on the outside of the stick.

Pastel sticks are often protected by a paper wrapper printed with information about the color. This is very useful when replacing used-up colors. However, the paper must be removed as the stick becomes smaller from drawing and coloring.

The wrapper can be bothersome when drawing. It can be partially or entirely removed according to the requirements of the drawing.

IMPORTANT

Special care must be taken to avoid dropping or jarring all soft, semisoft, and hard pastels as well as pastel pencils. The sticks will break, and the broken lead in a damaged pencil will be exposed as the pencil is sharpened.

Boxed assortments of pastels are usually protected with foam padding. If you buy pastels individually, you should provide similar padding to keep them from bumping into or touching other colors.

Graphite

Before graphite was invented, metal points were used for drawing. The gold, copper, and silver points made a warm mark, whereas the line made by a lead point was gray. The use of metal points declined with the discovery of graphite in the seventeenth century and the recipe for using it as a drawing medium.

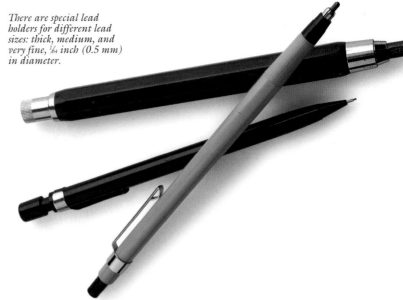

There are special lead holders for different lead sizes: thick, medium, and very fine, ¹⁄₆₄ inch (0.5 mm) in diameter.

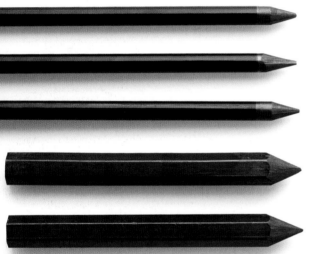

Sticks of graphite can be either cylindrical or hexagonal.

STICK, LEAD, AND PENCIL

There are many shapes of sticks, among them a hexagonal shape, with a point at one end. It measures as much as 3¼ inches (8 cm) in length and is nearly ⅖ inch (1 cm) thick. There is also a cylindrical stick sharpened at one end. Some companies offer this thick lead of about ⅓ inch (8 mm) in diameter in the form of a pencil, and it can be the same size as a normal pencil. A thick plastic wrapper usually protects the solid lead pencil and must be removed as the pencil wears down from drawing and shading. There are other leads, about 2¾ inches (7 cm) long and ⅕ inch (5 mm) in diameter, that can be used to draw as they are or inserted in a holder for thick leads.

There are a wide variety of widths of leads; the thinnest for drawing is just ¹⁄₆₄ inch (0.5 mm) in diameter.

Graphite pencils are cylindrical leads with a protective wood case. The thickness of the lead depends on its hardness. The diameter varies from about ⅛ inch (3 mm) in the case of a very soft lead to ¹⁄₁₆ inch (1.5 mm) in the case of a hard lead.

COMPOSITION

Graphite can be found in a natural form or be created artificially. It is crystalized carbon, and it has the appearance of a greasy substance with metallic reflections. The forms that we know today—stick, lead, and pencil—are natural powdered graphite mixed with clay and baked. The hardness of the different sticks, leads, and pencil leads varies according to the amount of clay in the mixture and the baking time.

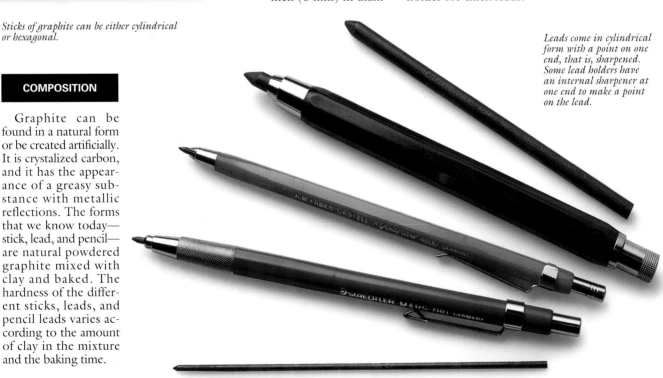

Leads come in cylindrical form with a point on one end, that is, sharpened. Some lead holders have an internal sharpener at one end to make a point on the lead.

Pencils, like graphite sticks, have different grades of hardness, and it is advisable to test the various gray and black marks they make.

There is a special pointer or sharpener for thin leads.

A graphite pencil with a hard lead will make a very fine line, which makes it easy to see the textures of the three different drawing surfaces.

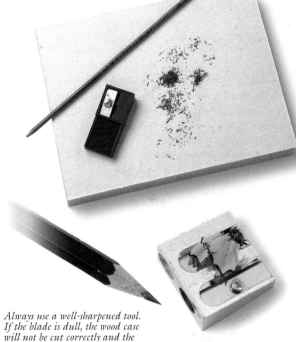

Always use a well-sharpened tool. If the blade is dull, the wood case will not be cut correctly and the lead will be damaged and end up breaking.

Thick graphite sticks usually have a thick plastic covering that must be cut off when sharpening the graphite, since it can ruin a drawing by rubbing or making unwanted sgraffito marks.

SHARPENING

When sharpening a solid graphite stick, first remove the rigid plastic cover with a knife. Sticks and thick leads can be sharpened by rubbing them on a piece of sandpaper to shape their points. A pencil can be sharpened with either a pencil sharpener or a craft knife. A small diameter lead pointer is used for thin leads. Some lead holders have a built-in pointer or sharpener. It is used by first extending the lead a little from the holder, then removing from the end of the holder the metal cap that is pressed to load or move the lead. Inside is a small cone-shaped file into which the lead is introduced and then turned to shape the point. Finally, the cap is replaced and the lead is adjusted so it can be used for drawing.

HARDNESS

The characteristics of graphite that should be important to the draftsman are good quality and a grade of hardness that is appropriate for the drawing in progress. A soft lead pencil makes a very intense black; the lead wears down quickly and the lines do not stay fine very long no matter how often the pencil is sharpened. Conversely, a hard grade pencil draws very fine lines and leaves a light mark. A hard lead does not shade well nor does it make intense lines; they are always gray.

The artist has a large assortment of grades of hardness to choose from—up to nineteen are available. Each pencil has a letter on the end to indicate how hard its lead is: the B means that it is a soft pencil; the H refers to a hard one. There are numbers along with the letters; the soft leads range from B to 8B (the softest); the hard leads start with H and range to 9H (the hardest). There are also medium-hard pencils, HB and F.

Colored Pencils, a Full-Color Medium

Colored pencils are a direct medium just like the other dry media. But the characteristics of colored pencils allow them to make full-color drawings with a lot of detail. The appropriate format must be chosen for this medium. It is best that the drawing always be small, given the difficulties in creating intense tones and the limits in line length and precise hatching.

Assortments of professional quality colored pencils are sold in boxed sets. A set of 48 colors is recommended for making quality drawings with a range of hues.

COMPOSITION

Colored pencil leads are mixtures that incorporate pigments as the main ingredient. The pigments are bound with kaolin and a small amount of wax. This results in a lead that is quite durable, with the perfect hardness for easily making a sharp point. But the wax in the lead and the presence of kaolin mean that the colored pencils must be used for lines and hatching, and coloring that will not be as intense as that of other media.

The colors can be bought separately, building an assortment of special tones and shades that should be arranged in order and in relation to each other.

QUALITY AND HARDNESS

Professional colored pencils are the only ones that color well. Several brands offer assortments in two grades of hardness: the hard ones are used for very precise drawings, and the semihard ones are better for coloring large surfaces more or less uniformly.

The leads of the water-soluble colored pencils are, without a doubt, softer than the semihard ones. As a result, the intensity of their colors is greater.

Many artists use this type of water-soluble pencil to introduce elements to contrast with the coloring done with conventional colored pencils, which is not that intense.

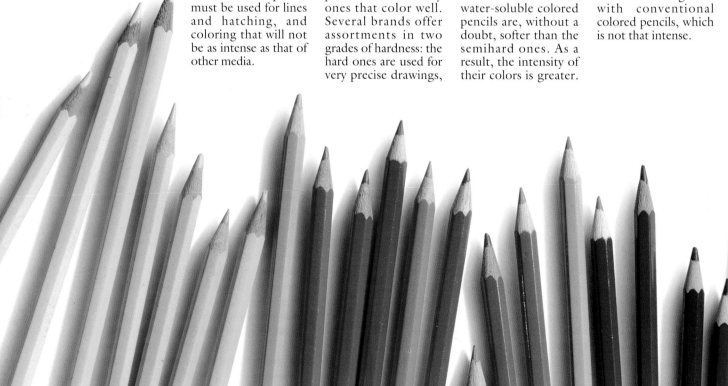

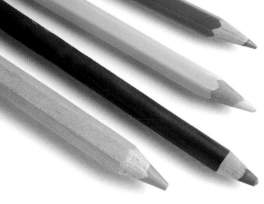

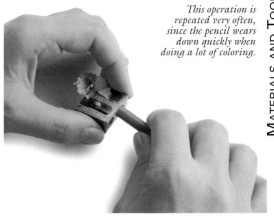

This operation is repeated very often, since the pencil wears down quickly when doing a lot of coloring.

LEADS

There are also colored leads of different widths. Only the thickest can be used without a lead holder. The thinnest, 1/64 inch (0.5 mm) in diameter, can be used for very precise drawings and requires a special lead holder because of its size.

Colored pencils are made with different lead sizes. The hard or semihard ones will have a thinner lead and the case will be hexagonal. Water-soluble pencils are thicker and are normally cylindrical. There are also hard pencils with very thick leads.

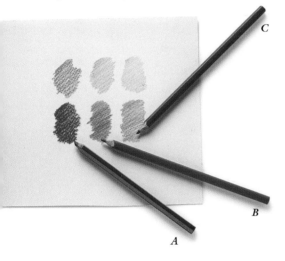

Pencils of different grades of hardness color lightly. The water-soluble pencil (A) can color quite intensely, the medium-hard pencil (B) with less intensity, and the hard pencil (C) with even less intensity.

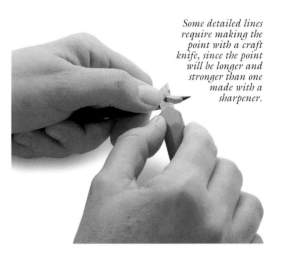

Some detailed lines require making the point with a craft knife, since the point will be longer and stronger than one made with a sharpener.

ASSORTMENT AND ORDER

If you have a box, it is easy to put each pencil back in its corresponding spot after using it to keep the pencils well organized. However, when drawing a particular subject or model, you may find it helpful to choose only the colors that will be needed rather than sort through the entire box. They should be placed in order on the table or in another box. This way, it is easier to select the right colored pencil while drawing.

COLOR ASSORTMENTS

Boxed sets of colored pencils contain from 12 basic colors in a small box to ten times that, 120 colors, in the largest assortments. A box of 48 pencils is enough to make a full-color drawing while avoiding the typical limitations of mixing colors with pencils.

The professional brands also sell individual pencils, as seen in the catalogues of Caran D'Ache, Rexel Cumberland, Berol, Faber Castell, Schwan, and Prismacolor. This makes it possible to personalize your colored pencil assortment.

SHARPENING

Professional brands of colored pencils have high quality wood cases that make it easier to sharpen the lead. A sharpener makes a uniform, conical point, but a craft knife can be used to shape a longer point while keeping the base thicker, so it will not need to be sharpened as often.

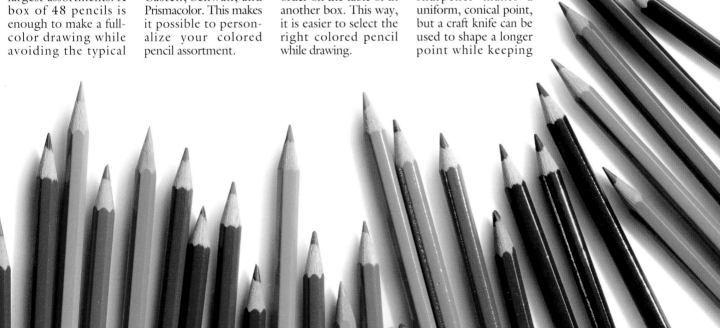

Wax Crayon and Oil Pastel

Wax crayons are cylindrical sticks of color that have a point at one end. This medium is well liked by artists, who are seduced by the colors and versatility of wax crayons and use them alone or in mixed media. Used correctly, wax crayons can be used to make paintings that are striking in their color and quality. The other grease-based crayons, oil pastels, have other uses and are more limited if they are used only with dry techniques. Their chromatic and textural potential can only be tapped with the use of solvent, which is a wet technique.

idea to practice and get to know the characteristics of each one before drawing with them. It is also important to be aware of the amount of opacity of each color.

Pigments add the color to wax crayons.

COMPOSITION

In the composition of wax crayons, the pigments are the ingredients that determine the color, and vegetable oils are the agglutinates. Some colors also incorporate calcium carbonate to make them opaque. It is necessary to add ingredients to accelerate the hardening process in hot climates. There are small variations in their composition, and some sticks can be softer than others. It is a good

FORMS

Wax crayons are cylindrical sticks about 2¼ inches (6 cm) long and ⅛ inch (1 cm) in diameter, with a point at one end. The sizes vary from one brand to another—some as thick as ⁵⁄₁₆ inch (1.5 cm) in diameter and longer as well. They usually have a small protective paper wrapped around the middle to keep fingers clean while drawing; it can be removed whenever necessary.

Oil pastels are very similar in appearance to soft pastels and are available in boxes of limited assortments.

Colors can be acquired individually, but they should be arranged in order. It is very useful to have a wide range of grays.

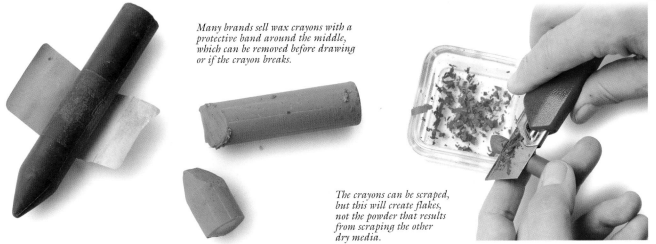

Many brands sell wax crayons with a protective band around the middle, which can be removed before drawing or if the crayon breaks.

The crayons can be scraped, but this will create flakes, not the powder that results from scraping the other dry media.

CHARACTERISTICS

Any crayon will break relatively easily if it is applied with too much pressure to the paper or other support. Even a new box will have pieces and remnants of crayons after the first drawing session. They should be saved in the original crayon's slot.

The outside of the crayon melts easily from the warmth of the artist's hand. In addition, the composition of the crayons will cause two crayons in contact to smudge each other very easily. It is very common for this to happen.

Unlike other dry media, such as graphite and colored pencil, scraping a crayon will not produce powder, but flakes. However, doing this is a way to create some immediate texture effects.

A BOXED OR PERSONAL ASSORTMENT

It is very important to use professional quality wax crayons. The smallest box has 12 colors, and the largest 75. Crayons are also available individually, allowing the artist to assemble a personal palette. This material is very affordable, so we recommend putting together a large assortment of colors. The beautiful colors in the resulting work of art are more than worth the cost of the crayons.

WHITE

A lot of white crayon is used in a drawing. White is used for reserves and also to lighten the tones of colors, and it is important to have several crayons so you will not run out in the middle of a drawing. White crayons can be bought separately or in boxes of 12.

The color white is used often when drawing with wax crayons. It is a good idea to buy several sticks, or even a box of them.

OTHER TECHNIQUES

Although this book addresses only dry media, it is important to point out that wax crayons, like other grease-based pastels, have an oily base similar to that of oil paint and can be used as a wet technique when mixed with a solvent like turpentine or mineral spirits.

Another technique for working with wax crayons is melting them with heat. The work is tedious, since it means heating the wax and applying it before it hardens, but the results are colorful, and interesting textures can be created.

Paper

Paper is the most common support used when working with dry media. There are many appropriate papers; even papers that are meant for wet techniques can be used. The only essential requirement for a paper to be a good support is for the particular medium to adhere well. There is a large selection of colored papers. Besides the special colored papers for dry media, there are wrapping papers and recycled ones that have unique neutral tones and interesting textures.

Special drawing papers are sold in the form of sketchbooks and blocks, and paper made for use with wet media can also be used with dry media.

A

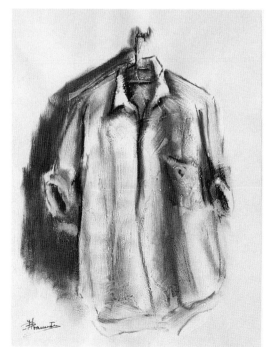

B

There is a large variety of white papers (A) of different quality, weight, and surface texture. Recycled paper is also useful (B).

FORMS

Paper for drawing with dry media is available in sheets, rolls, and drawing pads. The sheets are 20 × 26 inches (50 × 65 cm) for drawing, and 30 × 44 inches (75 × 110 cm) for dry media. Rolls of paper for dry media measure 5 × 40 feet (1.52 × 10 m). Drawing pads with spiral or glue binding come in several sizes, but 9 × 12 inches (24 × 32 cm) can be considered a standard medium size. Graphite and colored pencils sometimes require a smaller format. On the other hand, dry media like charcoal, sanguine crayon, chalk, pastel, and the grease-based wax crayons are better used on large sheets of paper.

CHARACTERISTICS

The format of the paper and its dimensions depend on the model and the medium that will be used. But there are several characteristics that are important to keep in mind to help choose the most appropriate paper: weight, texture, and color.

WEIGHT

The classification of paper is based on the weight of a ream, or 500 sheets, of that particular type of paper. A 20-lb. paper is very light, and without a doubt will not stand up well to vigorous drawing. Progressively more durable papers have weights of 50 lb., 72 lb., and 90 lb. Papers for watercolor painting must stand up well when wet, and they can be quite heavy. For example, 90-lb., 140-lb., 300-lb., and even 400-lb. papers are typical, and quite thick. The watercolor papers can be used with dry media, since they all adhere well to this kind of paper.

M. Braunstein drew The Shirt with vine charcoal on paper that had been textured with acrylic medium.

Some types of cardboard, like mat board, have paper glued to one or both sides. Drawings can be made on this paper if the surface allows it.

All the manufacturers of professional quality papers offer a wide range of colors for pastel drawings; these can also be used with all the other dry media.

COLOR

A wide range of colored papers is available for drawing with dry media. It is a good idea to experiment on a separate piece of paper with the different optical mixtures that result from superimposing the dry media or colored pencils over colored paper.

The choice of one color of paper or another is based on whether the goal is to achieve harmony or contrast. Many neutral pastel colored papers, with either warm or cool tendencies, introduce delicate variations that favor harmony and, therefore, are never a risky choice.

TEXTURE

In addition to the weight, another important characteristic of paper is the surface texture, which can be heavy, medium, or light, and granular or smooth. When choosing paper for drawing it is a good idea to establish which texture is best for the desired results.

Most papers have very different textures on each side. Paper for pastels has a heavy texture on one side and a light one on the other. Generally, lightweight papers do not have this advantage.

Some special drawing papers and even some wrapping papers have a texture of parallel lines that create very interesting finishes because of the resulting contrast effects made by the drawing media.

Paper for pastels usually has a heavy texture on one side and a light texture on the other. Sketch paper for dry media can have a texture of parallel lines (laid) and can be used vertically or horizontally. Wrapping paper with line texture has one glossy side that should not be used with dry media.

Drawing on colored paper requires knowledge of color theory. It helps to arrange colored papers into warm, cool, and neutral groups. Then, you must decide whether you want harmony or contrast when choosing the paper color for a specific drawing.

Other Supports

There are many other supports besides paper. Among them are posterboard, cardboard, corrugated cardboard, foamcore boards, fabric (primed or not), and canvas boards. Sandpaper and even rigid plastic and glass can also be used with oil pastels and certain pencils. In every case it is important to know the material well, because each medium usually has different effects and results according to the characteristics of the support.

Cardboard and foamcore boards are available in many thicknesses.

Nowadays there is a large selection of corrugated cardboard for crafts and industrial cardboard for packaging.

CARDBOARDS

Posterboards come in a large assortment of colors. Normal cardboard and recycled cardboard are usually gray. However, some cardboard has paper glued on one side to dress it up. This is also the case of foamcore board. The essential characteristic that all the different supports must have in common is a drawing surface that allows the media to adhere well.

Corrugated cardboard is a variation of common cardboard. It is usually a grayish or brownish color. In addition to the types used for packaging, there is corrugated cardboard for crafts, which is available in a wide range of colors. The unique thing about corrugated cardboard is the effect of its texture on the drawing. The lines, either vertical or horizontal, become a pictorial element.

SANDPAPER

It is even possible to draw with dry media on industrial sandpaper, but there are also special papers on the market that imitate fine sandpaper and work very well. The small grains glued to the surface of these papers easily scrape any dry medium, helping it adhere well. The color of the paper is very important to the final effect of the overlying drawing.

Some companies offer an assortment of colored papers similar to industrial sandpaper but made especially for dry media.

Drawing on industrial sandpaper with vine charcoal, sanguine crayon, chalk, and pastel is an interesting exercise.

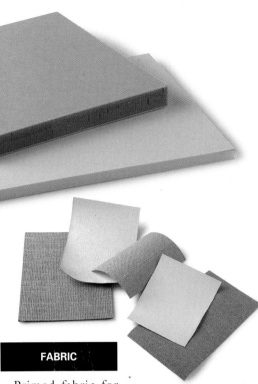

Wax crayons are an extraordinary medium for achieving very realistic decorative effects on Styrofoam.

Fabric is another option. Primed fabric is best, prepared for painting with oils or acrylics. All the dry media that can be used on fabric will contrast with the white primer.

Wax crayons can be used on rigid plastic. If the plastic is transparent, a white sheet of paper should be placed underneath. A passe-partout mat and glass are indispensable for conserving the work executed with this technique.

FABRIC

Primed fabric for painting with oils or acrylics has a special characteristic; it has a coat of dry paint over which these paints can be applied directly. Despite the primer, the fabric has a heavy, medium, or even fine texture. Drawing on a primed fabric results in textural effects from the surface of the fabric and the white of the primer.

WOOD

It is possible to draw on wood, MDF (medium density fiberboard), chipboard, and plywood. It is important that the wood finish does not contain varnish, wax, or oil so that any dry medium that is used will adhere well.

OTHER SUPPORTS

Styrofoam is a very interesting material for creating decorative effects. This support is ideal for drawing with wax crayons. It is not necessary to apply much pressure, but try to soften the wax with the heat from your hands, because the hardness of the medium could damage the surface of the Styrofoam.

Rigid plastic and glass are other options for drawing. The surfaces of both should allow wax crayons and some grease pencils to adhere. A white sheet of paper should be placed underneath transparent plastic and glass to better show the characteristics of the media and the colors of the drawing made with wax crayon. A drawing made on this type of support requires good conservation; that is, it should be matted and framed.

Canvas boards are very practical supports. They do not give way when drawn on since the board makes them rigid, and they weigh less and occupy much less space than fabric mounted on a stretcher.

Strokes of vine charcoal, sanguine crayon, pastel, and wax crayon show the textures of a fabric with heavy texture (A) and another one with a finer texture (B).

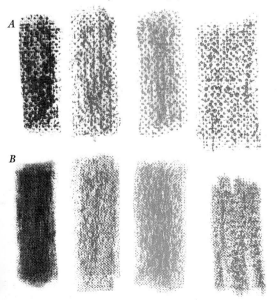

A

B

CANVAS BOARD

Fabric mounted on cardboard is lighter than canvas on stretchers. Most oil and acrylic artists use canvas boards only for unimportant works, sketches, and color notations because the fabric cannot be stretched on a conventional frame. However, canvas board is a perfect support for drawing with dry media because it is rigid and easy to draw on.

Sketch Boards

Paper, the typical support for dry media, has to be attached to a sketch board. This has multiple functions, giving the paper rigidity, keeping it flat and wrinkle free if attached correctly, and holding the drawing while it is being worked on so that it does not have to be touched and smudged. Many materials can be used as a sketch board, so it will be easy for the artist to find one that is appropriate for his or her needs.

WOOD

A wood sketch board is the most commonly used. It should not be too heavy, especially for large-scale drawings. It should be a type of wood that does not warp easily, although using alternate sides can help preserve it. The grain of the wood should not be raised, because doing so would leave marks on paper that is too thin.

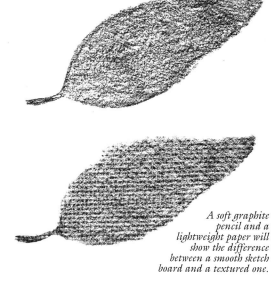

A soft graphite pencil and a lightweight paper will show the difference between a smooth sketch board and a textured one.

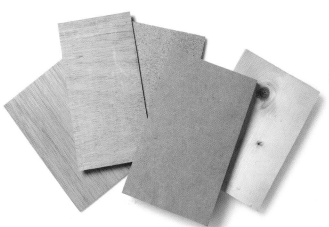

Sketch boards vary in rigidity, surface texture, and dimensions.

A lightweight paper on a piece of corrugated cardboard can be shaded using the lines in a horizontal or vertical direction to create contrast effects.

DIMENSIONS

The dimensions of the sketch board should exceed those of the paper being used for the drawing. Space should be left on all four sides around the drawing to hold the sketch board without smudging the drawing while working on it. A good rule of thumb would be about 2 inches (5 cm). If the sketch board is too large it will be uncomfortable to work with; therefore, it is a good idea to have several sketch boards of different sizes.

CARDBOARD

Very thick and rigid cardboard can work perfectly well as a sketch board. If you are drawing directly on a cardboard support rather than on paper, a sketch board may not be needed. A cardboard sketch board can be very handy for small and intermediate-sized drawings. Drawings can easily be done in sketchbooks that have a thick cardboard backing, which acts as a sketch board, and a spiral or glued edge that holds the paper in the sketchbook.

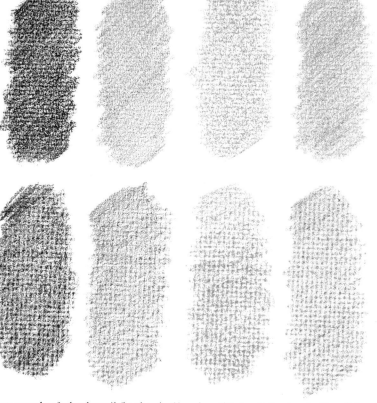

These examples of colored pencil (hard and soft) and graphite pencil (hard and soft) on lightweight paper illustrate the effects created by drawing on supports with two different textures.

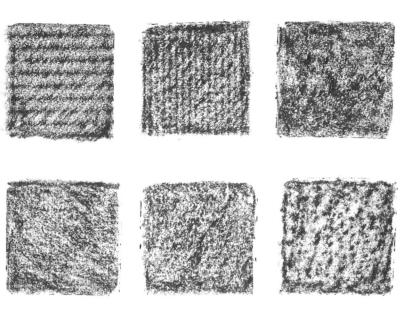

TEXTURE OF THE SKETCH BOARD

It is a good idea to use a very smooth support to keep a drawing under control, especially in the beginning. Later, experience will show that the characteristics of each drawing and the paper must be taken into consideration when choosing a sketch board. For example, a heavy paper will not let the texture of the surface of the sketch board show through, so it is not necessary to use a perfectly smooth board.

Paper for drawings done in graphite or colored pencil does not have to be very heavy. Besides, the lines and details can be seen better with lighter paper. On a light enough paper, the texture of the sketch board can be seen, and it can be used to good effect in the final drawing.

Coloring with a blue crayon shows the different textures made by different supports: above, two corrugated cardboards and a smooth one; below, two wood boards and a wall.

The sanguine and sepia crayons reveal the direction of the wood grain on the sketch board.

MORE SKETCH BOARDS

Many appropriate materials are available for use as a sketch board, for example, engineered wood products like chipboard and plywood.

Medium density fiberboard (MDF) is a product made with glued and pressed pulverized cardboard. It is very rigid and durable and its surface has a very smooth finish, but it is heavy. It is even used for manufacturing furniture. MDF boards are available in different widths, so a thin one can be used as a sketch board. Masonite can also be used as a sketch board, alternating sides so it does not warp. A drawing made on the smooth side ensures that only the texture of the paper appears in the sketch. A drawing made on the rough side will show the texture of the sketch board on the paper, if the latter is sufficiently smooth. However, Masonite is very impractical because it tends to warp easily over time; it is designed to be glued to a rigid surface that will hold it perfectly flat.

Overlaid hatching with colored pencils shows the direction of the grain of the wood sketch board.

On a heavy paper, the surface of the sketch board does not show, only the texture of the paper itself.

The texture shown was created by placing a tree leaf between the paper and the sketch board and coloring or shading over it.

Easels, Drawing Boards

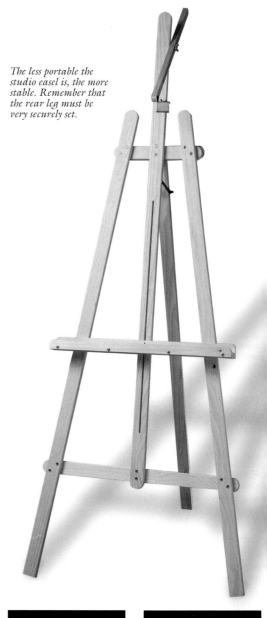

The less portable the studio easel is, the more stable. Remember that the rear leg must be very securely set.

Easels and drawing boards are very useful tools because they make the artist's work easier. There is no set standard, but easels are usually used for drawing with dry media, oil pastels, and graphite sticks, while the drawing board is used for drawing with graphite and colored pencils. In reality, it is a matter of being as comfortable and accurate as possible when making the drawing.

WOOD EASELS

One way of making drawing easier is to have the paper and sketch board well supported on a stable easel that cannot be moved by the artist's motions. This leaves his or her hands free for making strokes with more or less intensity.

Another useful item for making medium- or small-sized drawings is a tabletop easel, for which a table is also required to set it on. A good tabletop easel will hold the sketch board securely and will allow the artist to work either standing or sitting. The simplest tabletop easel is the humble bookstand. The drawing will tilt back, which is helpful when making small drawings, but it must be held with the hand that is not doing the drawing.

This tabletop easel is very stable for working, especially if it is braced from behind so that it will not move when it is pushed during drawing.

METAL EASELS

These collapsible easels are very useful for the graphite and colored pencil media. They usually must be worked horizontally and require a table. This is simply more comfortable because it ensures a better line and does not require the effort of keeping the arm raised while shading and coloring meticulous and detailed work. This easel has the option of leaning back and holding the sketch board and paper nearly horizontal at the height required for drawing in a standing or sitting position.

PORTABLE EASELS

The portable easel is very useful for drawing outdoors because it is collapsible and easy to transport. However, portable ones are not as stable as studio easels and may need to be weighted or braced with rocks. In reality, depending on the medium, the artist usually prefers to make quick sketches and photographs of the model in the field, and make the definitive drawing in the studio surrounded by all the conveniences he or she needs. Of course, many artists are able to draw in adverse conditions, without an easel.

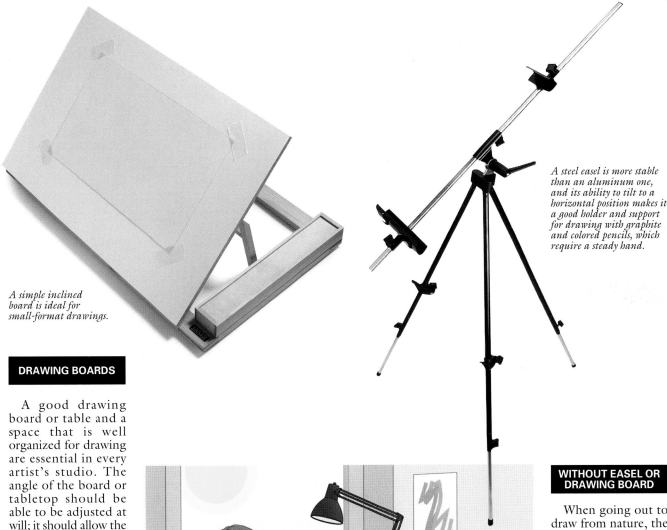

A simple inclined board is ideal for small-format drawings.

A steel easel is more stable than an aluminum one, and its ability to tilt to a horizontal position makes it a good holder and support for drawing with graphite and colored pencils, which require a steady hand.

DRAWING BOARDS

A good drawing board or table and a space that is well organized for drawing are essential in every artist's studio. The angle of the board or tabletop should be able to be adjusted at will; it should allow the forearms to rest and let the entire drawing be easily viewed. Work can be carried out on a very flat surface or a more inclined one, from either a sitting or standing position.

The lighting should not cast reflections. Direct sunlight on the paper should be avoided because it is very bad for the eyes. The angle of the board should be adjusted for this. In a studio without natural light, the fixture should be directed so that it will not create irritating reflections on the surface of the paper or shine directly into the artist's face. The drawing hand should not project a shadow over the drawing area because it will make the drawing difficult to see.

WITHOUT EASEL OR DRAWING BOARD

When going out to draw from nature, the artist often cannot carry too much because the place is inaccessible. All that is needed in such cases are a sketch board, paper, a simple box with the drawing media, some material for blending, an eraser, and so forth, and a cotton rag for cleaning the hands. A surface that acts as a table or a support must be improvised: a rock, a tree stump. Once the sketch board is well supported, the artist can proceed without worry.

The drawing table can be tilted to the best angle for working. Properly illuminated, it is the best place for drawing with graphite and colored pencils.

Blending Materials

The materials used for blending are without a doubt the most important materials needed when working with dry media. All the dry media—including charcoal, sanguine crayon, chalk and pastels in stick or pencil form, crayons, and oil pastels—can be blended. Colored pencils, in their soft version, and watercolor pencils can also be blended.

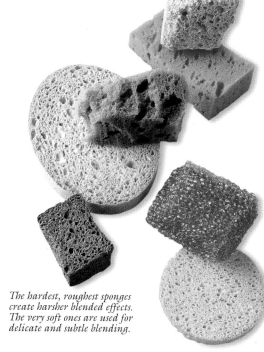

The hardest, roughest sponges create harsher blended effects. The very soft ones are used for delicate and subtle blending.

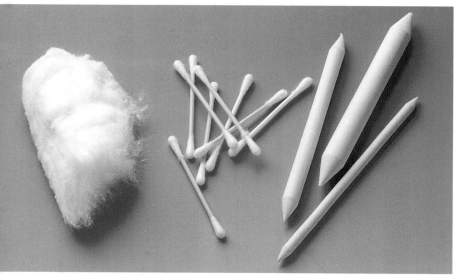

Blending sticks are designed to be used for rubbing and blending. But cotton swabs and simple cotton balls will create somewhat different effects when used for the same purpose.

SPONGES

There is a large variety of natural and artificial sponges. Their most important characteristics when used for blending and rubbing are their softness or roughness and their particular texture. They should be tested on a separate paper before use on the final drawing to ascertain the effect they will produce.

BRUSHES

Any brush can be used for blending or rubbing. All brushes—from the soft ones up to the very hardest ones—can be used with dry media. A brush with very stiff bristles must be used with grease-based media in order to move it on the paper.

BLENDING STICKS

The blending stick is a tool that can both blend and rub. It is a piece of paper that is rolled into a cylinder shape. It comes in different widths, from ¾ inch (2 cm) in diameter to the thinnest, barely ⅛ inch (3 mm). The thickest blending sticks usually have a point on each end. The thinnest are usually shorter so they will be more resistant to bending and breaking. They often have a point on just one end.

When blending, the point is used for details and the side of the cone-shaped point for larger areas. The width of the blending stick will depend on the size of the area that is to be blended.

This tool gets dirty as soon as it is used. It is a good idea to have several blending sticks, using one for each type of medium (charcoal, sanguine crayon, and so forth) so that media will not mix and accidentally smudge the drawing.

COTTON

Cotton in all shapes and forms can be used to blend and rub any of the dry media, except for the hard colored pencils.

A cotton towel is not just for cleaning your hands; if used correctly, it can also be a drawing tool. A cotton ball can be very useful for working with powdered media, and a cotton swab can be used for very detailed and accurate work.

A cotton towel or a piece of a towel can become the perfect tool for blending.

HOW TO MAKE A TOOL

Devising personalized tools specially designed to create a textural effect can be left to the imagination of each person. There are an endless number of materials that can be used for this purpose: straw, a scrubbing pad, Styrofoam, fine twigs, a cork, and so on. Once tied together to use for blending, they can even be attached to a handle.

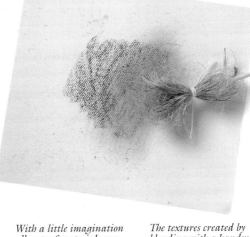

With a little imagination all sorts of materials can be used to make tools for blending and rubbing.

The textures created by blending with a handmade tool are usually very interesting.

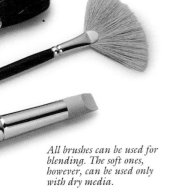

All brushes can be used for blending. The soft ones, however, can be used only with dry media.

The hand is the best tool that an artist has for blending and rubbing.

THE HAND

The hand is the most practical tool of all for blending because it is always available and it allows complete and intimate interaction with the drawing. All parts of it can be used for blending and rubbing. But in most cases the fingertips, the sides of the fingers, and the base of the thumb are used.

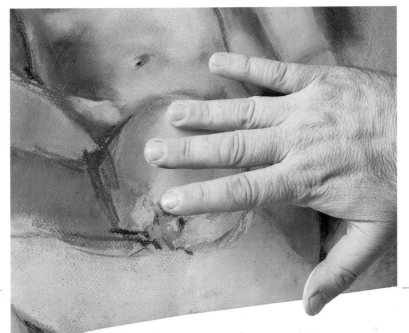

The fingertips are ideal for rubbing the colors of the straw hat to create a chiaroscuro effect.

Complementary Materials

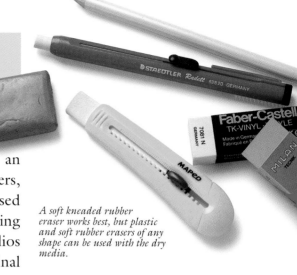

Properly attaching the paper to the sketch board is an indispensable first step in making a drawing. Erasers, materials for making reserves, and the mahlstick are used throughout the work session. Products for fixing the drawing medium are used at the end or between sessions. Portfolios and framing materials are important for temporary or final conservation of the work of art.

A soft kneaded rubber eraser works best, but plastic and soft rubber erasers of any shape can be used with the dry media.

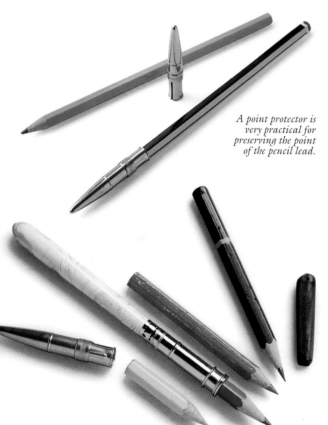

A point protector is very practical for preserving the point of the pencil lead.

MATERIALS FOR THE PENCIL

A pencil extender and a point protector are two very useful objects for the draftsperson. The extender helps get more use out of the pencil, which can be so difficult to control when it gets too short that it is often discarded. The point protector covers the lead when the pencil is in the box and when it is being transported. It is shorter than the extender, but it can also be used to lengthen the pencil.

THE MAHLSTICK

This tool is especially useful for large-scale works where the hand must be held steady.

RESERVES

Masking tape can be used for reserving small areas and the edges of a drawing. Paper and cardboard templates can also be used. Liquid masking gum is more effective for wet media. However, it is of very limited use and often inappropriate for dry media techniques.

Any clip that does not damage the paper and holds it in place is acceptable, even if it is somewhat smaller than the sketch board. Even a clothespin will work.

ERASING

A kneaded rubber eraser is usually used for dry media, but a good plastic eraser is better for detail work. Either a soft rubber eraser or a plastic one can be used with the grease-based media like graphite, colored pencil, and wax crayon because neither will damage the surface of the paper.

HOLDING THE SKETCH BOARD

A variety of clips and tacks can be used to attach the paper to the sketch board, as can masking tape.

An extender is used with graphite, color, and even charcoal pencils. The point protector can also be used to lengthen the pencil a little.

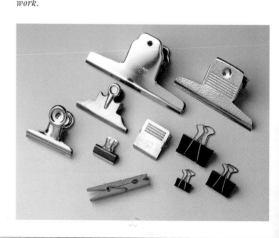

The mahlstick helps to keep the hand steady without it touching the drawing surface.

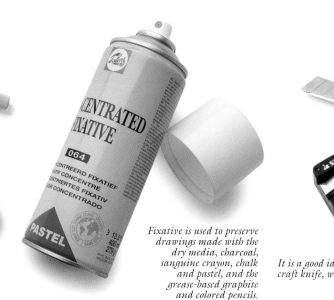

Fixative is used to preserve drawings made with the dry media, charcoal, sanguine crayon, chalk and pastel, and the grease-based graphite and colored pencils.

It is a good idea to have a pencil sharpener, or at least a craft knife, which, given its versatility, is indispensable.

FIXATIVE

Dry media need to be conserved with a fine layer of fixative. Fixative is especially recommended for soft graphite pencil. It is optional for hard graphite and colored pencil. Wax crayons, being a grease-based medium, can be fixed with latex or with varnish for oil pastels.

PRESERVING WORK

Portfolios are essential for temporarily storing drawings, which must be separated by sheets of vellum paper. It is good to have portfolios of different sizes. However, permanent conservation of drawings means framing them with glass, a window mat, backing board, and a frame.

MAKING POINTS

Pencil sharpeners, pencil pointers, and craft knives are necessary, especially for charcoal, sanguine, pastel, graphite, and colored pencils.

CRAFT KNIFE

The craft knife is versatile and indispensable. It is used for cutting paper, scratching, making reserves from paper or adhesive tape, making points on pencils, and scraping dry and oil-based media.

Drawings should be protected with a sheet of vellum or tracing paper before putting them in the portfolio.

OTHER PRODUCTS FOR WET MEDIA

Wax crayons and oil pastels can be diluted with turpentine and also with mineral spirits. These media are compatible with oil paint.

It is a good idea to have portfolios of different sizes so the drawings will not slide around inside and get smeared.

Specially made varnish is very useful for fixing oil pastel drawings.

Holding the Work

There are several extremely important steps to take before actually beginning to draw. If these steps are not done correctly, the paper will move during the process and become seriously damaged. The paper must be attached to the sketch board and the board to the easel. If there is no easel, the sketch board can be set on a table or on your lap.

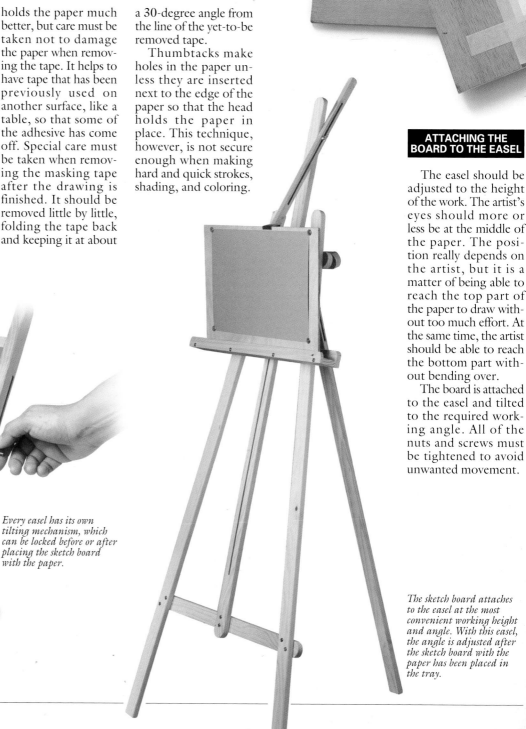

ATTACHING THE SUPPORT TO THE BOARD

There are several ways of attaching the paper to the sketch board; the best way depends on each drawing. There is a large assortment of clips that do not damage the paper. It is important to have some that will hold paper that is somewhat smaller than the sketch board on all sides. Masking tape holds the paper much better, but care must be taken not to damage the paper when removing the tape. It helps to have tape that has been previously used on another surface, like a table, so that some of the adhesive has come off. Special care must be taken when removing the masking tape after the drawing is finished. It should be removed little by little, folding the tape back and keeping it at about a 30-degree angle from the line of the yet-to-be removed tape.

Thumbtacks make holes in the paper unless they are inserted next to the edge of the paper so that the head holds the paper in place. This technique, however, is not secure enough when making hard and quick strokes, shading, and coloring.

Every easel has its own tilting mechanism, which can be locked before or after placing the sketch board with the paper.

ATTACHING THE BOARD TO THE EASEL

The easel should be adjusted to the height of the work. The artist's eyes should more or less be at the middle of the paper. The position really depends on the artist, but it is a matter of being able to reach the top part of the paper to draw without too much effort. At the same time, the artist should be able to reach the bottom part without bending over.

The board is attached to the easel and tilted to the required working angle. All of the nuts and screws must be tightened to avoid unwanted movement.

The sketch board attaches to the easel at the most convenient working height and angle. With this easel, the angle is adjusted after the sketch board with the paper has been placed in the tray.

Thumbtacks, clips, and masking tape can all be used to attach the paper to the sketch board.

ON THE TABLE

How the sketch board is placed on the table depends on various factors, but whether standing or sitting the artist should be able to reach all parts of the drawing comfortably. If no table easel is available, the board can be leaned against a support, like a pile of books, to raise the top of the work of art. The sketch board is held against the chest with the hand that is not drawing, if the artist is sitting, or against the stomach, if the artist is drawing standing up.

ON THE LAP

Drawings can also be made in a sketchbook or on a small- or medium-format paper attached to a board without an easel or a table.

If you are drawing standing up, the sketchbook or sketch board can be held with one hand at the top and the bottom edge braced against the body.

When drawing sitting down, the board or sketchbook should be held against the lap with the free hand holding the top. There are many ways to do this. The board can be held against a single leg, a footrest can be used to raise one knee for a better angle, or the sketch board can be held as it is when drawing standing up.

This is how the board is held when sitting.

When standing, the artist can hold the work steady.

All of the fasteners are double-checked to make sure that the work will not accidentally come loose during vigorous drawing.

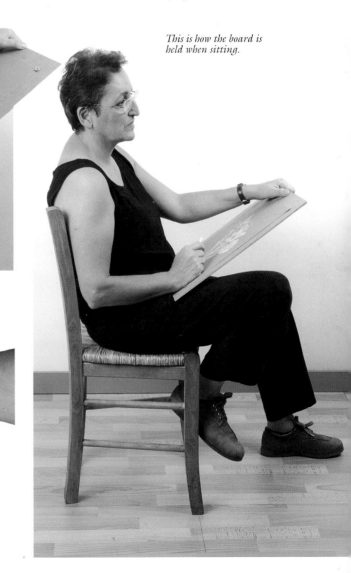

Drawing with Charcoal

With practice you can find out at what point a charcoal stick will break. This way you can keep it from happening, at least with important lines.

The different forms of charcoal can be used together or separately in the same drawing. Whether they are applied directly or indirectly by later manipulation, very different effects can be achieved. All these procedures are based on different techniques, and the results vary according to the charcoal and the auxiliary materials that are used.

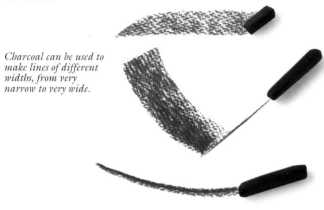

Charcoal can be used to make lines of different widths, from very narrow to very wide.

DRAWING LINES

Any part of a vine charcoal stick, a stick of artificial or natural compressed charcoal, a lead or the point of a charcoal pencil can be used to draw on paper or on an appropriate support. The resulting line must have a beginning and an end. When a lot of pressure is applied to the tool the resulting line is intense; conversely, when the pressure is light, the line is light. Lines that are straight, curved, broken, and expressive can be achieved by practicing different movements of the wrist and the fingers. When drawing expressive lines one must hold the charcoal so that it is fully under control.

The angle that the charcoal is held at determines the width and length of the strokes.

An expressive shadow is fresh looking and spontaneous, such as drawing with small, broken pieces of vine charcoal.

DRAWING AN OUTLINE

Good line technique is essential in drawing the outlines of the forms. The more expressive the outline, the more painterly the final drawing. It is a good idea to practice this type of line. To begin, study the model attentively. Once you have memorized the form, draw it freehand without referring to the model. Do this again and again until the lines look confident and intentional.

AN ESSENTIAL POINT

Vine charcoal is very fragile. If the point is pushed too hard against the paper, it can easily break. It is advisable to test it on a separate piece of paper to discover its breaking point. This will help you avoid interrupting a line that was intended to be expressive, when you are working on the final drawing.

For practicing curves, one option is to draw a circle within a square, completely freehand.

EXERCISES FOR PRACTICING LINES

Charcoal drawings are usually large in format. To be able to draw a long line with confidence, you should practice on a 36 × 36-inch (1 × 1-m) sheet of wrapping paper. Try drawing diagonal lines using the two opposite corners as guides. The freehand middle lines are done by eye.

To practice curves, draw a large square, always freehand, and then draw a circle inside the square. The diameter of the circle should be the same size as the length of the lines of the square.

There is an ideal exercise for better control of the beginning and end of a line. It consists of drawing two parallel lines—call them *a* and *b*—and then drawing two more, also parallel, that begin at *a* and end at *b*.

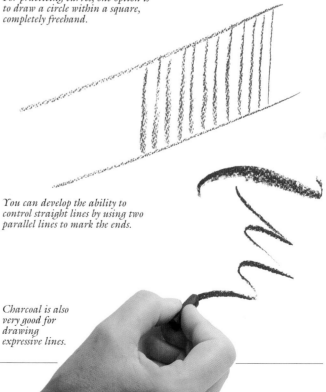

You can develop the ability to control straight lines by using two parallel lines to mark the ends.

Charcoal is also very good for drawing expressive lines.

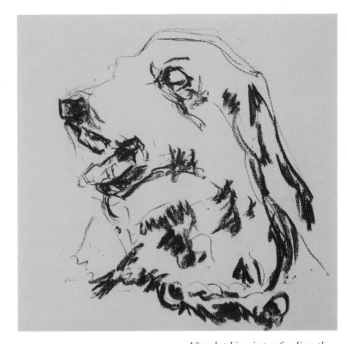

SHADING

Shaded effects can be applied with juxtaposed charcoal lines or by smudging an area of the paper. Like line work, shading can also be done expressively and should be applied in a crisp, fresh way, indicating the volume or the shape of the forms without hesitant and repeated lines. Practice and observation are the best tools for learning this.

THE EFFECT OF TEXTURE

Lines have a tendency to emphasize the texture of the paper, and in the case of a smooth paper, the texture of the sketch board it is mounted on will also stand out.

CONTROLLING THE LINE

Since the hand cannot rest on the paper when drawing because it would smear part of the charcoal that has already been applied, the only way to make a line is freehand. Sometimes, when a large-format subject requires precision, it is a good idea to use a mahlstick to control particular lines. Any long stick will also work. A commercial mahlstick has a ball on one end, which is placed against the paper or the sketch board in the area outside the drawing. It is held slightly above the paper with the hand that is not drawing while the other hand rests on the stick, to be held steady when making lines.

After sketching just a few lines the expressive character of the drawing can already be appreciated.

The lines show the texture of the sketch board on smooth paper.

The mahlstick is a very helpful tool for drawing steady lines.

Charcoal pencils can also be used to draw fine expressive lines.

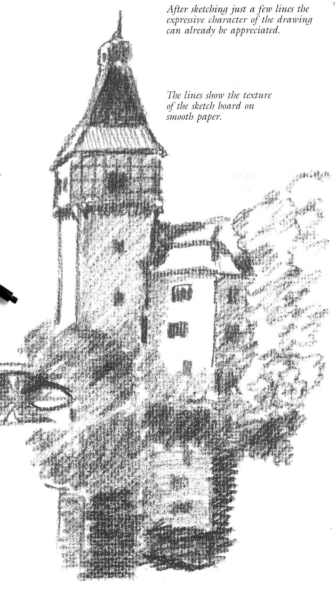

The lines representing the shapes of the forms should be light until the figure is blocked in.

After the outline has been adjusted, the lines can be darkened and made to overlap.

VOLUME USING CONTOUR LINES

Simple outlines describe shapes but say little about their volume, unless the lines are made to overlap. Contour lines offer additional information, especially if they are of different widths. The widest lines illustrate the outlines of the nearest volumes, and the thinnest lines indicate those that are farthest away. If the drawing is analyzed as a representation of different planes, a contour line is always wide on the closest plane and becomes thinner as the planes recede. A sketch may not always have contour lines because of doubts at the moment of drawing the outlines and concern for the proportions, but it is advisable to add them once the lines of the sketch have been laid down. This will create a greater sense of volume.

BLENDING TECHNIQUE

Shading can be blended just like a line, using a blending stick, a cotton rag, or the fingers. The tool need only be wiped across the charcoal powder to remove it from the paper. Shading that has been blended looks less intense when compared to shading that has been left untouched, and the blended shading gradually fades to nothing.

Charcoal applied to the paper can be blended by wiping it with a cotton rag, which will pick up a large portion of the powder.

RESERVES

One of the biggest problems of working with charcoal becomes evident from the moment the first lines and shadows are laid down. It is very difficult to draw cleanly unless certain precautions are taken. Although lightly drawn charcoal is easy to erase with a kneaded or plastic eraser, it is a good idea to protect the work before it accidentally gets smeared. The paper should be covered with a cardboard frame to prevent smudging it with dirty fingers; the frame allows the work to be held firmly without damaging or smearing the drawing.

Cutout templates are also frequently used to reserve areas and shapes.

A frame surrounding the entire work, or a template for the details, are two of the options for reserving an area of a drawing.

ERASING MINOR SMUDGES

A light line that was made a bit too long or blending that spilled into some white areas can be eliminated with an eraser. On the other hand, dark lines and shading and charcoal pencil can only be partially removed. They will not disappear, despite vigorous erasing. Besides, doing so is not good for the paper, because it ruins the surface and can wrinkle lightweight paper.

It is advisable not too draw too heavily until you are sure of the exact direction and darkness required, so the work will not have to be erased.

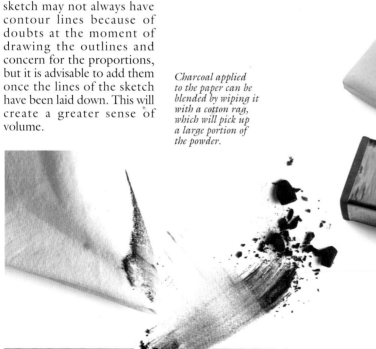

Specific effects are possible only if you are familiar with the characteristics of each eraser.

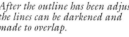

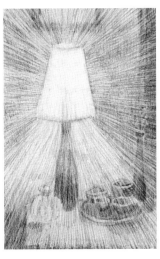

Here the white lines were created to dramatize the source of the light.

VARIOUS EFFECTS

It is important to represent the progressive movement from light to dark seen on the entire surface so that the drawing expresses the volume of the forms. The most intense light and the reflections are the brightest points of light, and they are assigned the color of the paper, whether it is white or a light color. It is in these areas that it makes sense to create highlights.

The darkest areas, contrasting with the lightest ones, block in the forms.

Creating white areas is not always a matter of trying to reclaim the original color of the paper, however. This technique can be used to create textures or relief that indicate the direction of the light source. This treatment used on an entire drawing will give it a rhythm that dramatizes the forms and volumes.

Creating highlights is a useful, dynamic effect that can be used for expressing movement.

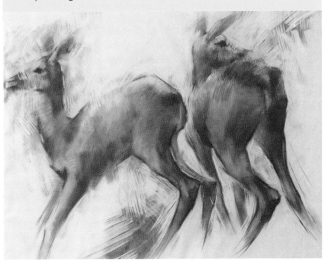

The kinetic effect that accentuates the sense of movement is very expressive. It is one application of the highlighting technique.

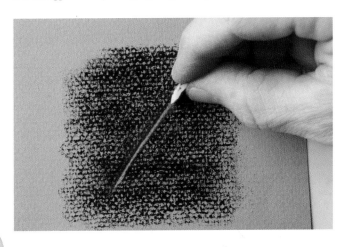

Both the full width and just a corner of a plastic eraser can be used to create highlighted areas.

CREATING HIGHLIGHTS

An eraser is used to create highlights on paper. A piece can be cut from a plastic eraser to use for making a thin, linear highlight; it is less malleable than special kneaded erasers for charcoal. The latter can be used for creating large areas of white. This technique is a way of reclaiming the white of the paper, or whatever color the paper support may be, when adjusting the light in the drawing.

Only a rigid plastic eraser can be used for thin linear details.

Pieces can be cut off of kneaded erasers.

The kneaded eraser is used for lightening details and large areas.

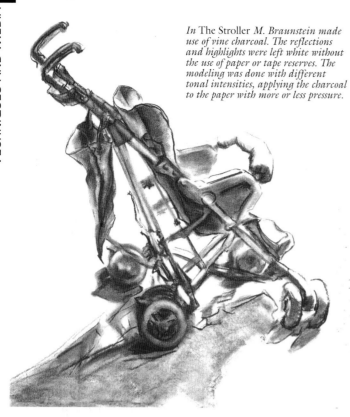

In The Stroller *M. Braunstein made use of vine charcoal. The reflections and highlights were left white without the use of paper or tape reserves. The modeling was done with different tonal intensities, applying the charcoal to the paper with more or less pressure.*

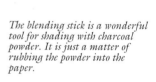

The blending stick is a wonderful tool for shading with charcoal powder. It is just a matter of rubbing the powder into the paper.

OTHER SHADING TECHNIQUES

Shading can be done with more than just lines. It is also possible to apply charcoal in powder form. But the powder itself will not adhere to the surface, so it needs some sort of help, like the hand and fingers, which are the artist's natural resources. They can press the charcoal powder into the paper until the mark adheres.

Other tools, like blending sticks, a cotton cloth or ball, or a cork are also useful for pressing the powder into the paper.

TONAL VALUES AND TONAL RANGE

The more pressure you apply to vine charcoal, a compressed charcoal stick, or a charcoal pencil, the darker the mark it makes. In the case of charcoal powder, the larger the quantity of charcoal on the surface of the paper, the more intense the "black" that is created. Less pressure results in a very light mark, similar to one made using a small quantity.

It is possible to put the different tonal values in order—for example, from the lightest tone to the darkest. This is how you create a tonal range. It is important to be aware of the differences between vine charcoal, charcoal pencil, and compressed charcoal. Charcoal pencil and compressed charcoal make the darkest tones; vine charcoal, on the other hand, will not make a darker tone when more pressure is applied. Vine charcoal is used when a light range is required. For these reasons most artists use two or more forms of charcoal in the same drawing to achieve richer and more complex results. Nevertheless, the somewhat greasy composition of the charcoal pencil must be kept in mind, which makes it a bit difficult to combine the three forms of charcoal.

White chalk is also used to increase the tonal range and the potential for creating more gray values.

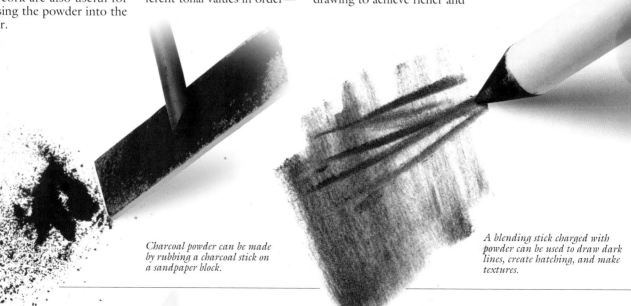

Charcoal powder can be made by rubbing a charcoal stick on a sandpaper block.

A blending stick charged with powder can be used to draw dark lines, create hatching, and make textures.

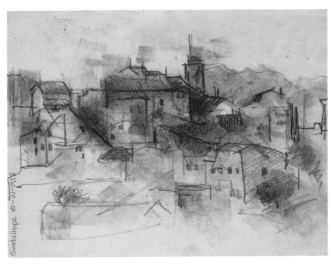

Several tools were used to blend and rub this drawing: fingers, a cotton rag, and blending sticks of different sizes. Drawing by Gabriel Martín.

Throughout a drawing or quick sketch the different tones are approximated so that the range will serve as a reference. The placement of one against the other creates the depth.

TONAL VALUES AND VOLUME

While observing the model, the artist applies light charcoal tones to the areas that are well lit, with progressively darker tones as the light diminishes. The darkest tones correspond to the areas hidden in darkness. This system of assigning tonal values allows us to represent the volume of forms. Therefore, it is important to develop tonal ranges that can be used as the basis for modeling forms with depth.

A cotton ball is ideal for applying a tone to a large area.

CREATING DARKER TONES BY OVERLAYING

Pressing harder on vine charcoal, a compressed charcoal stick, or a charcoal pencil will create a darker tone. But you can also darken a tone by adding another layer of shading.

When superimposing charcoal you must consider the saturation point of the paper and that of each form of charcoal. It is good to test the saturation level on a separate piece of paper and then establish the value range based on the darkest tone that the paper allows.

FIXATIVE IS ESSENTIAL

You will notice how easily the powder comes off of the paper almost as soon as you begin drawing with charcoal. All you have to do is blow on it or lightly wipe a fingertip over some shading to see how fragile this medium is. The drawing must be fixed to prevent disaster or to prevent the charcoal from coming off and losing its contrast and vitality. Although there are bottles of liquid fixative on the market, the most common and simple form is the aerosol spray.

Spray fixative is applied 6 to 8 inches (15–20 cm) away from the paper with circular or zigzag motions to cover the entire surface with a thin layer. An even coat should be applied, taking care not to allow too much liquid to accumulate in one area. If there is any doubt, it is best to let it dry completely and then give it another spray.

It is a good idea to practice with the fixative, because using it incorrectly could damage a drawing.

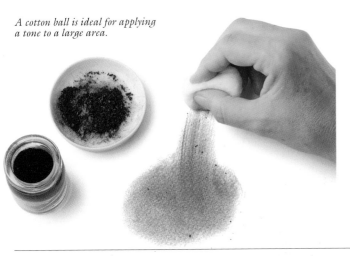

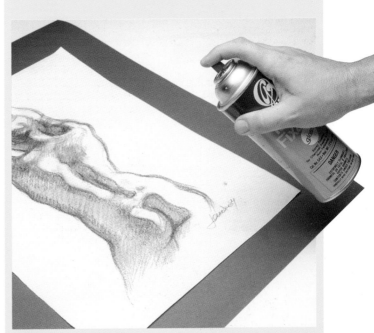

Charcoal is so volatile that it should be fixed not only when the drawing is completed but even between sessions. A fine coating of the fixative is applied from a distance of about 6 to 8 inches (15–20 cm) in a well-ventilated space.

Sanguine and Modeling

Sanguine crayon and sanguine pencil can be used for drawing and coloring. A drawing made with a single color is monochromatic. White chalk can also be used for making highlights. However, greater contrast can be achieved by using regular sanguine along with sepia for blocking in the shadows and making the modeling more dramatic.

These are the darkest tones that can be achieved with sanguine.

DRAWING AND COLORING WITH CRAYONS

Any part of the crayon may be used for drawing. It is common practice to break a piece off for making wide lines (the width of the line is the width of the crayon). To color large areas without leaving lines, draw with the side of the crayon, making circular or zigzag motions. The intensity of the marks varies depending on how much pressure is applied to the crayon.

OUTLINES WITH CRAYONS AND PENCILS

A sanguine pencil can be used to make very descriptive lines that cannot be much wider than the diameter of its lead. The sanguine crayon, with its sharp edges and peculiar hardness, can also make very fine lines, as well as expressive lines of varied width (as wide as the crayon is long) and intensity. In this sense the crayon is more versatile than a pencil lead.

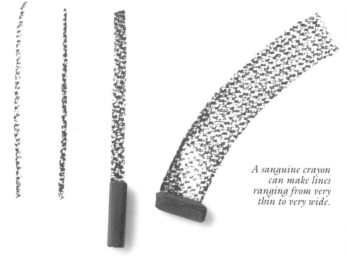

A sanguine crayon can make lines ranging from very thin to very wide.

SANGUINE PENCIL FOR COLORING AND HATCHING

Coloring without leaving visible lines requires good control of the pencil, making lines so close to each other that they give the impression of not having used a pencil. It is easier to use a crayon for coloring large areas.

On the other hand, a sanguine pencil can be used to draw very good hatch lines. Although the corner of a crayon may also be used to create the same texture, the lines end up being somewhat wider than those made with the pencil.

The sanguine pencil can be used to draw fine lines and make hatching with parallel lines. But it is possible to color areas that are not very large without leaving visible lines.

SKETCHING WITH SANGUINE AND WHITE CHALK

Sketching life-model studies on small and medium formats and making brief notes that resolve the essential issues will help you become familiar with sanguine. These studies should be outlines of the figures with potential overlapping lines and a couple of mid-tones, and include white chalk highlights. When a colored paper is used, it also plays an important role as a light tone that is an addition to the value scale.

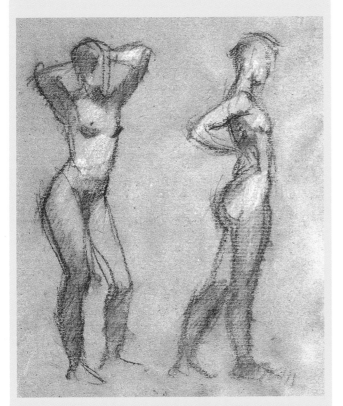

In a quick sketch, the aim is to obtain an outline adjusted with foreshortening that consists of approximate lines. On a colored paper that already suggests skin tones and plays the part of a light color, all that is needed are a few white chalk highlights for the most intense areas of light and a couple of sanguine tones to express the shadows.

SANGUINE COLORS AND TONES

Applying the medium to the paper with considerable pressure creates the darkest sanguine tones. In some cases, coloring over another layer of color can create a darker tone. But at some point it is no longer possible to color anymore because the paper becomes saturated and will not take any more powder.

A tonal range for sanguine can be created by taking as references the white of the paper as the lightest tone and the darkest shade of sanguine as the darkest tone. It is a matter of pressing lightly on the sanguine crayon or pencil to make a light tone, and making progressively darker ones by pressing harder and harder.

The same is true of sepia. Some artists combine vine charcoal, sanguine, and white chalk in the same drawing, and they use the different volatility of each medium to achieve diverse effects. Others prefer to use sanguine and sepia. Some only require white chalk to highlight the sanguine. There is also the possibility of using sanguine with black chalk and white chalk since the media are completely compatible.

Here the goal of the artist, M. Braunstein, was to draw the folds of the hanging cloth so that the cloth would be immediately recognizable. A system of tonal values created with lines and coloring techniques was used for this artistic rendition.

MODELING FORMS IS THE GOAL

Sanguine drawings attempt to represent volume by applying a tonal value system, just like charcoal drawings. This can be done with the tonal ranges of sanguine on the color of the paper (white, cream, or a bright color). Nevertheless, white chalk highlights, or outlines and shading with sepia, black chalk, or charcoal can increase the values.

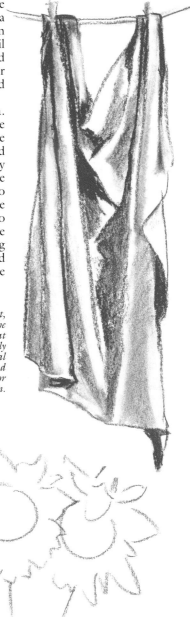

Flowers, like these sunflowers, can be rendered with expressive lines, which in this case are pencil. The challenge is to capture the rhythm of the forms in a loose and free manner.

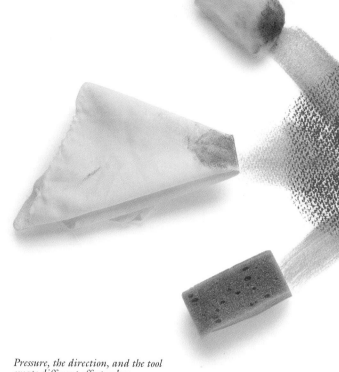

CONSISTENT COLORING

Some areas of the drawing can be colored consistently. When using a **sanguine crayon** it helps to color with the side so the mark is even. Practice making consistent light areas, and darker ones, too, by pressing harder with the crayon and going over the same area several times.

Very consistent results can be achieved using a **sanguine pencil** to make very close lines. The lead is pressed lightly on the paper for light coloring; several layers, each in a different direction, are applied for dark and even coloring. This creates darker and darker results.

The most consistent coloring, very often used for making backgrounds, is done with **sanguine powder** and the help of a cotton ball. In this case, the effect is very different from coloring done with a crayon or a pencil, since applying the powder to the paper with the cotton ball is one of the blending and rubbing techniques.

GRADATIONS

To make a light gradation with a **sanguine crayon**, the artist colors the paper by barely applying pressure to the crayon and sweeping up and down to cover the desired area. Begin with a very light tone, darkening it with each pass, without forgetting that the desired result is a light and consistent tone. Pressing harder on the crayon will create darker gradations.

The **sanguine pencil** is ideal for making light gradations without abrupt changes of tone, by drawing lines in the same direction without leaving white spaces in between. For darker gradations it is a matter of pressing harder from the beginning. Another option is to overlay even coloring on light coloring, or gradated coloring over light. These last two techniques must respect the order of the original gradation—that is, whether it goes from dark to light, or vice versa.

Pressure, the direction, and the tool create different effects when blending.

BLENDING OR RUBBING?

Blending consists of spreading and removing color with the intention of reducing its intensity. Rubbing focuses on evening out or reducing contrasts. These techniques are closely related, because you do rub when you are blending. In either case, it is the artist's intention and the resulting effect that define the process.

Both blending and rubbing can be done on evenly colored areas and gradations.

With the model in front of you as a guide, you can see if there are large areas that can be represented using gradations, like the shadow projected here.

THE EFFECTS OF BLENDING

The effects resulting from blending depend on the tool that is used, on the amount of pressure that is applied to it, and above all, on the intention of the artist. There are many reasons for using this technique, like reducing contrasts, introducing shading, evening out a mixture, and so forth.

The blending action leaves a straight or curved mark. For example, a straight line and a curve can be alternated to represent the volume of the thigh or the arm of a figure. A gluteus muscle, on the other hand, would be more circular.

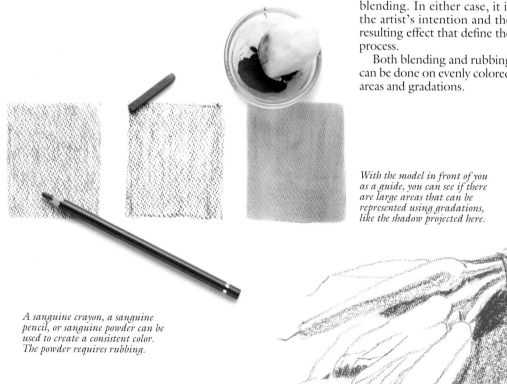

A sanguine crayon, a sanguine pencil, or sanguine powder can be used to create a consistent color. The powder requires rubbing.

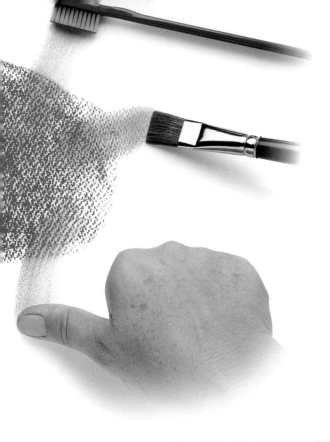

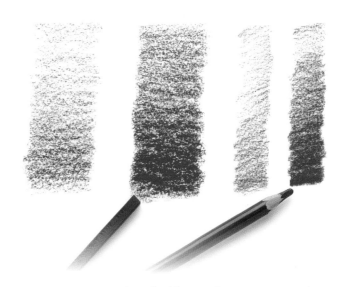

Very light gradations can be made with a sanguine crayon or a sanguine pencil. More pressure is applied to the drawing tool or color is overlaid to make darker gradations.

EVEN OR GRADATED COLOR?

This question implies that you have analyzed the tonal value system and established a relationship between the tones and the corresponding areas where they will be applied.

Attention should first be turned to the gradations that will be created to represent the background and sky. This coloring covers a large part of the work of art, and helps give the drawing a sense of space.

The shadows are blocked in with sepia color powder and a small cotton ball.

ANOTHER EFFECT WITH SANGUINE POWDER

The subtlety of gradations made with sanguine powder and a cotton ball is very attractive. It is a way of using sanguine and sepia without abruptness, greatly softening the contrasts of the texture. A consistent color is immediately created with this technique. But it is a good idea to practice gradations. The cotton ball, charged with powder, is used first for the darkest tone,

and the color becomes lighter as the powder is used up. This forces the artist to work from dark to light.

The spontaneous gradations made with a cotton ball are finished with lines, delineating the forms carefully by creating contrasts between the blending and the outline.

Small light touches are applied now that the cotton ball has less powder.

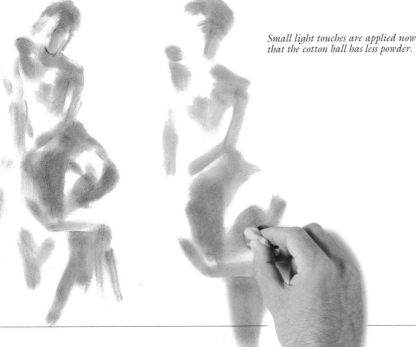

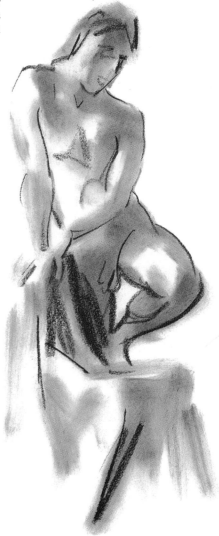

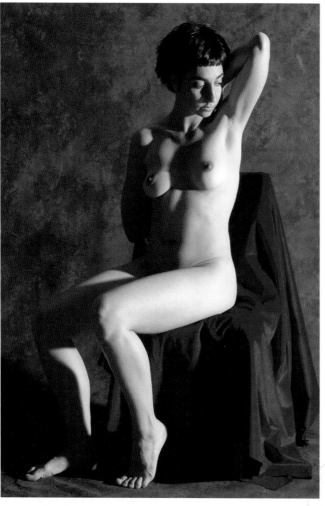

FIRST LIGHT LINES

Only an experienced artist is able to approach an accurate and expressive drawing without reference points and blocking in. To draw the figure with sanguine, it is necessary to begin drawing the essential forms with very light lines. Lines and reference points are used for blocking in the model. All of these should be able to be erased, or at least be light enough that they will barely be seen against the final lines.

After a careful observation of the model's pose, the figure is blocked in on the sheet of paper. It is important to correctly place the most important parts so that the drawing is not distorted.

THE FIRST COLORING

The first marks for representing the light and shadow, however light, should begin to express gradations. In the first approximation it is better to fix the intermediate tones, to ensure that everything that is applied at the beginning can easily be corrected.

All coloring is treated as either gradation or an even tone from the beginning.

The direction and intensity of the coloring should correspond to the modeling needs. There will always be a straight or curved line that best describes the volume of the form. A good way of determining the direction and length of the coloring is to analyze the form according to the principles of perspective. Simply locating the horizon line, the vanishing points, and the vanishing lines can be very useful for coloring accurately.

SANGUINE AND THE FIGURE

The subject that makes best use of sanguine's potential is, without a doubt, the human figure. The tonal range of sanguine or sepia on white paper, or even on cream-colored paper, is capable of creating the chiaroscuro effects that are required to express the volumes of the figure's forms. On white paper the different tones are seen as semitransparencies, while colored paper has the added effect of optically mixing the tonal range with the color of the paper.

When the paper has a heavy texture, the sanguine color is really an optical mixture that highlights the paper's color. But blending and rubbing reduces or removes the effect of the texture.

The blocking in of the figure serves as a guide until outlines defining the forms are added. This can be done on a piece of scratch paper or on the final drawing itself.

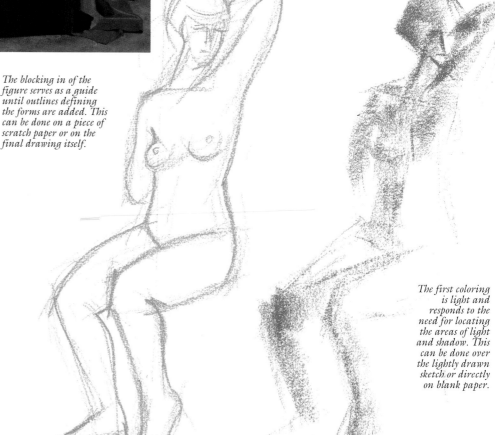

The first coloring is light and responds to the need for locating the areas of light and shadow. This can be done over the lightly drawn sketch or directly on blank paper.

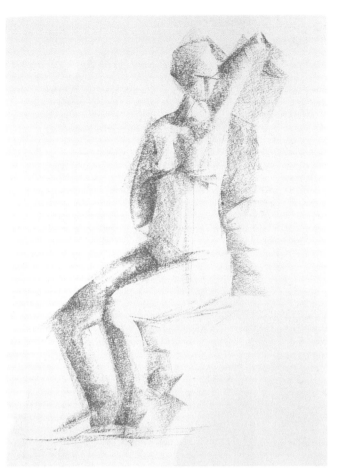

Forms are blocked in by darkening the tones.

INTERPRETATION AND STYLE

Expert draftspeople eventually develop a style that is appropriate for them. They have a particular way of approaching their work, a special touch in their coloring, a way of applying blending and all the other effects and techniques.

A personal style does not always result in an interpretation; it can also be applied to a very realistic rendering. Besides, an interpretation does not require developing a personal style, because the rendering can be modified to achieve the constant goals of form and tonal value.

In reality, when an artist is capable of substantially and deliberately modifying the representation of a model, it is a clear indication of his or her know-how, the result of a lot of practice.

Esther Olivé de Puig, in her personal and emphatic style, offers us a version of the model's pose using rounded forms.

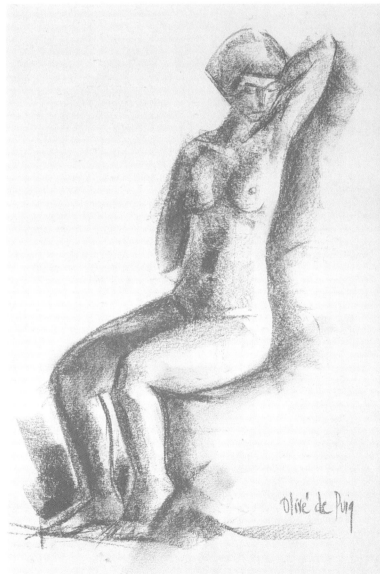

FIRST CONTRASTS

When the color is first applied, contrasts between the tones and the color of the paper begin to appear. But strong contrasts are created only by coloring darkly. When making a dark, consistent tone or a generally dark gradation it is important to know exactly where to put it. The first light-colored areas, in which the risk is not too great, are good guides or references.

IS BLENDING NEEDED?

Why does an artist decide to blend? We know that there are several reasons, but it is also possible to complete a drawing without using the technique.

Although there are various reasons for the choice, it is good to take into account this point of view: A drawing that is not blended is perceived as clean and precise. As soon as blending takes place, the drawing begins to look dirty. If the decision is made to blend, the technique must be used to achieve good results. Blending should be applied only where it is really needed to ensure contrasting textures.

Drawing with Chalk

Full-color drawings can be made with chalk. However, it is important to understand drawing techniques and how to use different colors to model the forms being represented. An assortment of colored chalk, always smaller than that of soft pastels, is a good place to start. Actually, chalk is basically hard pastel, the perfect entry-level medium to use before moving on to more involved work with soft pastels.

The achromatic value system relates different tones of charcoal; with chalk, both tones and color systems are required.

DRAWING WITH COLOR

Line is the primary technique for drawing with chalk, and the same is true for charcoal and sanguine. Any part of the stick will work for coloring. Some chalk is softer than others, and drawings made with chalk look more powdery.

Since chalk is a hard pastel, it does not have the same amount of pigment as soft pastels, and it leaves less color on the paper. However, working with chalk is cleaner, since the light lines can be completely eliminated with an eraser.

Applying different colors of chalk will immediately show the chromatic possibilities of any quick sketch.

CHALK AND CHARCOAL

It is recommended that one learn to draw with vine charcoal because it is an achromatic medium, and then move on to sanguine, which is monochromatic. Complications increase with chalk because we progress to full-color challenges.

One way to understanding this level of complexity is to do part of the drawing with vine charcoal, trying to represent the greatest number of different possible tones. When moving on to coloring with chalk, you will see that because the colors are flat the drawing will progress rapidly. But when it is a matter of expressing shades, the value system becomes one of colors and tones.

MONOCHROMATIC DRAWINGS

Another simple way to become familiar with chalk is to investigate the possibilities of drawing with a tonal range based on a single color that is highlighted with white.

This consists of the tonal range of the chalk's color on the paper, the tonal range of the white, which can be seen only on colored paper, and the tonal range between the selected color and the white in a mixture or overlay.

Blending and rubbing techniques will increase the tonal ranges.

THE USES OF STICK AND PENCIL

The pastel pencil has a hard pastel lead, and is therefore a chalk pencil. The crayon or piece of a crayon can be used to evenly color a dark or light area. On the other hand, the pencil is better for making hatching, the simplest kind being parallel lines that color an area of the paper.

Besides consistent coloring, gradations can easily be made. Because of the ability to control the pressure of the medium on the paper, it is easy to make gradations of different intensities.

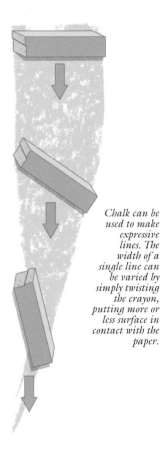

Chalk can be used to make expressive lines. The width of a single line can be varied by simply twisting the crayon, putting more or less surface in contact with the paper.

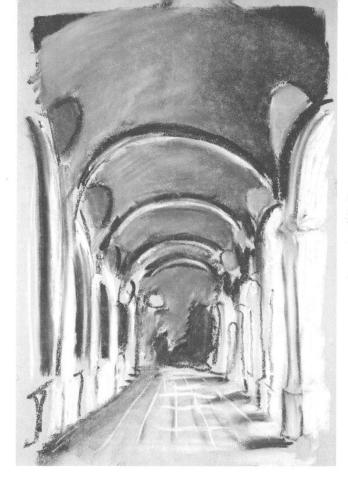

A quick sketch with blue and white chalk on a light blue paper shows the possibilities of depicting a subject with perspective. Drawing by M. Braunstein.

Gradations done with pencil can be made light or increasingly darker.

It is also possible to create very light and dark gradations with a stick of chalk.

A seascape is a very attractive model for working with chalk powder.

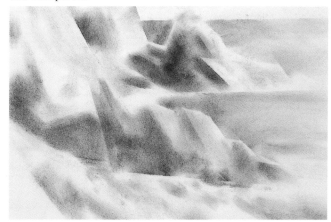

The highlights are reserved from the first application of color.

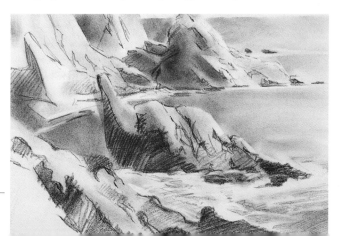

CHALK POWDER FOR MODELING

Chalk powder can be applied with a cotton ball or a blending stick. In this case, the effect that is produced is quite different from coloring with compressed chalk, whether in crayon or pencil form.

Chalk is composed of a small amount of kaolin that allows the particles to glide easily, much like talcum powder would.

Chalk in stick or pencil form can be used for coloring and hatching.

INTRODUCING CONTRASTS

Lines over a drawing that was begun with powdered chalk create a clear contrast to the color of the paper. With a crayon or pencil, very suggestive hatching can be drawn to differentiate between the foreground, middle grounds, and background.

Creating a highlight is a good technique for returning to the color of the paper. When the paper is white, it can best express the brightest point of light, and when it is colored it will correct some intermediate value. Either way, erasing chalk is much easier than erasing charcoal and sanguine.

Then, some forms are blocked in with a pencil, and hatching is applied to contrast the texture and the rubbing and to make the rocks look more natural and realistic. Exercise by Óscar Sanchís.

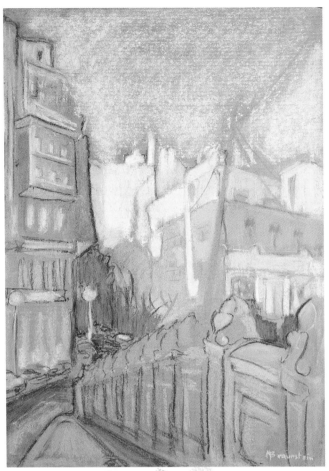

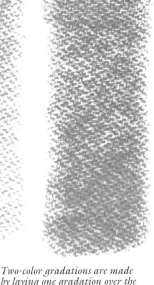

The secondary and tertiary colors begin to appear when the primary colors are overlaid. With chalk, the results cannot be compared to the equivalent manufactured colors.

You can make direct chalk drawings using colors from the box without mixing them, as in Gomis Street, *by M. Braunstein.*

Two-color gradations are made by laying one gradation over the other—for instance, to darken the lighter one. This is an example of painting two such colors.

COLOR THEORY AS A REFERENCE

When working with chalk, you must use basic color theory as a guide, remembering that mixtures of primary colors create secondary and tertiary colors. It is also good to keep in mind how to mix neutral colors and how to use complementary colors. Although the mixtures do not turn out as well, from a chromatic point of view, as manufactured colors, the theoretical part is essential for deciding which colors and which technique should be used to "mix" them.

PRIMARY, SECONDARY, AND TERTIARY COLORS

The three primary colors are the closest to the yellow, magenta, and cyan used in the graphic arts. Mixing two primary colors in equal parts will make a secondary one: Yellow and magenta will make red; magenta and cyan will make dark blue; and yellow and cyan make green. Mixing two primary colors at

Red is lightened by all the colors that are lighter than it, whether they are other reds or related colors.

a one-to-three ratio will make tertiary colors: A lot of yellow with a little magenta make orange; a little yellow and a lot of magenta will make dark red; a lot of magenta and a little cyan will make violet; a lot of yellow and a little cyan make yellow-green; a little yellow and a lot of cyan will make blue-green.

DARK COLORS AND GRAYS

The most important complementary colors are yellow and dark blue, magenta and green, red and cyan. Each pair creates a maximum contrast. It is known that mixing equal parts will make a very dark and dirty color, a "black." On the other hand, using two complementary colors in very unequal parts will create the so-called "neutrals," delicately grayed colors that exhibit the warm or cool tendencies of its dominant color.

On dark colored paper, white chalk brings out the other colors, but it also greatly contrasts with the color of the paper.

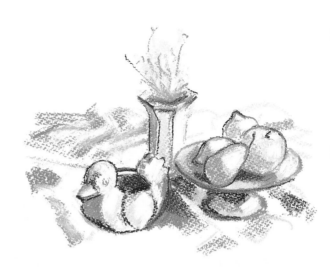

A good exercise for starting out is to work with a single color of chalk and a gray tone for shading.

HOW TO WORK WITH CHALK

Chalk is used the same way soft pastels are. Always choose the manufactured color that is closest to the color that is needed. Then adjust it with another color that lightens or darkens it. The lighter colors of the same hue will make it lighter, and so will light colors of other hues. For example, a dark red is made lighter with a light red, or with oranges, yellows, and ochre. To darken, use colors darker than the original color, like a dark carmine, but blues, neutral colors, and grays can also be used.

When darkening a color, you can choose to create a great contrast or a lesser one. Different results come from mixing with a light blue rather than with a darker one.

The most appropriate blue tone must be selected for darkening a color.

WHITE CHALK AND THE COLOR OF THE PAPER

White chalk lightens all chalk, but it gives their colors a gray tone. It is helpful to lighten chalk after it has been applied on white paper. However, on colored paper the white becomes quite visible because of the contrast.

CHALK GRADATIONS

Creating a gradation of one color of chalk on either white or colored paper is done the same way as with sanguine, which is explained on previous pages. A gradation can also be created with two colors—for example, by darkening a color with gray. In addition, because so many colors are available, it is possible to develop a very rich and colorful gradation using many of them. The same process can be used to darken

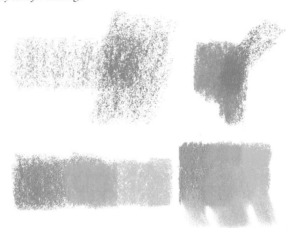

Blending requires that the color be light. However, mixing by overlaying requires fusion, an effect that is carried out by rubbing.

a gradation. It is just a matter of selecting the appropriate colors. A finished gradation with a varied color palette always represents depth better.

MIXING BY OVERLAYING AND RUBBING

A light color is shaded simply by very lightly applying a second very light color. Dark colors are approached in the same way. But "mixing" two dark colors requires fusing the overlaid particles.

Fusion is best achieved by rubbing, which in the case of chalk is usually done with the fingertips.

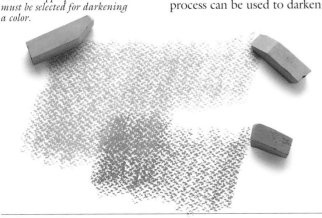

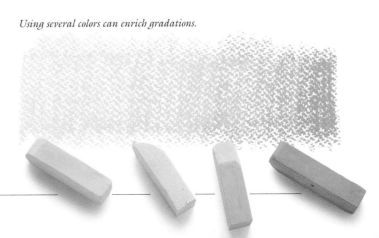

Using several colors can enrich gradations.

THE POSSIBILITIES OF WHITE CHALK

It is good to explore the possibilities of drawing with white chalk alone. To do so, it is necessary to choose a colored paper with a noticeable contrast. The final drawing will vary greatly depending on whether you use a chalk stick or chalk pencil; the stick lends itself to drawing solid or gradated areas of color, whereas the pencil is more appropriate for creating hatching.

THE VALUE OF GRADATING

A wide range can be created with white chalk on colored paper. Gradating, with its great potential, creates the volumes of the forms. Using a colored paper changes the reference. In such a case, the darkest color (if we discount the black used for sketching, which is eliminated as the drawing is developed with the white chalk) is the color of the paper. All the tonal values are created based on whether the application of white chalk is heavy or light. The light layers, as well as the opaque and gradated ones, should be applied with purpose and confidence. They are not repeated. This is the only way to create a clean, fresh drawing.

HATCHING AND PERSPECTIVE WITH PENCIL

A model that depicts a view in perspective requires creating a framework to dramatize the depth and emphasize the view.

It is very important to correctly construct the sketch to match the point of view of the perspective. These lines are essential and should not be drawn inaccurately when the artist is creating the framework. They should not be drawn without clear guidelines, nor should any coloring be done before the artist's exact intention is clear.

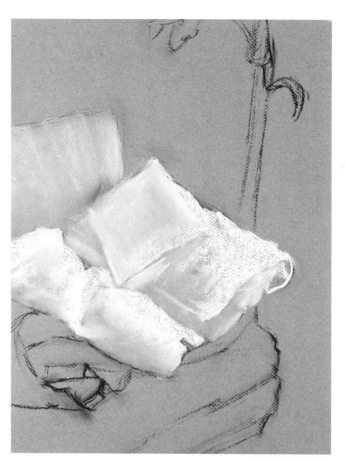

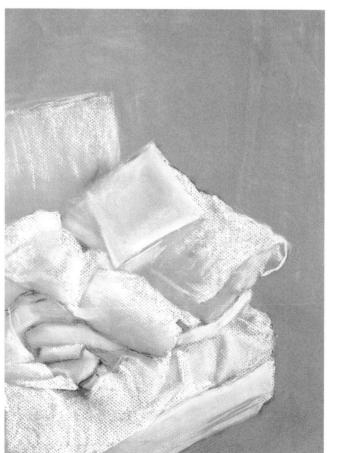

A bright model like this one is very appropriate for the exercise with white chalk on gray paper.

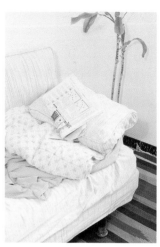

The impressive potential of chiaroscuro, using just a white chalk stick on gray paper, can be seen from the first marks.

The most intense white chalk lines are used for the brightest areas. The gradations represent all the values from light to dark because of the semi-transparent chalk on the gray paper.

Always make hatch lines in the same direction as the perspective lines. When working with several layers of hatching, the resulting optical mix should also echo the direction of the perspective lines.

The same guidelines should be used when creating gradations and solid areas of color.

A work drawn with only a white pencil will have less contrast than one created with a stick of white chalk.

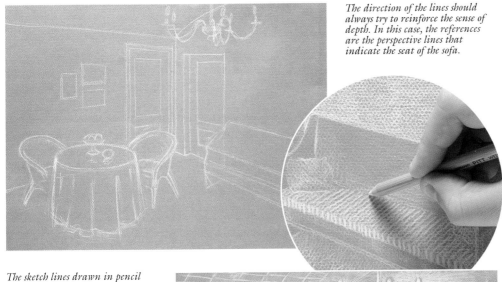

The sketch lines drawn in pencil should follow the perspective of the model.

The direction of the lines should always try to reinforce the sense of depth. In this case, the references are the perspective lines that indicate the seat of the sofa.

MODELING AND NEUTRAL COLORS

You can work with a pure color and adjust it and darken it with colors that will produce neutral colors. However, if you begin with a manufactured color, the chromatic richness and delicate look of the neutral color is always assured. It is interesting to explore the possibilities of ochre because it is a good point of departure for both plant subjects and human figures.

Here, the delicacy of the gradation made using colors that create neutrals by mixture is evident. The base color is ochre.

ATTEMPTING A FULL-COLOR DRAWING

Using the full potential of the colors of chalk means being aware of many more possibilities for overlaying colors than common sense would tell you. It is important to experiment with the colors on a separate piece of paper. A good exercise is to gather all your colors and choose a few of them: a base color, a shading color, and colors that will progressively darken and vary the base color.

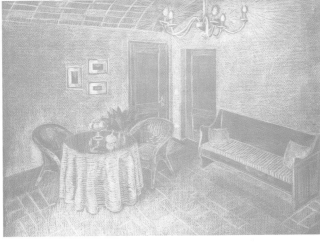

It is necessary to draw several hatched areas to create gradations or solid blocks when forms are being modeled. Drawing by Gabriel Martín.

THE FIRST MARK

After experimenting and deciding on the assortment of colors that will be used to represent the most important forms in the drawing, each area is colored with its respective base color. Sketching can also be done with a single color if it will blend in with the rest.

Begin by drawing lightly. This means coloring without covering the essential lines of the sketch, since they are the only reference until the color and tonal values are established.

BUILDING UP COLOR

The light coloring can be darkened by adding a second layer of the same color or using colors selected while experimenting with darkening and detailing.

Keep referring to the values of the model that you are drawing. The light colors and tones belong in the bright area and the dark colors and tones in the shadowed area. No coloring should be done without identifying the area it is being applied and adjusting its intensity beforehand.

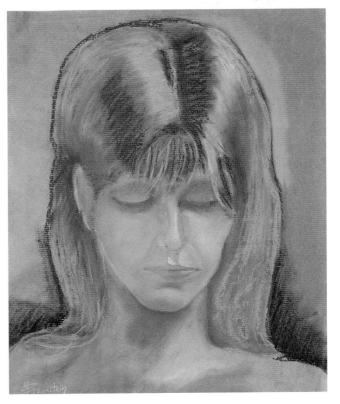

M. Braunstein used several gradations and rubbing to create this 30-minute sketch based on a life model.

Chiaroscuro with Pastel

Chalk can be used to make a full-color drawing, but soft pastels gradually increase the possibilities of the painting. These sticks of color are almost pure pigment, and their adhesive abilities turn any work into a true explosion of color. They can also create incredibly delicate paintings based on harmonious and pastel colors. The techniques are the same as those used for chalk, but the results offer greater contrast and chiaroscuro effects of higher quality.

Lines of different widths can be created.

The line can be light or dark.

The line can be as wide as the side of the stick.

LINE AND STROKE

Like all dry media, pastels rely on line technique. You can draw a wide line or a narrow one, a light one or an intense one, with a stick of soft or medium pastel. Any part of the stick that is not wrapped with the protective covering will leave a mark on the paper. A very wide line can be made by breaking off a piece of the stick and dragging its side across the paper. When making long lines, the artist can hold the stick in several ways according to the direction of the area that is to be covered. When drawing details and outlines one usually holds it between the thumb and the index and middle fingers.

FIRST MONOCHROMATIC SKETCH

To become comfortable with the properties of soft pastels, it is a good idea to begin with a sketch made with a single color. Develop a range of different tones, and experiment using your fingertips and the pastel's ability to adhere to the paper. It is important, as always, to locate the highlighted areas and those that move into shadow with the appropriate tones.

This is how the pastel is held to make a long line.

The pastel is held so that it can be fully controlled when drawing details.

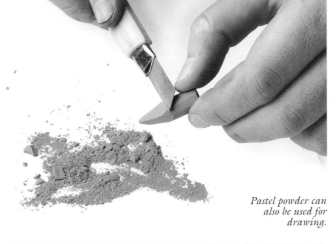

Pastel powder can also be used for drawing.

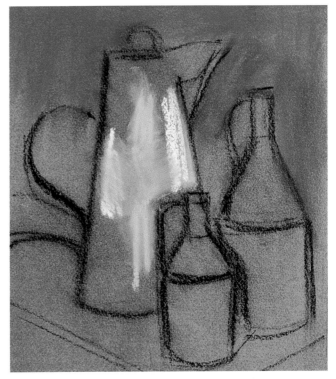

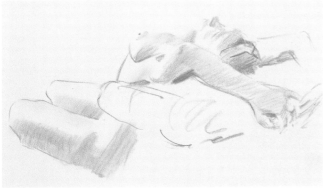

It is preferable to make the first pastel drawings using a single color.

Larger areas of color contrast strongly with the paper's color.

THE LITTLE PIECES ARE ALWAYS USEFUL

As soon as you begin drawing with pastels, especially the soft ones, you will notice how fragile they are. They accidentally break when coloring vigorously, and they can be broken on purpose when a piece is needed to create a line with special proportions. After just a few sessions you will have pieces of all shapes and sizes. It is a good idea to save them, since any piece, no matter how small, can still mark the paper, and more important, these pieces are ideal for making powder.

A MINIMAL PALETTE

There are so many colors available that we recommend starting with a selection of about thirty. The sticks should be arranged in groups to make the work easier. Intermediate colors can be placed in between the pure colors or set apart. The point is to always have all the sticks within reach.

THE COLOR OF THE PAPER

The color of the support plays an important role with all the dry media but especially with soft pastels. There is a wide range of colors of special papers for this medium. When beginning a drawing, the artist should immediately think, upon seeing the model, about what color paper would give the best results.

In the beginning, it is best to choose white paper. You can begin with neutral colors and later become more daring with darker papers and colors that create greater contrast.

To keep from getting confused at the beginning, it is a good idea to limit your selection to about 30 colors.

The small pieces of pastel that break off the sticks should be kept in a separate box or with the stick they came from.

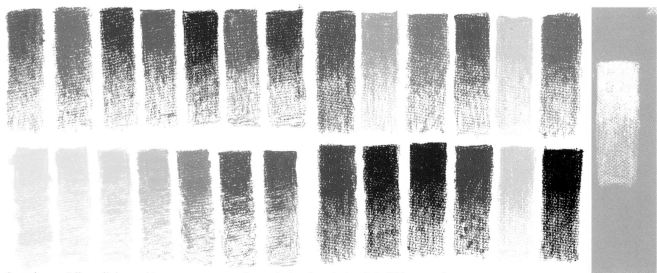

One color carefully applied to a white paper creates a perfect gradation, from dark to light. This group of gradations shows the chromatic qualities of the soft pastels.

GRADATIONS WITH SOFT PASTELS

Semihard and hard pastels do not create such spectacular effects as the soft pastels. The options are gradation of each color by applying it lightly over the color of the paper, gradations between two colors, and gradations of several carefully chosen, related colors. Soft pastels can be used to create a true chromatic display.

ONE COLOR AND ITS GRADATIONS

Gradations of one color are made with semitransparencies on the color of the paper, preferably white. It is also possible to make more opaque gradations by putting one color over white pastel; both gradations can progress from dark to light and back to dark, or not, according to the effect that you wish to create. The gradation can be light if all of it has been made light, but the gradation can also be very dark in its darkest part.

GRADATIONS WITH TWO COLORS

Gradations between two soft-pastel colors can be created very quickly. A semitransparent gradation is made with the first color, then a gradation is made with the second color in reverse. At one end of the band we have a lot of one color and little of the other. At the other end, the amount of each color is reversed. This example is just a guideline, because each time the intensity of the pressure is varied a different gradation is created, which opens up endless possibilities.

RUBBED GRADATIONS

The contrast between two colors is much reduced when they are rubbed where they are in contact with each other. In fact, since you are creating a small gradation, the effect achieved is that of a progression from one color to the other. This is a very useful technique to apply in every situation where it is necessary to reduce a very strong contrast between complementary colors or between two tones of a slightly different shade.

VARIEGATED COLOR

You can make a background that is neither homogenous nor gradated by using the powder from several pastel colors. The powder is not mixed beforehand because you are trying to create an optical mix that will have an atmospheric look. The more irregular the layer of pastel the better, as this will add more depth to the main subject.

It is possible to cover a background with variegated color using powder from different colors when neither a homogenous nor a gradated ground is desired.

It is possible to create very rich chromatic gradations using different colors.

WHEN MANY COLORS ARE USED

Rubbing will create a very rich and colorful effect with small, juxtaposed marks that create a tonal range with clear color and no gaps. The chromatic effect is only limited by the number of colors that are used.

Several contrasting complementary colors will create a striking gradation on the paper, but the texture and the contrast between the marks will be diminished. The possibilities of soft pastels are infinite and permit very daring work.

GRADATING AND RUBBING ON COLORED PAPER

An appropriate color paper with dark pastel coloring can create a strong contrast, although the colored paper is not always necessary. What is necessary is that the colors that are applied can be easily distinguished on the color of the paper.

Gradations that are not retouched produce a very dramatic effect. When they are flat and pure, these colors do not reproduce the chiaroscuro values. Chiaroscuro is created when the colors are rubbed or blended, creating an atmospheric feeling in which figures and still lifes seem to appear from nothing.

USING GRADATIONS: A SKY

The first example of a gradation that covers a large area will be the creation of a calm sky, without clouds, on a clear day. You will make gradations of the blues seen in the landscape that is used as your model. Different tones and shades must be applied to represent the atmosphere and the depth of the sky.

On this dark color paper you can see the contrasts that can be created by choosing the appropriate colors.

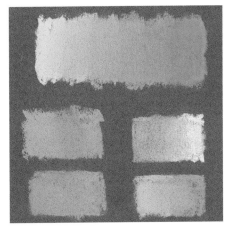

Marvelous gradations appear when rubbing the colors with a fingertip, one more example of the potential for creating chiaroscuro effects with soft pastels.

1. The first layer made with blue is quite even.

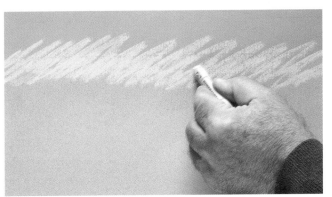

3. A second layer is applied by "scribbling" over the first with a lighter blue.

2. Blending and rubbing with the fingers reduces the contrast.

4. Rubbing both blues will create a gradation that shows how a sky can be created.

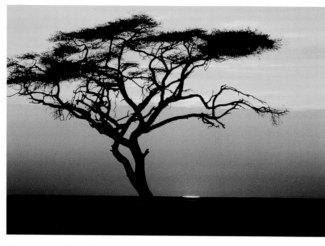

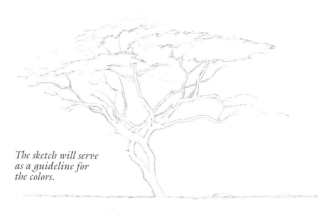

The sketch will serve as a guideline for the colors.

To represent this model with pastel, we create the background with a gradation and use dark colors to indicate the foreground in silhouette.

The rubbed colors represent the sky very accurately.

It is important to have a clear idea of the coloring sequence from the beginning. The sketch, which is done with light and basic lines, is without a doubt the best guide. By analyzing the model carefully, the artist can plan the sequence for the procedures that he or she needs to carry out. It is important to use a general approach. Later, the details will be applied area by area and shape by shape.

The simplest approach for a typical subject is one that uses a tonal gradation for the background and a few contrasting elements on the foreground.

The dark lines and colors of the tree create a strong contrast against the gradated background.

Only careful observation of nature can train the artist for distinguishing between colors and shades. In a sunset the sky does not show the same orange color all over. In fact, all the colors and shades that can be created with yellows, oranges, and red are present. The order is not accidental, either. The reddest and darkest part is located at the bottom portion of the model, while the brightest and most yellow color is found at the top.

The red is darkened with a small amount of carmine, which, in turn, is lightened with orange, and the orange with yellow. This way we create a color gradation that, after being rubbed, will represent a luminous and realistic sunset.

The details are added, differentiating between the trunk and the upper branches. The yellow point of light is added to represent the sun. Exercise by Yvan Mas.

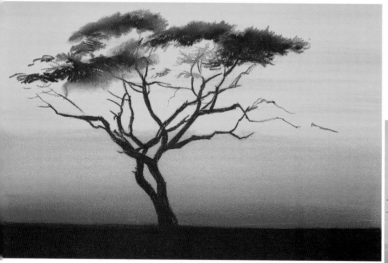

To create tonal gradations, orange is used to darken the yellow, red for the orange, and carmine for the red.

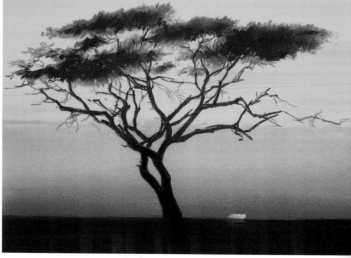

The carmine color provides a greater sense of depth and contrast when it is used to darken red or to adjust sepia.

CONTRASTING FORMS

It is easy to represent a building, a boat, or a figure that stands out as a silhouette against a lighted sky. Sepia is a very dark color that complements the warm tonal range of the sky in this sunset. To create a lighter mixture, we simply combine this color with burnt sienna, which is also a neutral color.

A strong contrast is created by painting with sepia over the gradated colors of the background. A few expressive lines are sufficient to represent the bare trunk and branches. But the details of the treetop need to be rubbed to spread the dark color that will create the impression of a different texture.

CONSTANT EVALUATION

A pastel artist applies overall colors, introduces shading, lightens contrasts, creates new ones, draws outlines, makes touch-ups, corrects, adds highlights, and so on. It is a process of constant evaluation to make sure that each color that is introduced creates the desired effect and to decide if further work is needed.

CHOOSING A COLOR PALETTE

Although the subject suggests the pastel colors that should be used, it is normal to introduce a different contrasting color that is not present in the model. This is done to enhance the drawing.

An exercise that demonstrates the unlimited possibilities of pastels consists of forming small groups of juxtaposed colors. Lining up pastel sticks and pieces shows the colors and tonal contrasts that are available; the artist can decide if a color should be darkened or lightened with another one, evaluate the effect of pure colors against neutral ones, and ponder their contrast and definition.

Going back to our model, this exercise helps with the selection of colors beyond the obvious ones, since some can only be created by gradation and blending, a result that may not be so obvious. The presence of these colors creates contrast, adds another

FIXATIVE TO AVOID MIXING

Often a fixative can be used to prevent two superimposed colors from mixing. Sometimes the purpose of this is to avoid accidental mixtures and other times to preserve the crisp and clean outline of a colored area.

The fixative is sprayed over the color and then left to dry out completely. This way, when the next color is applied over it, the colors will not mix with each other.

It is important to remember that the fixative should be applied in thin layers, sprayed quickly, without stopping in one particular area. The fixative should dry thoroughly, because wet paper is easily damaged. Finally, fixative should be applied only where it is needed, leaving a last, general application for when the drawing is finished.

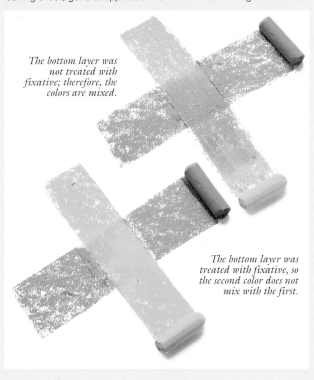

The bottom layer was not treated with fixative; therefore, the colors are mixed.

The bottom layer was treated with fixative, so the second color does not mix with the first.

note of color, and enriches the work; using pastel drawing techniques, the artist can create the colors that are found in the model.

The colors that form these columns are proof of the unlimited number of combinations in which colors can be arranged to create either contrast or harmony.

Graphite Techniques

The basic techniques of graphite are line and shading, with or without visible hatching. Other approaches can be used as well, such as pointillism or divisionism, and even scribbling. These techniques are not all used at the same time in the same drawing; the artist must decide which technique best suits his or her vision.

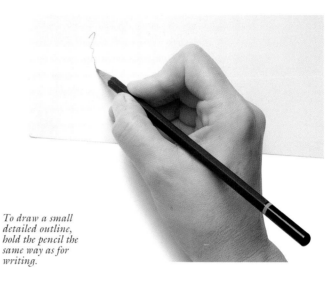

To draw a small detailed outline, hold the pencil the same way as for writing.

A very soft graphite pencil can be used for lines ranging from light to very dark.

A graphite stick produces wider lines than a pencil does. It can be used for light to very dark lines as well.

DRAWING WITH THE GRAPHITE STICK AND THE PENCIL

The line technique is usually reserved for drawing outlines. The result depends on the presentation. Therefore, it is important to practice with the graphite pencil and stick until their respective properties have been mastered.

Graphite pencils can be used to draw detailed outlines and very thin lines. A soft lead can produce lines that are darker and somewhat thicker, but a hard lead can maintain a very thin line without ever being too dark.

Graphite sticks are especially suitable for very light and very dark wide lines. When the artist learns how to go from thick to thin, from dark to light, and so on, the outlines can be very representative of the forms.

Lines created with a graphite stick are similar to those done with charcoal. However, the characteristics of a soft graphite stick are its typical shiny finish and the very dark tones, which do not smear like charcoal, resulting in a much more stable drawing.

THE FIRST LINES

At the beginning, it is hard to draw long lines with one continuous stroke. Insecurity forces the artist to draw small short lines that together show the right direction. It is important to practice with several exercises to become proficient at handling the pencil and to be able to draw a continuous long line with confidence.

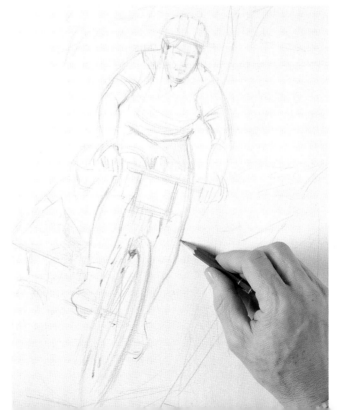

Some long lines are more easily drawn by holding the pencil with all the fingers and the opposing thumb. The end of the pencil is directed toward the palm.

HOW TO HOLD THE TOOL

The way the tool is held is indicative of the results desired. Therefore, to create a detailed outline, hold the graphite pencil the same way you would for writing. However, to draw a longer line, hold the pencil by pressing the four opposing fingertips against the thumb. The index finger exerts the pressure that guides the pencil. This way of holding the tool is similar to the way a charcoal bar is held to make long lines.

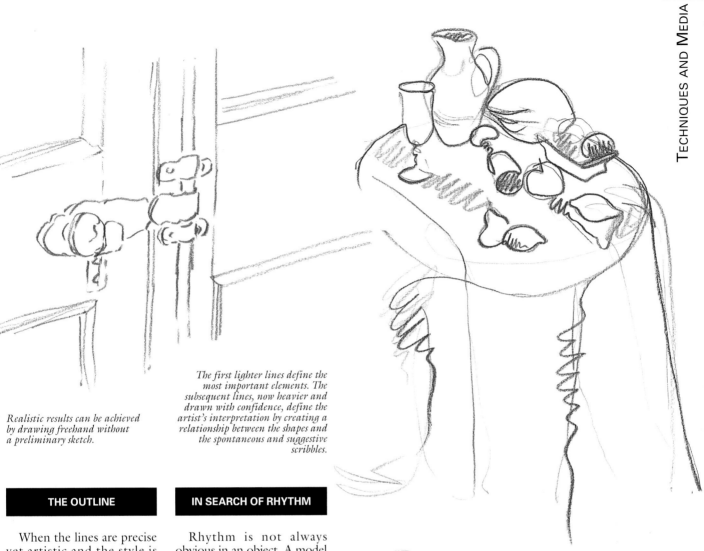

Realistic results can be achieved by drawing freehand without a preliminary sketch.

The first lighter lines define the most important elements. The subsequent lines, now heavier and drawn with confidence, define the artist's interpretation by creating a relationship between the shapes and the spontaneous and suggestive scribbles.

THE OUTLINE

When the lines are precise yet artistic and the style is realistic, the representation will look like the model. There is no room for the imagination. The artist must practice doing detailed sketches to achieve this result. But a suggestive representation can also be achieved with an informal, scribbled drawing. For best results with this technique, it is important to study the model and to try to represent it from memory, associating the lines and curves mentally, combining them to create relationships and to discover a rhythm.

A very interesting exercise that helps produce such results is to attempt to create a drawing with a single line, without lifting the pencil from the paper at all. The idea is to repeat rounded forms. This artistic approach gets away from strict copying to discover the many interpretative possibilities of graphite.

IN SEARCH OF RHYTHM

Rhythm is not always obvious in an object. A model can suggest it only if the artist looks for analogies. But certain models, still life in particular, can be arranged in a way that emphasizes this aspect. Ovals are usually preferred, although vertical and horizontal lines are also useful. A composition with variations includes some element that breaks the monotony of repetitive forms. For example, it is interesting to find among several oval forms some contrasting straight lines that cause a change in rhythm.

Even though this drawing shows different intensities and an attempt to convey some rhythm to this composition, it was created with a single, continuous line.

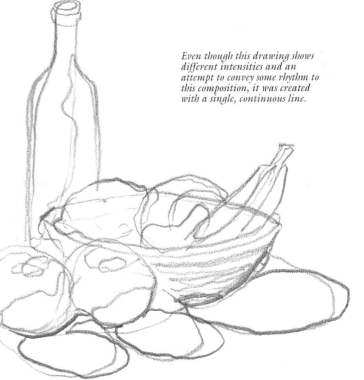

Another option for shading is to draw a series of parallel lines by holding the pencil almost flat against the paper.

USING GRAPHITE IN STICK FORM

Graphite is without a doubt the ideal medium for shading large areas. The artist only needs to break off a piece of graphite and to shade by pressing on its side. The application will be as wide as the stick itself. The shading done with the tip will be as wide as the thickness of the stick, and the line can be light or very dark. This is the approach used for very large drawings that do not require detailed work.

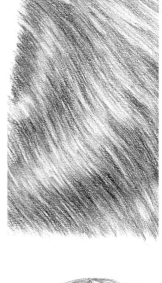

SHADING

Forms can be modeled by shading the areas of the drawing that receive less light. The way to shade with graphite is by drawing a series of lines, which seen all together creates a hatching effect. But it is also possible to shade without visible lines. The possibilities and characteristics of the shading vary depending on whether the graphite is in pencil or stick form, and on the particular interest of the artist. These details are worked out before the artist begins to draw, when the artist is planning the organized sequence of events.

SHADING WITH A GRAPHITE PENCIL

A graphite pencil can also be used for shading, but the intensity of the tone will depend on the hardness of the lead. A very soft lead can produce either light or very dark shading. A hard lead, on the other hand, does not provide very dark shading. The darkest tone possible is gray, as opposed to the intense black of a soft lead.

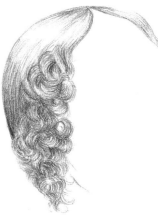

A graphite pencil can produce very realistic details, such as the curls and waves of the hair. Each series of lines is shading with all the lines going in a specific direction.

A pencil can be used to create shading without leaving any spaces between the lines, resulting in a block of color where the lines are not visible at all. However, using the point of a pencil it is also possible to draw very thin lines that will remain visible in the shading.

This sample of different shading effects shows only a few of the many possibilities of hatching.

THE CONTRAST BETWEEN DIFFERENT HATCHING

Although hatching can be created with graphite in stick form, this technique is usually reserved for work done with a pencil. There are many hatching styles. A series of parallel lines can be drawn in different directions. Lines can also resemble ringlets or scribbles. Even zigzag strokes are suitable.

Different types of hatching can be used in the same drawing to create contrast. They can also be used to draw different planes and to create a feeling of depth.

CONTRASTING TONES

Light shading without visible lines produces a particular tone, and working it lightly creates a soft tone. The harder the shading is applied, depending on the hardness of the lead, the darker and more intense its effect becomes. A tonal range can be created by arranging the tones from lightest to darkest and vice versa.

When the lines of the shaded area are visible, the tone is established according to the intensity of the lines and the density of the hatching. By arranging the tones within the hatching itself, the artist can create a tonal range. By comparing two different hatched areas, the artist is able to determine which one is lighter or darker and thus establish a wider tonal range with both.

A POINTILLIST APPROACH

A dot is an element that can be used to fill out an entire area when it is required. It can be drawn lightly or heavily, with a soft or hard lead. It can be as small as ⅙₅ inch (0.5 mm) or as large as a thick lead. This opens up an array of possibilities.

When the pointillist drawing is dense, the color is darker, even though the dots may be light. On the other hand, a pointillist drawing that is not very dense but where the dots are large and dark has a tone resulting from optical mixing that must be incorporated with the rest of the areas of the drawing.

A pointillist approach makes use of the various tones that can be created by shading with dots to produce clearly defined forms and planes.

CHOOSING A TOOL

It is extremely important to know how to shade with any type of graphite tool and to decide which one is most appropriate for the desired effect. It is not unusual to alternate the stick and the pencil in the same drawing. Even using graphite in powder form can be interesting.

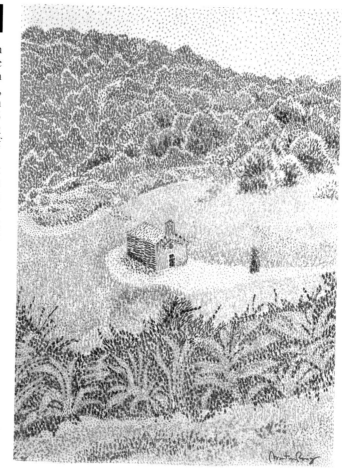

A landscape can be created using the pointillist technique. The greater the number of dots, the darker the tone. Larger dots contrast with smaller dots. This is how the different planes are created. Drawing by Gabriel Martín.

Shading can be done by drawing with very visible lines.

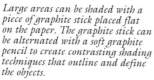

Large areas can be shaded with a piece of graphite stick placed flat on the paper. The graphite stick can be alternated with a soft graphite pencil to create contrasting shading techniques that outline and define the objects.

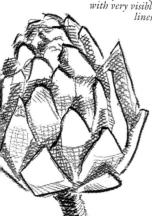

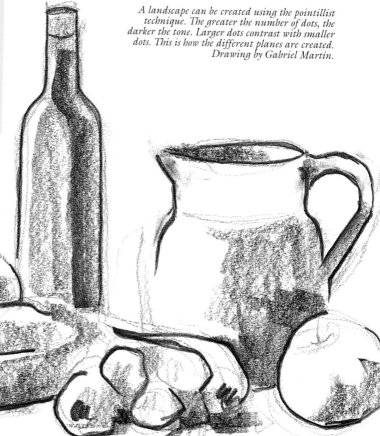

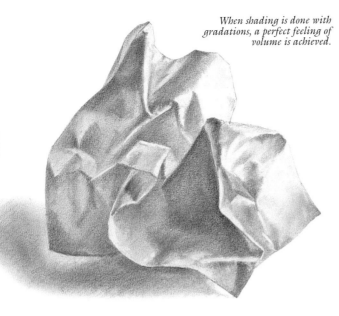

When shading is done with gradations, a perfect feeling of volume is achieved.

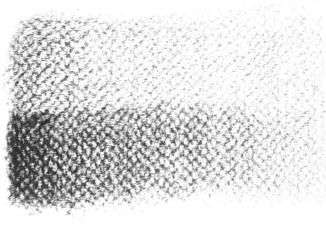

To create a gradation that covers a very large area of the paper, the application can be as wide as permitted by the stroke. Then a second lighter shaded area is drawn right next to the first, darkened by shading repeatedly until it resembles the first area.

GRADATIONS AND RUBBING GRAPHITE

To model the volumes, the artist can create gradations with graphite and rub them as needed. Graphite, either in stick or pencil, is an ideal medium for creating gradations that represent the forms with their respective areas of light and shadow using chiaroscuro. The effect of the gradated tones is enhanced by rubbing, which evens out the graphite, repairing tonal gaps and adding new values.

GRADATIONS WITH GRAPHITE

A gradated effect is achieved by progressing from a light tone to a darker one in several steps without gaps between them.

Each graphite tool produces distinct characteristic results. Since the darker tones are obtained with soft leads, the darker overall gradations are created with soft graphite in stick or pencil form. The harder version of the graphite, on the other hand, produces lighter gradations overall.

A gradation may or may not show visible lines. In this case, it progresses from the lightest to the darkest tone gradually, without sudden tonal jumps and without visible lines.

However, a gradation made with visible lines is perceived through optical mixing, which is a function of how close together the lines are drawn.

The contrast between different gradations is another element that can be introduced to model forms and to differentiate planes.

Tonal gradation means creating shading that goes from light to dark without any tonal gaps: with a stick (the overall tone is intermediate), with a soft pencil (the tone is more intense and can be darker), and with a hard pencil (the general tone is light).

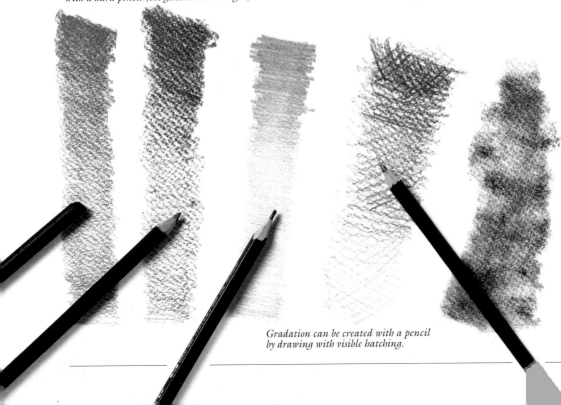

GRADATIONS THAT COVER A VERY LARGE AREA

A very large area can be covered with a single gradation using a stick of graphite. To make the shading process more comfortable, the artist can break the stick into pieces and apply more or less pressure as needed until the desired tone is achieved.

A graphite pencil can also be used for shading a large area. It is a matter of establishing a gradation size that is easy to control, so that the lines of

Gradation can be created with a pencil by drawing with visible hatching.

Interesting effects can be created with small gradated areas using graphite powder.

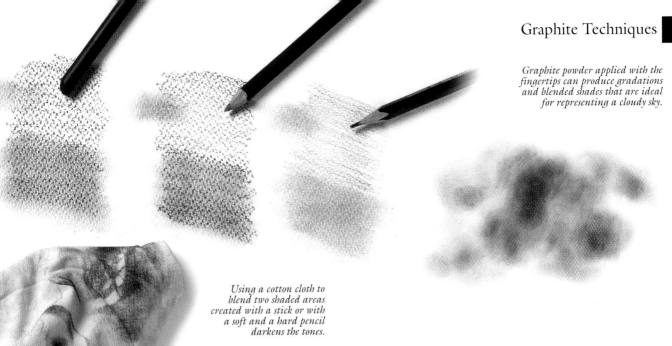

Graphite powder applied with the fingertips can produce gradations and blended shades that are ideal for representing a cloudy sky.

Using a cotton cloth to blend two shaded areas created with a stick or with a soft and a hard pencil darkens the tones.

RUBBING GRAPHITE

When the artist layers one shaded area over another, the graphite particles are mixed, creating darker and clean-looking tones.

However, rubbing is done over a shaded area. When a gradation is involved, the result of rubbing repeatedly with the fingertip or with a cotton cloth creates a very even-looking blended area without any tonal gaps or contrasting lines, but the result has a smeared look.

RUBBING RESULTS IN TONAL CHANGE

A light tone looks dirtier and also darker when blended. A dark tone appears a little darker and dirtier, but is more consistent after it has been blended. The tonal range is increased with shading of different textures. Therefore, one of the effects that is created in a gradation done by blending is an overall darkening effect of the tone.

GRADATIONS WITH GRAPHITE POWDER

A gradation is the best technique for describing volumes, and graphite powder is the ideal medium for creating ethereal textures.

The artist only needs to apply a larger amount of graphite powder to shade the darker areas. Shading with a cotton ball is done by moving it in circular motions that become increasingly wider. This way, the darker area will correspond to the center of the circle, becoming lighter as it moves outward. Gradations created this way are very delicate. They are a result of using a cotton ball and varying the amount of graphite powder to create lighter or darker areas.

the gradation can be visible or not. To enlarge this shaded area, another gradation is drawn next to the first one. This procedure is repeated by using the lighter tone as a reference point. If the second area of shading does not match the tonal value of the first, the artist has only to continue shading until the line between the two areas disappears.

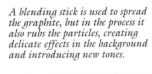

A blending stick is used to spread the graphite, but in the process it also rubs the particles, creating delicate effects in the background and introducing new tones.

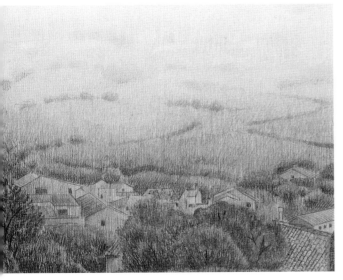

The drawing incorporates soft gradations, which illustrate the distance.

Drawing with Colored Pencils

Colored pencils are the ideal tool for creating colorful work. The basic technique is the line, the same as with graphite, although shaded areas are replaced by colored areas. But the effects produced by colored pencils go well beyond the possibilities offered by monochromatic drawing. Colored pencils can produce richly colored work, which can be an exact rendering of the real model or modify and even improve on it.

A pencil sharpener whose blade is dull or damaged should be avoided because it can easily break the leads of the pencils.

The point made with a sharpener looks very regular, but it is short in comparison with the one sharpened by hand.

THE QUALITY OF THE LINE

A graphite pencil with a good point is essential for drawing lines. The tip can wear down and lose its shape very quickly. Therefore, it is important to find a way to create a more resistant point that lasts longer. The same is true for colored pencils.

A defective sharpener easily breaks the tip and should be discarded. Besides, a point that has been made with a sharpener has an even, conelike shape that wears out faster than a tip sharpened with a knife or with a blade. This irregular point can be left thicker at the base, which makes it more durable. It can also be made longer so it will not have to be sharpened as often.

FROM LINES TO COLORS

Lines drawn next to each other eventually cover an entire area of the painting and create a block of color. With practice and a steady hand, it is possible to make colors where the lines are not visible.

One color can be applied over another area of the same color to make it darker.

WATCH FOR WRINKLES ON THE PAPER

A blunt tip or vigorously drawn lines can leave wrinkles on the paper that can become more noticeable with subsequent coloring sessions because the most raised parts absorb all the color and the indented areas none at all. This effect, when it happens by accident, can ruin the results of the drawing; therefore, it is important to avoid it. As a general rule, it is better not to apply too much pressure on the paper; it is preferable to layer the colors if they need to be darkened.

Sharpening the pencil by hand lets you shape the point.

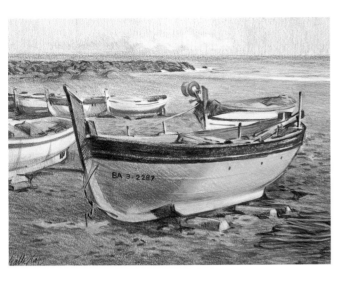

Applying colored pencils lightly and darkly produces very effective and colorful results. Work by Vicenç Ballestar.

Coloring can also be done with the powder from the colored pencils; however, because this is not a volatile medium, much pressure has to be applied. In this case, the fingertips are used.

Coloring vigorously with a pencil requires holding the paper on both sides of the area that is being colored, adding to the stability offered by the board or the sketch pad.

COLORING WITH THE POWDER OF COLORED PENCILS

The surface of the paper can be colored with the powder from colored pencils by rubbing the particles with the fingertip, although a cotton cloth can also be used.

Enough pressure should be applied to leave a mark. Being in direct contact with the powder allows the artist to be spontaneous and to direct the rubbing wherever he or she wishes, obtaining immediate results. The greater the pressure and the amount of powder, the greater the intensity of the color will be.

LIGHT OR INTENSE COLORING

Contrasts between these two kinds of colored areas are very obvious. If the overall plan of the drawing demands an ethereal, broken look, the entire process can be carried out with light coloring. If the preference is for strong color and texture contrasts, then the application should be more vigorous. A work created exclusively with intense colors has a very realistic effect.

HOLDING THE PAPER IN PLACE

When coloring is vigorously applied, the paper should be held in place with fingers surrounding the area that is to be colored, even though the general rule cautions against impregnating the paper with the natural oils of the fingers. Colored pencils, even watercolor pencils, which are softer, are much harsher on the paper than other dry media. Therefore, it is important to understand that pressing on the paper with the pencil may produce ridges, and scribbling vigorously may cause wrinkles or even make holes on thin paper that has not been held in place with the fingers.

AVOID DRAWING WITH A BLUNT TIP

If a blunt pencil is used, or one whose point is worn down, the wood of the case can scratch the paper. In such cases, the line technique does not produce the desired results. The line looks unfinished; it is rubbed by the pressure of the wood, producing very unsightly results. In addition, the paper will probably get wrinkled or torn.

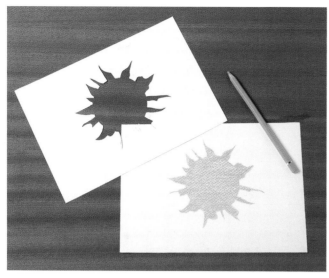

A template serves as a reserve that allows coloring evenly without going beyond the desired area.

CONSISTENT COLORING

With colored pencils, the artist can produce homogeneous areas of color by simply drawing lines of the same intensity next to each other until that area of the paper has been covered. With practice, the process becomes faster and even larger areas can be colored. The difficulty lies in stopping the coloring at an exact point.

The problem in coloring large areas is that line length is limited, making it difficult to draw parallel lines of the same intensity.

TEMPLATES AS RESERVES

Colored pencils are the perfect tool for drawing perfectly defined outlines. In this sense, templates can be very useful as reserves. Coloring is done by covering the entire area of the paper that is exposed. This way, no lines go beyond the boundaries of the template, and the colors create a clean and perfect outline.

SINGLE COLOR TONES

Pressing softly on the paper with the pencil produces a very light tone. As more pressure is applied, the color becomes more intense. By arranging the various tones of a color in order from lighter to darker, the artist can create a tonal range.

It is possible to create a tonal range of any color. It should be laid out with black as the tonal reference, just as with charcoal or graphite. An achromatic range is used to make drawings with values that create a perception of depth, and the same is true for a monochromatic range.

It is possible to make progressively darker tones of a color by superimposing more layers of the same color. With each layer, the tone becomes more intense. The sgraffito technique can then be used, which consists of removing the waxy pigment from the paper with a sharp object. It is a very involved process that requires careful work to avoid scratching the paper.

GRADATIONS WITH COLORED PENCILS

To create gradations using colored pencils, apply the pencils lightly and intensify the color gradually until it becomes darker, avoiding tonal gaps in the process. It is possible to produce a gradation that is light and others that are more intense.

A gradation can also be darkened by layering it with a color that is applied either evenly or with gradations. In the case of a gradated layer upon another gradated layer, it is important to remember to keep the lightly applied areas together as well as the more intense areas.

When the area to be colored with a gradation is very large, you should proceed with smaller blocks of color that can later be connected to cover the entire area. The first gradation is a guideline. The second area is colored next to it, using lighter applications as a starting point. If the color needs to be intensified, a second layer is added. The idea is to avoid a seam line. This process is repeated as needed.

A color can be intensified with the application of successive layers of that same color.

A tonal range can be created with any color. It is important to relate it to the tonal values of the monochromatic range.

THE SECRET OF MODELING

The gradation technique guarantees a volumetric expression. As we have seen earlier, the most illuminated area is represented with the white of the paper and the lightest gradation. The shaded area, on the other hand, corresponds to the darker gradation.

A gradation where the lines are visible reinforces the feeling of depth because the direction of the lines is used to enhance the dramatic effect of the vanishing lines of the forms and volumes. For volumes with flat sides, straight lines that converge at the vanishing point can be used. Arcs are suitable for cylindrical shapes, and circles for the spheres. This effect can be created with monochromatic tones when a single color is used. A one-color gradation can be darkened with black, or as will be seen later, the result can be enhanced with a full-color drawing. In any case, the basic technique is always the gradation.

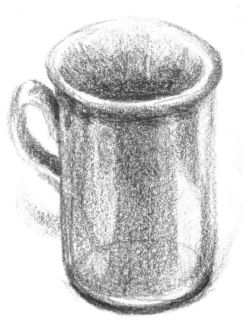

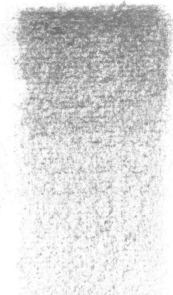

The texture of the paper adds an important artistic element to the coloring process because it produces a dramatic gradated effect.

The volume of a cup is represented with evenly applied colors combined with gradations and some lines.

It is possible to create gradations with any soft, medium, or dark color tone.

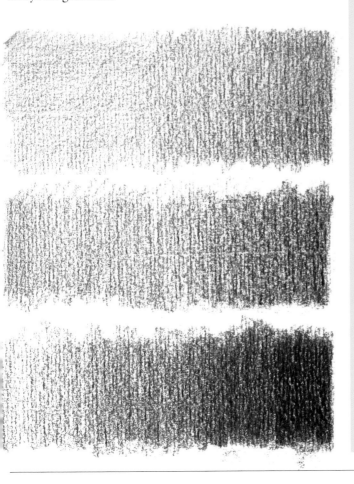

COLORED PENCILS AND COLLAGE

Drawing with colored pencils over a collage produces outstanding results. The layering of different papers has defined the planes and the outlines of the forms; colored pencils produce dramatic effects by creating textures that introduce contrast and optical mixtures. Each colored paper with its particular texture introduces nuances, which become a source of enrichment.

This type of drawing lends itself to gradations or the use of solid colors, and to practicing line techniques, with outstanding results.

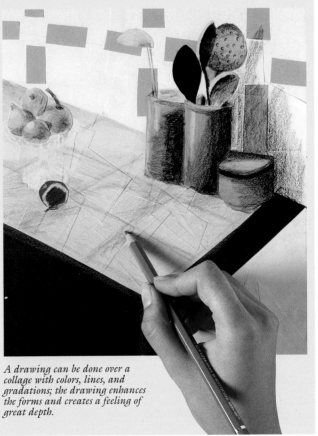

A drawing can be done over a collage with colors, lines, and gradations; the drawing enhances the forms and creates a feeling of great depth.

Choose the three colored pencils that are closest to the yellow, magenta, and cyan used in graphic arts.

COLOR THEORY AND COLORED PENCILS

The color theory can be used as a reference for superimposing colors. Only three colors are needed to put this theory into practice: yellow, magenta, and cyan. But the wide range of colors that are obtained provide an endless array of combinations that can be created by superimposing them.

USED AS PRIMARY COLORS

From the wide range of colored pencils available, the three closest to yellow, magenta, and cyan of the graphic arts are chosen as primary colors. These colors can be applied very lightly or very intensely, and gradations of each of them can be created on white paper.

TONE AND AMOUNT

Producing secondary and tertiary colors from primary colors requires the application of one over the other. The tone is the only reference that we have to gauge the amount needed of each one of the colors involved in the mixture.

If the same amount of each needs to be mixed, then they are applied one over the other with the same intensity. This produces combinations ranging from very light to very dark.

If, on the other hand, the amounts required are different, the layers involved should have different tones; that is, one should be darker than the other. The proportion of one to three is gauged by eye, because we know what the resulting color should look like. We need to adjust only one of the colors to create the desired combination.

You can develop gradations with primary colors on white paper: yellow (1), magenta (2), and cyan (3).

An intermediate tone is chosen for each primary color, which can be mixed by coloring one over the other in the common area, thus creating the secondary colors: red (4), dark blue (5), and green (6).

Tertiary colors are created when an intense primary tone is colored over another light primary tone. The proportion is one to three. The intersecting areas become orange (7), violet (8), blue-green (9), dark red (10), violet-blue (11), and yellow-green (12).

RED, DARK BLUE, AND GREEN

The secondary red color is obtained from yellow and magenta. Dark blue is made from magenta and cyan. Yellow and blue produce green. Because there are several kinds of yellow, carmine, and blue, other tones can be used as primary colors. Superimposing them will produce different colors. It is interesting to see that they also produce red, dark blue, and green, but it is simply a matter of a difference in shade.

TERTIARY COLORS INCREASE THE OPTIONS

How bright does a primary color need to be to produce a tertiary color? It is a good idea to begin with the lightest color and then add the second, darker, primary (among light, medium, and dark, the last is chosen), which is applied over the lighter primary to obtain an intersecting area that becomes the tertiary color.

Therefore, with a large amount of the first color and a small amount of the second one, new colors are created: with yellow and magenta, orange; with magenta and yellow, carmine red; with magenta and blue, violet; with cyan and magenta, violet-blue; with yellow and cyan, yellow-green; and with blue and yellow, blue-green.

WHITE

The technique for coloring with white involves the application of white over an area of color. The result is a fusion between the two; the resulting effect lightens the tone, providing a unique satiny patina.

WHAT DO ALL THESE COLORS SUGGEST?

If all the primary, secondary, and tertiary colors are properly arranged, three important color ranges are revealed. Yellow, orange, red, carmine red, and magenta represent the spectrum between yellow and magenta. Carmine, violet, violet-blue, dark blue, and cyan form part of the color range between magenta and cyan. Yellow, yellow-green, green, blue-green, and cyan make up the range between yellow and green.

By modifying the proportion of each color a little bit, more colors and shades are obtained in addition to the secondary and tertiary colors. This is just a sample of the endless color combinations that can be created.

MANY OTHER COLORS AVAILABLE

An artist can also make use of the large number of colors that are available. The colors can be darkened and shaded by adding another color over them. The interesting fact is that one can predict the result of the mixture by simply remembering the proportion of the primary color needed to create a particular combination.

To be able to create the range of pinks needed to color the petals and to give them a feeling of depth, a light pink, as well as a darker pink, carmine, and magenta were used. Work by M. Braunstein.

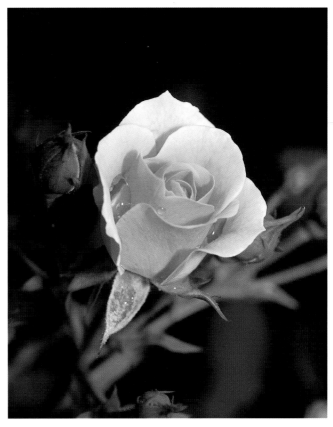

Any model can be a good subject for a successful color drawing.

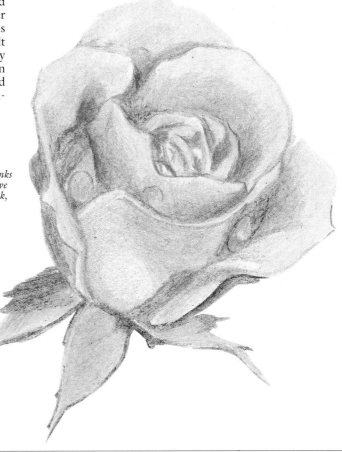

CREATING BLACK

When three primary colors—yellow, magenta, and cyan—are layered one upon the other with the same intensity, a grayish color that is not quite black is produced. It is possible to create a darker black with colored pencils by mixing carmine, Prussian blue, and sepia. Another possibility would be combining carmine, sepia, and dark green. Burnt umber can also be substituted for sepia. To mix "black," the three colors must be applied with equal intensity.

MANY MORE COLORS: THE COMPLEMENTARY COLORS

A very dark color close to black can also be created by superimposing a pair of complementary colors that have the same intensity.

When the three primary colors are combined with others of less intensity, the resulting colors look grayish or dirty. The greater the difference between the intensity of the layered colors, the cleaner the resulting color will be. The tendency of the color obtained by mixing reveals undertones like yellow, pink, red, earth, violet, gray-blue, gray-green, browns, and so forth. When the colors are applied very lightly, the result appears very luminous against the white paper.

Pairs of complementary colors can produce neutral colors when one is applied over the other. Remember that red and blue are the complements of each other; so are magenta or carmine and green; yellow-green and violet; and orange and violet-blue. It is important to practice with them because two colors that are not direct complements of each other can also produce a very dark and dirty color when they are layered with the same intensity.

USING ONLY THREE COLORS

If we add the range obtained with the three primary colors to the range created by mixing two primaries (yellow with magenta, magenta with blue, and yellow with blue), it becomes obvious that it is possible to draw in full color by using only the three primary colors. It is true that the resulting effect is not the same as that of a full palette. However, it is possible to create a sense of volume, even when the dark colors may not be dark enough.

COMMERCIAL NEUTRAL COLORS

With a commercial neutral color, the need for mixing is greatly reduced and the color needed is easily obtained. It is a matter of exploring the possibilities of ochre, earth tones, browns, greens, grays, and so on.

The color obtained from mixing a commercial neutral color with any pure color will also be neutral. With this approach, the desired shade is very easily obtained and a light application of the color will produce the desired effect immediately. In addition, these colors can be intensified by additional application until the appropriate tone is achieved.

Shading can be created with a gray pencil, which, as with white, must be applied over another color, fusing with it and darkening it to represent the areas of shade.

The gradation used to represent the wall in the background gives a sense of depth to the composition, and at the same time defines the areas of light and shadow.

The range of colors produced from commercial neutral colors and the neutral colors created by layering go very well with the blue tones.

WORKING THE PALETTE

In addition to using commercial neutral tones, it is better not to layer primary colors to make "black." A black colored pencil creates a very dark black that cannot be reproduced by superimposing colors. It is a good idea to use it for introducing heavy contrasts.

Layers of sepia or Prussian blue can be used instead of magenta and cyan to obtain the darker colors more easily. However, these are not the only options available; we recommend working with the palette to become acquainted with it.

CREATING HARMONY WITH COLORED PENCILS

The three most important harmonic ranges are warm, cool, and neutral. Therefore, commercial colored pencils are also divided into three groups: warm, cool, and neutral. Layering warm colors results in warm colors as well. This indicates that working exclusively with a single group guarantees complete color harmony, which can be warm, cool, or neutral.

To introduce a certain variation or to establish interesting contrasts, cool colors are used opposite warm colors, for example, or warm colors against a mainly cool palette, as well as contrasting a warm with a cool broken spectrum. And there are many other possibilities that the artist may want to introduce that are visually pleasing.

The neutral color technique demonstrated by Óscar Sanchís is based on the use of complementary colors and optical mixing.

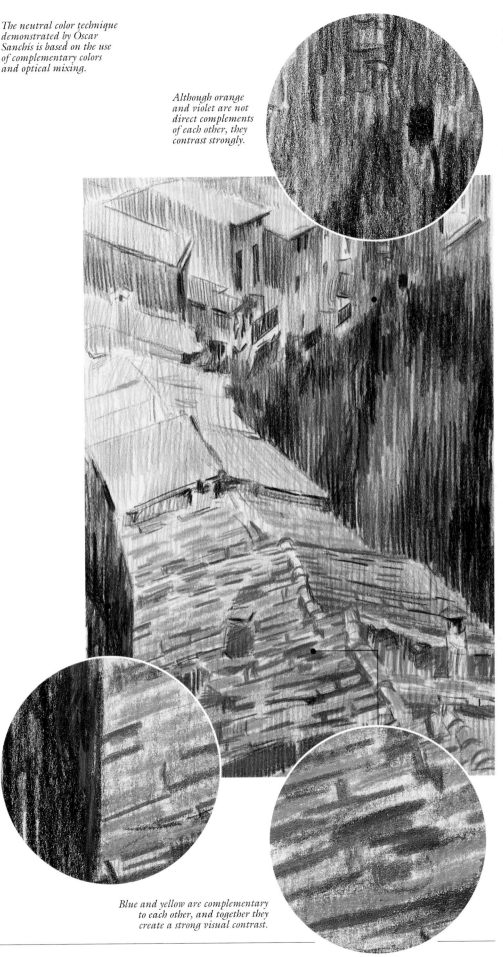

Although orange and violet are not direct complements of each other, they contrast strongly.

When the color of the paper is yellow, blue and carmine look very dark.

Blue and yellow are complementary to each other, and together they create a strong visual contrast.

Possibilities and Limitations of Wax Crayons

The chromatic potential of wax crayons encourages experimentation. Even though they have some intrinsic limitations, the possibilities are limitless. It is a very versatile medium that can be used for several different techniques. The medium's mark is quite wide because of the crayon's characteristics and form, but line techniques are often used. However, coloring, gradations, and rubbing are the basic techniques. Sgraffito takes on a spectacular dimension with wax crayons and deserves a separate chapter.

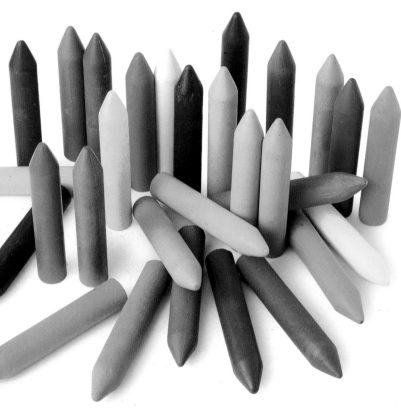

You can make use of the enormous chromatic potential of wax crayons by using the exact color needed from the large assortment available.

ABOUT ADHESION

One important drawback of wax crayons is their limited adhesion to the support. This issue can be controlled by selecting the most adequate paper and not coloring until you are sure of the effect you are going for.

It is also possible to increase the adhesive ability of the wax by applying a layer of fixative. Another option, which introduces a mixed technique, consists of using chalk and pastel. Coloring with them over the wax creates a drier paste that will be easier to color over with a new layer of wax crayon.

A third, if more drastic, measure is to remove the layer of crayon in the area that will take no more wax by scraping it. After removing as much as possible, you can go back and color it again, to a limited extent.

A heavy line cannot be corrected with a rubber eraser or by rubbing with a cotton ball or a cotton rag. On white paper, however, a light line can be corrected quite well.

The same is true for heavy lines drawn on colored paper. But when the line is light, its traces are more visible because the wax creates an optical mix with the color of the paper.

WAX COLORS ARE PERMANENT

It is advisable not to make a heavy line if you are not sure of the direction it should go. The mark left by wax cannot be erased except when it is very light. Errors must be avoided so that you will not have to make corrections and smear the paper.

Wax colors can first be tried on white paper. If you com- pare a light line with an intense one, you can see that there is no good way to erase. Although a light line is almost completely removed with an eraser, a cotton ball, or a cotton rag, an intense line just spreads and smears the surrounding area.

On colored paper the results are worse because the color of the paper is added to the smeared wax and even a light line leaves visible traces.

A BURST OF COLOR

The tremendous chromatic potential of wax crayons outweighs their limitations in making corrections. This is because it is possible to draw or paint with heavy applications that cover changes and last-minute modifications of the initial layer of color, as long as they are the same color or a lighter one. The crayons also are ideal for making flat areas of color. And because of their versatility and the way that they can be rubbed, they are the perfect medium for chiaroscuro.

Works done with wax crayons offer a wide range of interpretations: in value studies, full-color paintings, and even abstract color and form exercises.

OPACITY AND TRANSPARENCY

Each wax color has a different amount of transparency. It is worth finding out which colors are more transparent and which ones have more covering power. A more opaque color can be used to cover colors that have been previously applied. Generally, light colors like yellow, orange, ochre, and so forth, will not cover other colors like blue, green, and carmine, even if they were applied lightly.

ALWAYS AVOID SMEARING

Wax crayons will color more than paper. Your hands will become impregnated with an oily substance when they come into contact with wax crayons. The layer of grease will accumulate on your fingers as you handle more crayons, and the paper will become smeared and messy when touched with your dirty hands. This can be avoided by cleaning your hands very often, rubbing them with a clean cotton rag. There is also the option of protecting the work with a heavy paper frame that can be touched without worry.

White wax crayons are often used, in this case for creating highlights and making colors lighter.

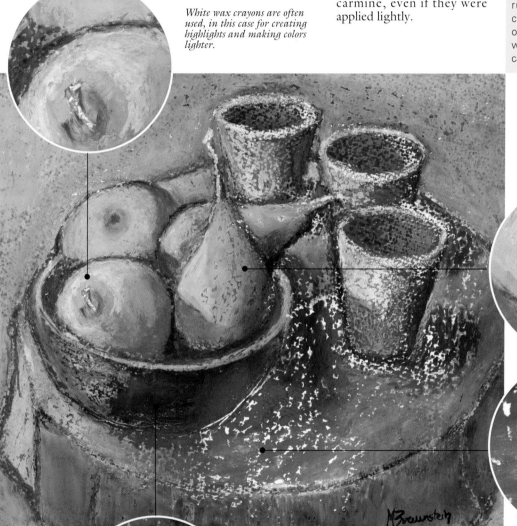

Gradations express the volume of forms.

Rubbing wax crayons spreads and mixes colors and tones.

M. Braunstein painted Still Life with Pears *on white paper with a rough texture, using a heavy impasto technique.*

Lightly applied wax does not completely cover the paper.

BASIC WAX CRAYON TECHNIQUES

The basic techniques for wax crayons are line and coloring. It is important to become used to the size of the crayons and to practice holding them for making lines and coloring. If you wish to make light lines or areas of color you apply only a small amount of pressure to the paper. To draw more intensely, you must press much harder.

CHARACTERISTICS OF THE LINE

The crayon is held like a writing instrument to draw details with short strokes. These outlines, however artistic, have their limitations, being thicker compared to lines made with other media. This characteristic influences the results and limits the medium's abilities to create a representation.

Consequently, the resulting works are always a synthesis. This requires the artist to analyze the model to eliminate superfluous details because they cannot be represented. On the other hand, the artist can decide which details are essential to the drawing: which details can be represented with crayons using a few lines and especially with coloring that defines the forms.

Long lines are made by holding the wax crayon between the thumb and the middle finger, supporting it with the index finger. The pressure must be controlled when drawing so that the crayon will not break.

EASY COLORING

The entire side of the crayon can be used for coloring. In this way, it is very easy to cover large areas of paper in a short time. Because of this, wax crayons are the ideal medium for making large-format posters.

The crayon can be broken for coloring with narrower strokes. The applications of color are made using circular motions, or using strokes that follow the direction indicated by the perspective (horizontal, vertical, lines of perspective).

Many repeated lines in the same area create intense coloring without visible lines. Thus, it is easy to make flat areas of color, which is, without a doubt, one of the most widely used techniques.

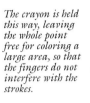

The long side of the crayon is very useful.

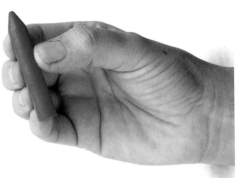

The crayon is held like a writing instrument when drawing details, but the end is directed toward the palm of the hand.

The crayon is held this way, leaving the whole point free for coloring a large area, so that the fingers do not interfere with the strokes.

To make a long line, the crayon is held between the thumb and middle finger, while the index finger controls the point and keeps the crayon from breaking.

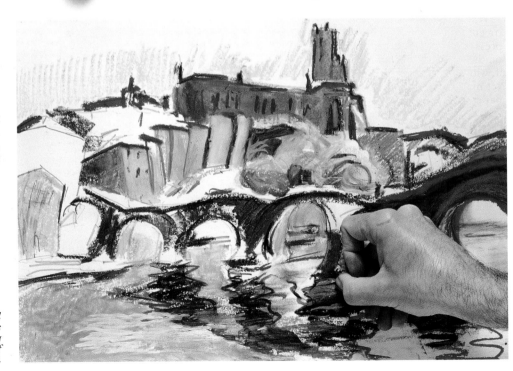

The strokes of carmine color add definition and contrast, while the light and dark coloring contribute to the explosion of color in this work.

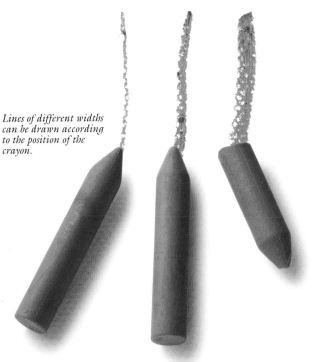

Lines of different widths can be drawn according to the position of the crayon.

A WIDE RANGE OF POSSIBILITIES

Light and fine lines can be drawn with wax crayons, at least as fine as the medium allows. The harder the wax is pressed on the paper, the wider and more intense the resulting line. The line will be narrow if the point or the corner of the opposite end is used. When more of the crayon is in contact with the paper, a wider line will be the result.

When drawing a dark line or colored area you must press hard and continuously on the crayon while dragging it, without causing it to break yet making sure it marks the paper. When used to draw very dark lines, the crayon is used up more quickly.

ALTERNATING LINE AND COLORING

Lines are usually used for outlining forms, and coloring for filling them in. However, it is not a good idea to make too much use of lines that tend to be wide. Artists usually color directly and decide later which lines will be important and necessary.

Some light coloring that allows the paper to show through is used as a contrast to more densely colored areas.

It is also possible to leave spaces completely white; when compared to the wax colors these white spaces seem transparent and in this way introduce more variety.

ALWAYS KEEP THE WAX CRAYON CLEAN

Although caring for your art materials is normal procedure for all media, it is especially important to keep your wax crayons clean. When they come into contact with each other, they get dirty. Streaks of various sizes are visible on them, caused by contact with crayons of other colors. These color streaks will show up on the paper if you draw with a dirty wax crayon. It is a good idea to keep the crayons clean and avoid unnecessary smudges that will ruin the drawing. You can easily restore crayons to their original color by wiping them with a clean cotton cloth.

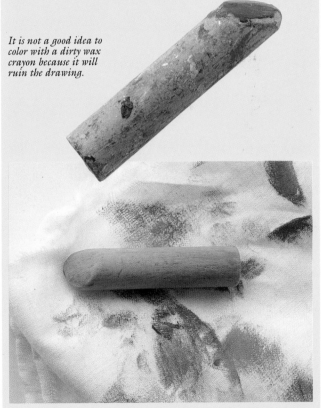

It is not a good idea to color with a dirty wax crayon because it will ruin the drawing.

The wax crayon can be cleaned easily with a cotton cloth.

A wax crayon will make lines of different intensities. The more pressure you apply, the darker the tone will be. The sample shows a light tone, a medium tone, and a dark tone.

THE TONAL RANGE OF WAX CRAYONS

Constructing a wide tonal range can be done by simply applying lines of the different tones in order. For a light tone, you press lightly on the paper; for a darker one, you press harder, and so on.

This range, perceived because of the semitransparency of the crayon over the color of the paper, is quite large. The range is smaller with some colors, as in the case of a very light yellow.

It is also possible to establish a lighter tonal range based on one color, this time an opaque one, by using the white crayon to lighten the tones. The challenge is to overlay just the right amount of white required to maintain the order of the range.

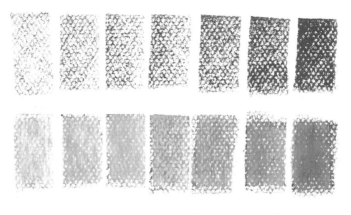

This blue tonal range was made by applying increasing pressure to the crayon to darken the tone.

Adding white over each tone will lighten this tonal range.

Gradations are based on coloring that flows from a light tone to a dark one, including several intermediate tones, without abrupt jumps.

A light tone or a dark one can be rubbed with the fingertip, and so can a gradation. The resulting effect is darker and less transparent.

To create an opaque gradation you need only apply white crayon over a gradation of another color.

Two light tones of one color where the white has mixed with the overlaid color can be rubbed with the fingertip to create an even more intimate fusion. An opaque gradation of white and another color can also be rubbed.

LIGHT GRADATIONS AND OPACITY

To create a gradation, begin by applying a light tone to the paper, then adding intermediate tones until arriving at the most intense. This is a semitransparent gradation, since the tones are perceived because of the white of the paper.

If you wish to construct an opaque gradation, it is enough to apply an even layer of white crayon over the gradation.

RUBBING WAX CRAYONS

This technique is without a doubt one of the most striking because of its effects. The oily wax medium melts and spreads with the heat of the fingertip and friction. Rubbing light and dark tones causes them to darken.

The effect of rubbing is increased when used with an opaque gradation made with white crayon. This is because the particles of the overlaid colors already have been somewhat melted. The rubbing completes this fusion and there is much less darkening of the tones and of the gradation in general.

By rubbing, a directional effect can be created. This is useful when indicating rays of light or the folds of fabric. When it is a matter of creating an area of consistent color, you should rub with small circular or up-and-down motions, going over the same areas several times. For example, to indicate a prominent area on a pitcher, you should rub the area of the reflection with a circular motion.

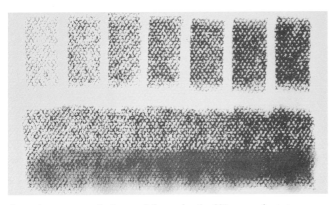

A tonal range, a gradation, and the results of rubbing on color paper.

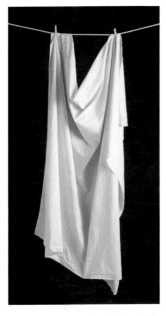

A quick sketch of this model by M. Braunstein, using black wax crayon and two gray values.

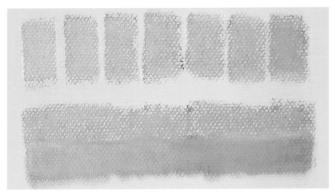

A tonal range and a gradation made with blue and white on color paper.

THE SAME TECHNIQUES ON COLORED PAPER

When the tonal range and the gradation are semitransparent, the color of the paper plays an active part in the optical mixtures that are produced by the colors of the wax crayon and the paper.

But when it is a tonal range or gradation of an opaque color made with the addition of white wax that contrasts with the paper, there are no optical mixtures.

As with chalk and soft and semihard pastels, the choice of the color of the paper is very important, whether working with light or opaque colors. Let's look at some examples. A blue wax crayon on yellow paper creates green tones when the light coloring mixes optically with the color of the paper. Also, although you may attempt to create a contrast by drawing with red on a dark blue paper, the resulting color will be very dark (however, as we will see, we can work with opaque colors if white wax crayon is applied before using conflicting colors).

COMMERCIAL TONAL RANGES

It is not difficult to find several tones of the same color made by a manufacturer. They can be applied heavily to make an opaque tonal range without the need to use white. One very useful tonal range is that made by using black and some related gray shades. This range can be used for drawing with the same techniques used with charcoal and white chalk highlights.

The tonal values easily correspond to the tonal range of colors and can be applied to the different areas of light and shadow when representing a model.

This range is very practical for making notes and quick sketches that can quickly situate the most relevant aspects of a model: the outlines and their tonal areas.

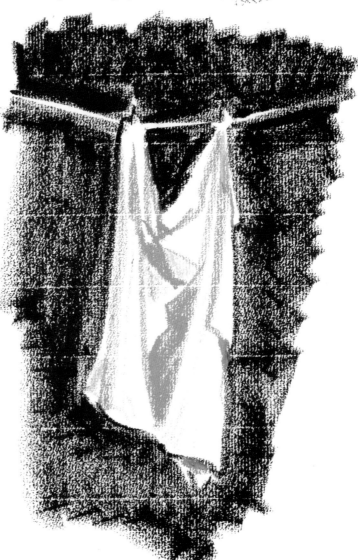

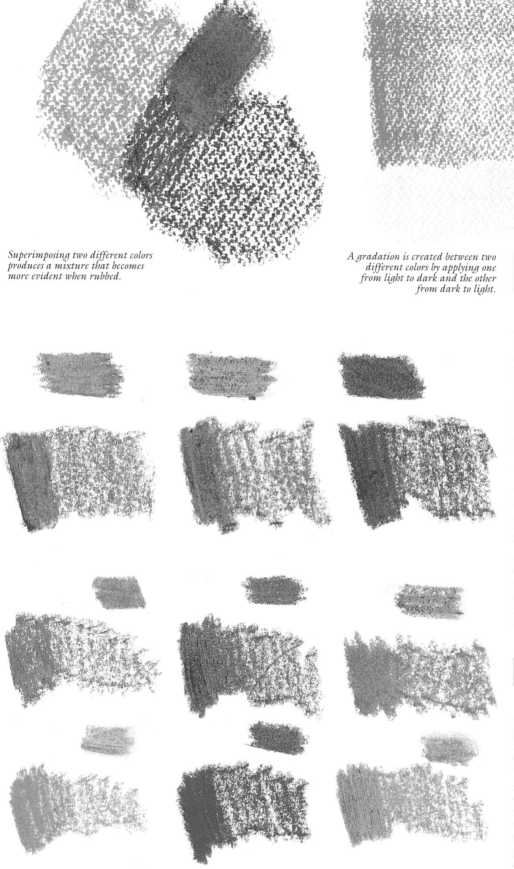

Superimposing two different colors produces a mixture that becomes more evident when rubbed.

A gradation is created between two different colors by applying one from light to dark and the other from dark to light.

GRADATIONS BETWEEN TWO COLORS OF WAX CRAYONS

For all media, color theory is useful as a guide to what colors should be selected, but it is better to use all the possible colors from the wide assortment of crayons. A mixture is produced when two different colors are superimposed, but this practice demonstrates that the clean and luminous qualities of manufactured colors are far better. The most luminous colors are created by using the ideal technique for wax crayons (the same as for dry pastels), that of direct gradations. Two colors are put next to each other and one dragged over the other. With wax crayons, the rubbing action combines them, making it an indispensable coloring technique.

THREE RANGES BASED ON THE PRIMARY COLORS

Color theory with wax crayons is based on the three primary colors: yellow, magenta, and cyan. Mixing two of them in equal parts creates the secondary colors: red, green, and dark blue. A light color mixed with a very intense one creates the six tertiary colors: orange, dark red, violet, violet-blue, yellow-green, and blue-green. However, these applications are heavy and cannot be used as light colors.

By comparing the manufactured equivalents of mixed secondary and tertiary colors, you can see that the former can be lighter and look cleaner.

NEUTRAL COLORS AND WAX CRAYONS

The result of superimposing two complementary colors is a very dark, gray or brown color, darker when the two colors are of the same intensity. However, light layers of these colors create interesting effects.

It is possible to mix any manufactured neutral color with another color and obtain a color that is also neutral. Examples of such neutrals are ochre, earth tone, and olive green, to mention a few of the many neutral colors available. It is a good idea to try the versions of gray wax crayons that create immediate effects by toning down colors.

Gradations between two primary colors permit three important ranges to be developed: yellow–magenta, magenta–cyan, and yellow–cyan. Here the three gradations are seen after being rubbed with the fingertip.

The use of ochre is essential for creating these green tones. Drawing by M. Braunstein.

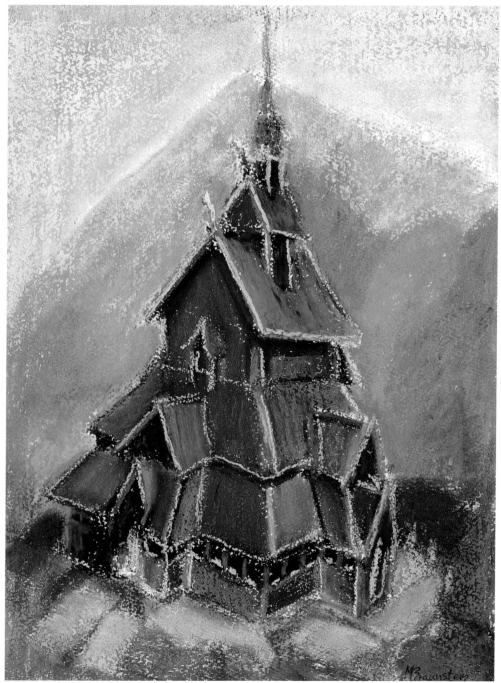

DIFFERENT RESULTS

The difference is obvious when comparing manufactured colors to the secondary and tertiary colors mixed by the artist. Using the wide range of wax colors will produce cleaner and more transparent colors, and allow more versatility in techniques. Besides the dirtier colors that result from mixing, an outline that is mixed requires two overlapping lines, which lessens their artistic expression.

GRADATIONS BETWEEN PRIMARY COLORS

In a gradation with two primary colors, many intermediate colors also appear along with the secondary and tertiary ones. If the lightest color corresponds to the most illuminated area, the progressive movement toward a darker color will indicate the movement toward the shadows. The potential of wax crayons is especially evident in the splendid effects of rubbing the gradations.

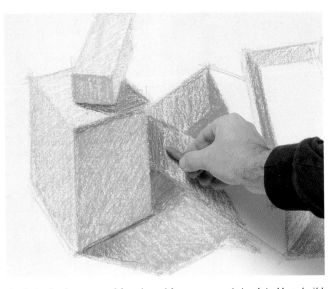

At the beginning stages of drawing with wax crayons it is advisable to build up light layers of color, so the effect of each application can be evaluated.

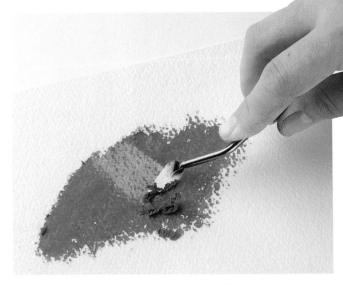

The sgraffito technique can be used with dark and heavy layers of wax, where a layer is removed with a spatula.

PROCEEDING WITH LIGHT LAYERS

Although wax crayons work well when used for intense coloring, it is better to begin by coloring lightly. When mixing colors by superimposing two lightly applied colors, the subtleties can be more easily appreciated and tones can be corrected by darkening them later.

The appropriate crayon should be selected for each line and application of color. It is a matter of finding the color closest to the one you wish to create from among the large assortment. This manufactured color is the one that will be worked with after it is applied, either to adjust the tone with the same crayon or to use other colors to lighten or darken it. It is the same process we have seen with chalk, soft pastels, and colored pencils.

COLOR APPLIED IN HEAVY LAYERS

Only after you are sure of your line or coloring should you apply it heavier and darker. The more opaque wax colors cover well, even covering light colors. But colors under very transparent crayons can be perceived even when heavy layers are applied.

In some cases, it is interesting to use the sgraffito technique to correct heavy coloring in a dark layer, although this action has its limitations.

The same sgraffito technique using a craft knife also exposes the paper, which always retains traces of color unless a white crayon was previously applied.

THE SGRAFFITO TECHNIQUE

The sgraffito technique, which is also applicable to colored pencils, creates great results with wax crayons. It is a matter of scraping off a heavy layer of color with a craft knife, a spatula, or a wood stick, among other tools. Proceed with care so you will not damage the surface of the paper. The paper is carefully scraped with the flat side of the blade, as seen in the picture. The craft knife can also be used to make fine lines. The spatula, which is not as sharp, is less aggressive toward the surface of the paper and very practical, although it has less control over the space that is being scraped.

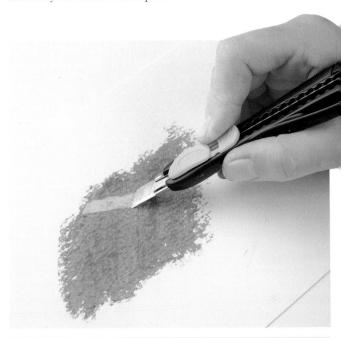

THE WET WAX TECHNIQUE

The oil-based wax medium can be dissolved with essence of turpentine or with paint thinner. For example, a brush charged with one of these liquids can be wiped across a wax line or colored area. The result is very expressive and reminiscent of the use of thinner in oil painting.

The oily base of wax crayons allows them to be dissolved with essence of turpentine or paint thinner.

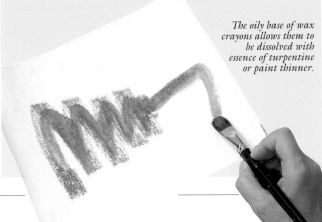

Applying wax crayons with the intention of using the sgraffito technique later requires the areas of color to be organized using the sketch as a guideline.

The colors that are applied first are those that will be exposed when the sgraffito technique is applied to the second layer, which is the black color.

COLORING ORDER

When the drawing is executed with the sgraffito technique in mind, the order of the colors should be carefully planned and the artist should know exactly what effects he or she wants to create.

The color that is revealed with sgraffito is the one that is applied first. If the artist wishes to expose the white of the paper, a reserve with white wax crayon should be made in that area before any other color is applied; this creates perfect reserves. Therefore, the first step is to apply white reserves if needed.

The colors that the artist will ultimately want to reveal are painted next. And finally, the entire surface is covered with a single color. This top layer should contrast with the underlying colors and cover them. Black is normally used for the strong contrast that it creates against very light and luminous colors. The colors are usually light on the bottom layer and dark on the top.

THE TEXTURE OF SGRAFFITO

The idea of sgraffito is to expose a large area of color, making the incision wide or very narrow. But thin sgraffito lines can produce strong contrast if applied with a hatching effect. The same guidelines for drawing are applicable to create a sgraffito hatching effect. The scratches or markings should be descriptive of the object's shape and should be able to represent perspective and foreshortening.

PAPER AND SGRAFFITO

With the sgraffito technique, the entire surface of the paper is covered with wax crayon. Sgraffito makes it easy to compare the characteristics of each paper. Some papers allow the pigment to be removed very easily; these papers are nonporous and have a smooth finish. In others, however, the oily media penetrates the surface and the color stains the paper. Only the bulk of the wax can be removed, while the residual stain color will persist.

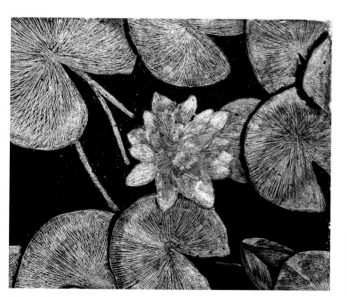

The result after sgraffito. The black layer makes the sgraffito difficult to do, so the work can be easier if lighted from behind, for example. Work by Marta Bru.

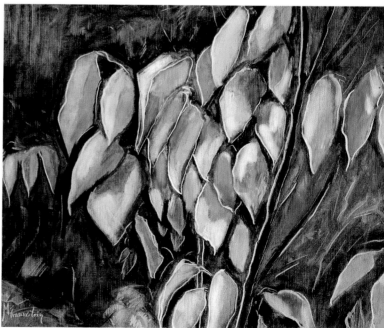

Figueras paper has a texture and a finish that imitates fabric. These properties make it a very suitable medium for painting with oils, and it provides a satiny finish that makes it possible to expose the white areas without the need for white wax crayons.

This model is ideal for the transparent quality of wax crayons.

A TECHNIQUE THAT COMPLEMENTS

The sgraffito technique can be used in a drawing that requires a texture that otherwise would be impossible to represent in any other way. One of the inherent limitations of wax crayons is the difficulty of producing thin lines with them. This is why drawings executed with wax crayons present great synthesis. But the sgraffito technique makes it possible to produce very thin lines whenever the process involves a lighter tone or color. Looking at the model makes it obvious that some areas call for the use of sgraffito. Optical mixtures are introduced with hatching, which act as contrasts against the areas that are left without any sgraffito intervention.

RESERVES FIRST

The purpose of reserving areas before the process begins is to maintain the surfaces that are intended to be white from being colored accidentally. The two most common options are using cardboard or art paper templates or making reserves with white wax crayon. If the template has a sticky side, it is a good idea to rub it against another paper to eliminate the glue completely. This way, they will be easy to remove from the paper without causing any damage.

DUAL PURPOSE

The idea of applying a layer of white wax crayon as a reserve has a dual purpose. In addition to protecting the white of the paper, it lightens any color that is applied over it. Keep this property in mind and use it with all its consequences. For example, a darker color can be used because it becomes lighter when it comes in contact with the white wax crayon.

SEVERAL TOOLS IN ONE DRAWING

The sgraffito technique can be applied with different tools. The effect created with each one of them depends in great part on the artist's intention. For example, a pointed stick can be used to produce thin sgraffito incisions. When the other end is used, however, the incision is somewhat heavier.

There is a technique that produces very good results because it does not create the strong contrast that sharp objects do. A fingernail, for example, can be used on wax crayons to remove the sgraffito pigment. But using a fingernail without protection can be very messy. It is better to wrap the finger with a cotton rag. This way, every time pigment is removed, the rag picks it up. The rag that touches the fingernail should be replaced often to avoid ruining the work.

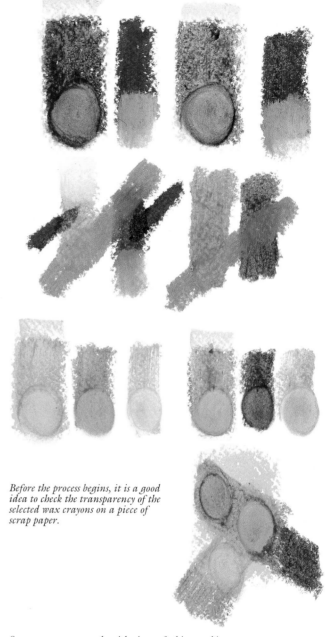

Before the process begins, it is a good idea to check the transparency of the selected wax crayons on a piece of scrap paper.

Some reserves are made with pieces of white masking tape.

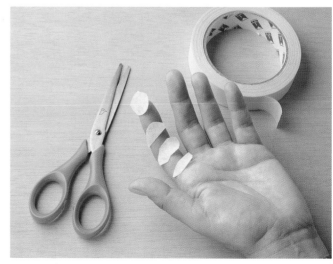

The sketch is begun directly with yellow wax crayon.

It is important to establish the light and dark areas of yellow.

The yellow-green color also covers different areas with light or heavy application.

Dark green is introduced to emphasize the illuminated area.

Ultramarine blue is used to darken intense and dark colors.

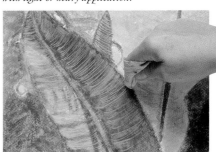

A fingernail wrapped with a cotton rag is used to create the fine sgraffito lines that model the leaf.

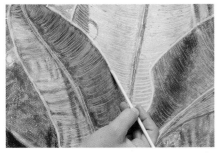

A thin wooden stick is easily used to outline and to create very fine incisions.

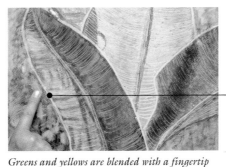

Greens and yellows are blended with a fingertip until the background is established.

THE TRANSPARENCY OF WAX CRAYONS

To emphasize the transparency of wax crayons, it is important to use them directly on white paper. The colors chosen must be transparent; therefore, several samples are created on a piece of scrap paper to find the desired effect.

The same way that white wax crayons are used to reserve white areas, light colors that come through as a result of their transparent properties are also reserved, making those that are applied over them lighter. This light color is the one that will be exposed with the sgraffito technique. Careful observation of the model in this exercise shows that the yellow is the reserve for yellow-green; then yellow and yellow-green act as the reserve for dark green; and finally, the greens are the reserves for blue.

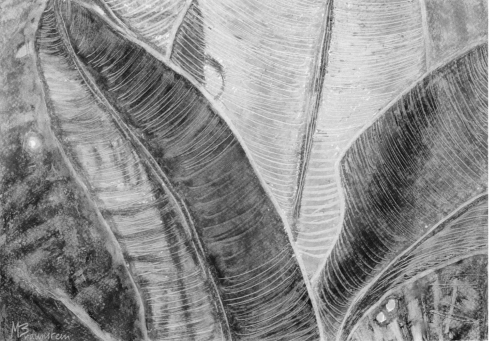

With this drawing, M. Braunstein brings to light the transparent quality of wax crayons, enhanced by the use of white paper and the sgraffito technique.

Dry Techniques with Oil Pastel

Even though oil pastels are not only a dry technique, they are worth mentioning for their usefulness for creating sketches *in situ* or for applying the first colors in an oil painting that will be continued in the studio. The most common techniques for this medium are lines and coloring, which can be applied evenly or through gradation, and blending. Oil pastels are not used as the end procedure; instead, they are part of a phase that will ultimately require the use of mineral spirits, which can be applied in conjunction with all the techniques derived from oil painting, such as impasto, glazing, and rubbing.

When two drawings are compared, it is difficult to know which is wax and which is oil pastel. But wax crayons smear a lot easier than oil pastels when rubbed with a finger. The colors of oil pastels are much harder to blend.

At first sight, lines or blocks of color created with soft or semisoft pastels have a powdery finish that is very different from grease-based pastels like wax and oil.

WHAT TO DO WITH OIL PASTELS

Oil pastels can be applied from very light to very intense, either by coloring evenly or through gradations, for which white is needed. Also, two-color and overall gradations can be created by using several colors that are chosen among a selection of a few values.

The sample shows that colors intensify through blending. In fact, the same techniques used with other pastels can be used, although the results are less showy.

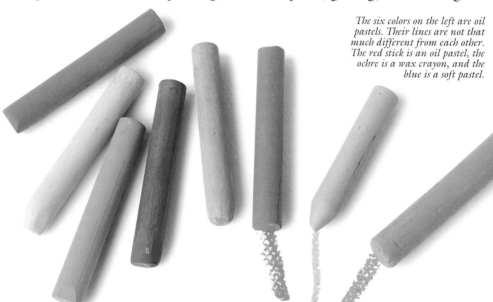

The six colors on the left are oil pastels. Their lines are not that much different from each other. The red stick is an oil pastel, the ochre is a wax crayon, and the blue is a soft pastel.

As with soft pastels and wax crayons, oil pastels can be applied lightly or intensely.

This orange color is an example of a light gradation.

Two-color gradations, like this yellow and orange, can also be made.

A gradation can also be created with several colors to model an object.

OIL PASTELS WITH MINERAL SPIRITS

Moistening oil pastels with mineral spirits or with essence of turpentine produces a special effect. The color is diluted to create delicate glazing effects when the color is lightly applied. When the color is opaque, the solvent produces a pasty look in a thick layer.

A CLOUDY SKY WITH OIL PASTELS

This is a very good exercise for becoming familiar with the characteristics of oil pastels. It is also very useful because it summarizes what should be

done when the artist wants to create the background of a painting that will be finished later with oil paints.

The colors are selected based on the model. Small color ranges are required—only the colors necessary for darkening a color with shading. The addition of white pastels is essential. The clouds are defined through gradations and opaque blending. Gradually, the depth of the atmosphere becomes more apparent. It is a matter not of creating a completely finished drawing but of applying the most important gradations because the subsequent work with mineral spirits and oil paints will eliminate the details.

All the tonal gradations, like this blue and green with blue, can be blended, thus intensifying the tones and creating colorful effects.

With two grays, three blues, and of course white, a very realistic cloudy sky can be created, like the one shown below.

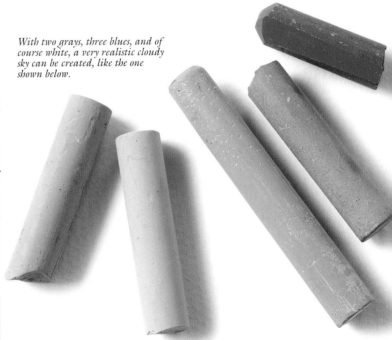

OILS PASTELS AND OIL PAINTS

Try to erase oil pastels. Rubbing vigorously produces a very thick paste that is hard to work with. However, simply adding turpentine or mineral spirits turns this paste into something that resembles the oil paints that come in a tube.

Both media, oil pastels and oil paints, are perfectly compatible because both have a similar oil base. This is why a first layer of color can be applied with oil pastels. One needs only to thin the pastel base with mineral spirits to apply a first, crude background for oil painting.

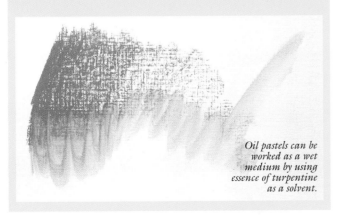

Oil pastels can be worked as a wet medium by using essence of turpentine as a solvent.

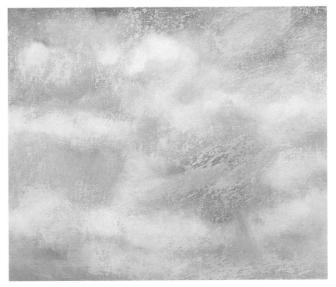

A sky created with oil pastels can be the perfect base for continuing with oil paints.

Objectives of Charcoal Drawing

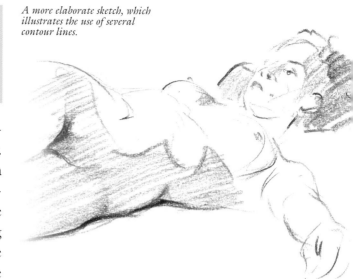

A more elaborate sketch, which illustrates the use of several contour lines.

Before you start drawing with charcoal it is important to define the effect you are looking for. There are many possibilities, which can range from a quick sketch, a note, or a shaded sketch to a complete chiaroscuro study representing the figure alone or with its surroundings. The purpose of the drawing and the shading are very different in each of these projects. It is interesting to compare them from the standpoint of their purpose and approach.

THE LINE AND QUICK SKETCHES

In a small sketch, the width of the charcoal line plays an important role. The texture in this case can be used to intensify the shaded area.

A QUICK SKETCH OF PEOPLE

These two figures should be drawn together and the gestures toward each other should look credible. A way to create a sketch of this type of subject is to block in both figures simultaneously and shade them with lines that are drawn in the same direction, defined by the light that shines on them. The unity in the shading process creates a visible relationship.

A SKETCH WITH CONTOUR LINES

Quick sketches constitute a good exercise for practicing contour lines. The shading is done very softly—just enough to reinforce the impression of these contour lines.

APPROACHING THE FIGURE

The first exercise in approaching the figure is to define some tonal values. Three or four different values are enough to approximate the volume of the figure.

The movement or the pose represented by a drawing composed of two figures must be coherent.

Depending on the size of the sketch, just a few charcoal lines drawn with as many strokes are enough to fill in the shaded areas.

This drawing of a figure shows a strong chiaroscuro, yet not many different tonal values.

EXPRESSION WITH CHIAROSCURO

A much more complete study of a figure incorporates gradations, which help model the volumes. Abrupt tonal changes are avoided whenever possible by blending and touching up.

ADDING THE FIGURE'S SURROUNDINGS

To achieve depth in a drawing, the figure is modeled working it together with an appropriate background and employing one of the most conventional elements for framing: the drapery.

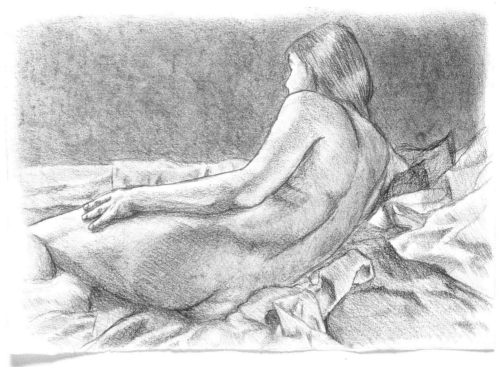

This drawing of a nude figure seen from the back shows how important it is to know how to work around the figure to make it stand out. A drawing by Marta Bru is shown here with the atmospheric effect and the drapery.

The chiaroscuro in this figure seen from behind illustrates complete mastery of tonal values.

DARKENING THE TONES

No matter what technique is chosen, it will undoubtedly incorporate an element of personal interpretation. Intensifying the tones requires the use of wide and decisive lines to apply shading.

Applying shading with large strokes produces a very dramatic effect.

First Exercise Using Charcoal

One of the most common themes when learning to draw with charcoal is still life. This particular still life consists of a single object: a cloth. Although simple, it allows the artist to work on the modeling of the cloth and its folds, to practice tonal values and the continuous balance between the space that surrounds the object and the object itself. Mercedes Gaspar draws with charcoal on sketching paper using basically her hands and a cotton rag.

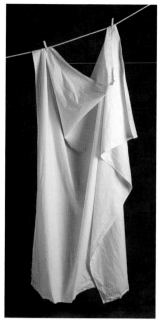

A hanging cloth is a good exercise to practice modeling, particularly the folds and the way it hangs.

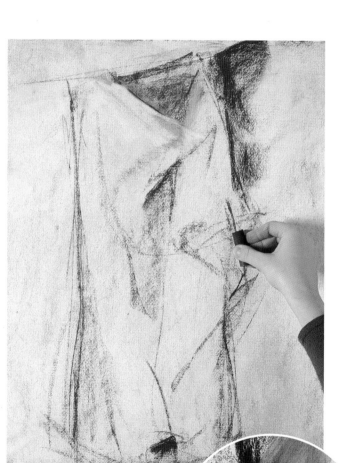

THE NEED FOR CONTRAST BETWEEN THE BACKGROUND AND THE OBJECT

Specific tonal gradations are needed to represent the cloth. For the modeling work to stand out, the object must be surrounded by a background whose shading is not the same all the way through.

3. The shading around the cloth enhances the perception of volume.

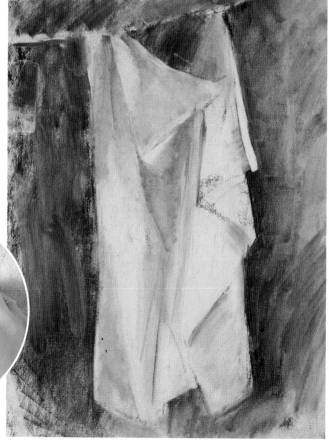

1. When the basic lines have been established, the artist begins shading to define the form.

2. The charcoal is rubbed and blended with a cotton rag.

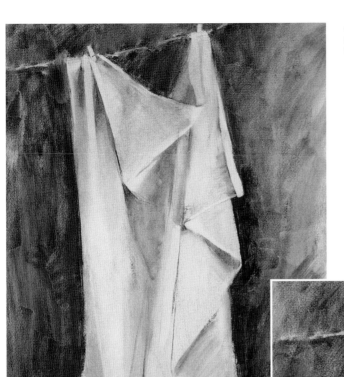

4. *After each tonal value has been established, it is simply a matter of intensifying the tones.*

5. *The last step consists of establishing white areas to define the most illuminated parts.*

6. *Finally, a few tones are intensified to better show the trajectory of light.*

Drawing Expressions with Charcoal

Charcoal is used in large and medium-sized work, and it is ideal for developing proficiency at drawing the expression. Drawing a dog's head, for example, provides a good opportunity to practice expressive lines. The shading conveys a realistic feeling of the fur and captures the animal's expression, which is centered basically in its eyes and the space between the brows. To highlight some of its features, in addition to charcoal sticks and pencils, white chalk is used, which is very useful for creating tonal values on the fur.

Sometimes, a dog's expression dictates the use of vine charcoal mixed with white chalk for highlighting, and charcoal pencils for intensifying the shadows.

CONTRAST WITH CHARCOAL PENCIL AND WHITE CHALK HIGHLIGHTS

Very dark black shading is created with short charcoal pencil lines, which are easy to identify from the vine charcoal lines of the basic drawing.

A few touches of white chalk are sufficient to enhance the reflection in the eyes and to better represent the dog's expression. The same procedure is used to create the volume of the tongue and the reflections of the wet snout and mouth.

The color of the paper, a dirty white, enhances the white chalk lines used to draw the texture of the dog's hair.

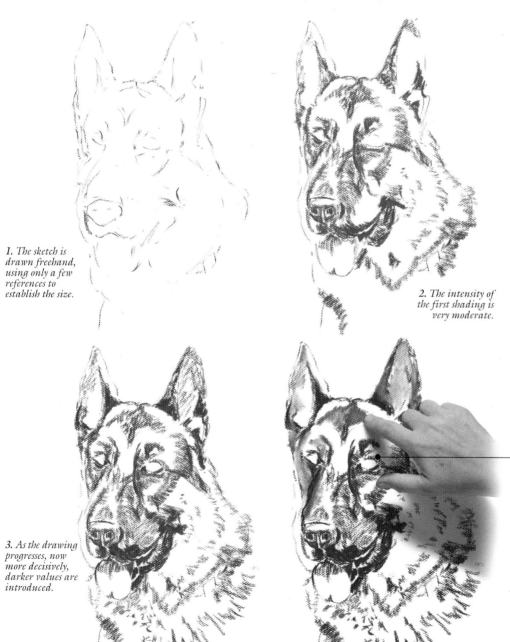

1. The sketch is drawn freehand, using only a few references to establish the size.

2. The intensity of the first shading is very moderate.

3. As the drawing progresses, now more decisively, darker values are introduced.

4. Rubbing a shaded area with a fingertip establishes intermediate values and models the forms.

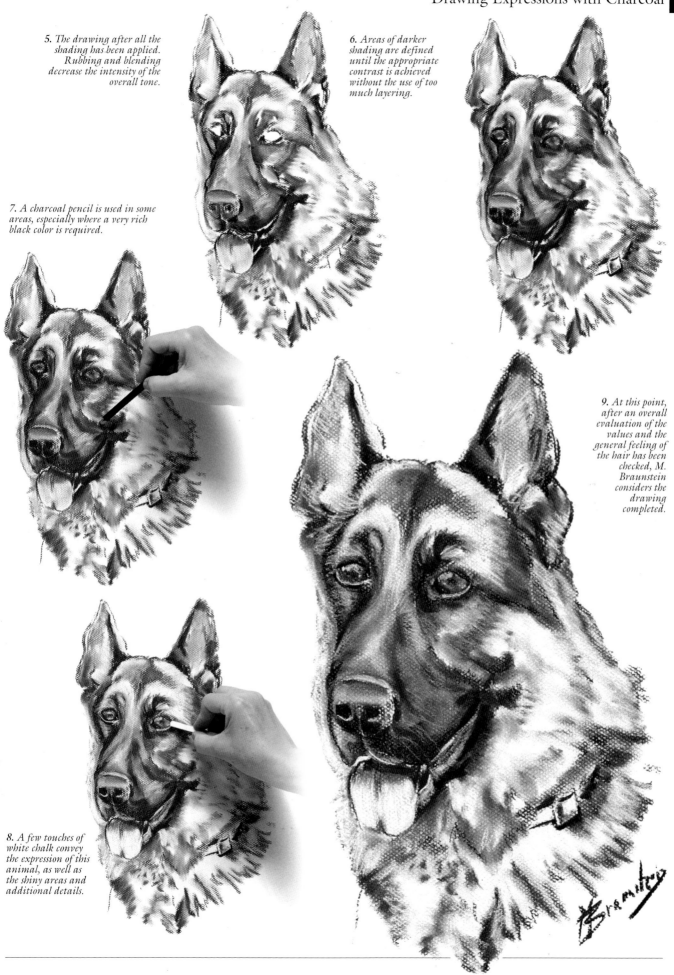

5. The drawing after all the shading has been applied. Rubbing and blending decrease the intensity of the overall tone.

6. Areas of darker shading are defined until the appropriate contrast is achieved without the use of too much layering.

7. A charcoal pencil is used in some areas, especially where a very rich black color is required.

9. At this point, after an overall evaluation of the values and the general feeling of the hair has been checked, M. Braunstein considers the drawing completed.

8. A few touches of white chalk convey the expression of this animal, as well as the shiny areas and additional details.

Landscape with Charcoal Powder and Blending

The soft look is, without a doubt, the most outstanding characteristic of a drawing executed with charcoal powder and a blending stick. Landscapes lend themselves perfectly to this procedure because the definition of the planes and the texture of the vegetation can be achieved quickly and without too many contrasts. The materials needed are a heavy paper with slight texture, which is ideal for applying the powder with a blending stick, and an eraser for making highlights.

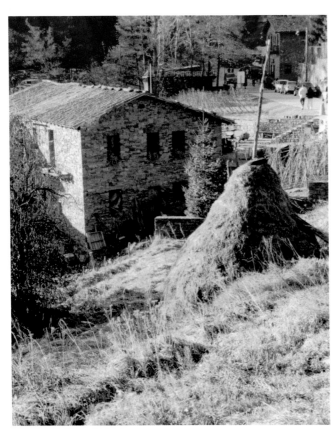

A landscape like the one in the picture is ideal for drawing with a blending stick and charcoal powder.

BLENDING STICK TECHNIQUE

Practically anything can be drawn with a medium-sized blending stick. One has to get used to charging the stick with the right amount of charcoal to apply a specific type of shade. Simply by modifying the pressure and direction on the charcoal powder, the artist can create consistent gradations and shading.

AN ERASER FOR DRAWING

When the shading is finished, yet not necessarily applied consistently, an eraser can be used to reestablish areas of light in the representation.

2. The important volumes are defined with darker lines.

1. First, it is important to shade the entire paper by spreading the charcoal powder over the surface with the blending stick.

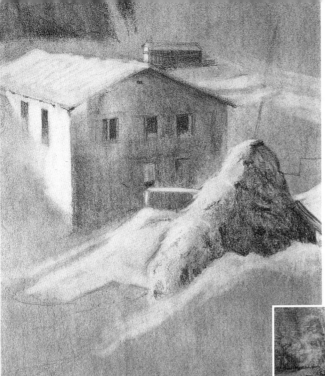

4. To create contrast, the shaded areas are darkened using charcoal powder and a blending stick.

5. This illustration shows the array of possibilities offered by this technique. Drawing by Esther Llaudet.

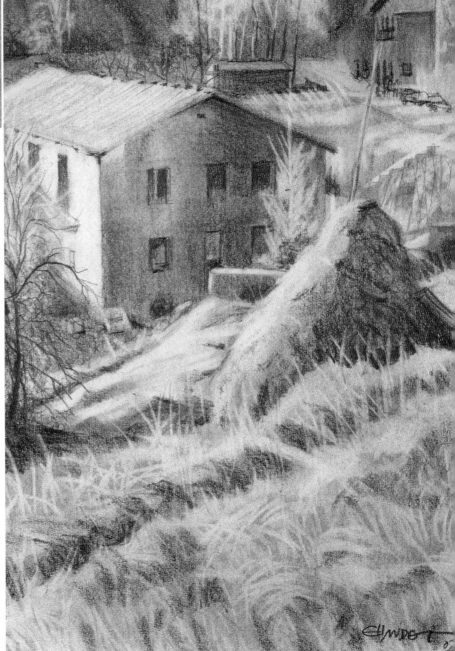

3. White areas are created by erasing; this defines certain parts of the building that are more illuminated.

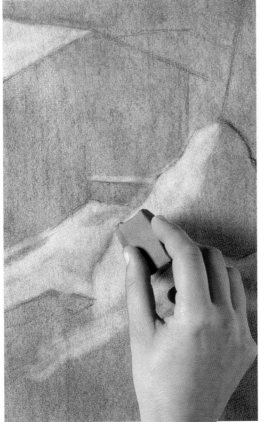

Beginning to Model with Sanguine

A still life with several objects is a good subject to practice modeling with a sanguine stick. The preliminary sketch is outlined with very light lines. Once the shapes have been established, shading begins to create a light tonal guide. The darkening of the colors that follows this step is done to reflect the contrasts of the actual objects. The procedure consists of combining the chiaroscuro with some gradations, using the fingertips to adjust the tones and an eraser to establish the highlights.

The color is applied following the sketched outlines of the forms. The volumes are drawn, lightly at first, with the flat side of the stick on the paper. Gradually, more tonal values are added by darkening the colors that need to be darkened, adding more layers with the same sanguine stick. Modeling continues by darkening the drawing.

This still life containing a variety of shapes is a good exercise for modeling.

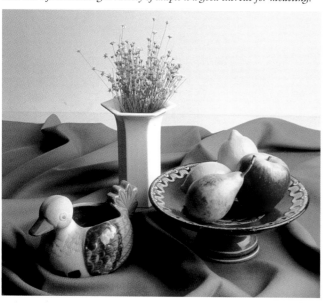

1. The sketch is drawn with very light lines to avoid smearing the paper.

2. The first color is applied very lightly as well.

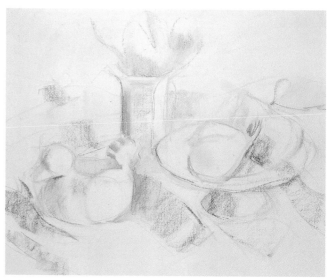

3. An attempt is made to begin coloring by laying out the basic shapes and shadows.

5. This drawing lends itself to modeling by erasing, and some highlights are added to finish the scene.

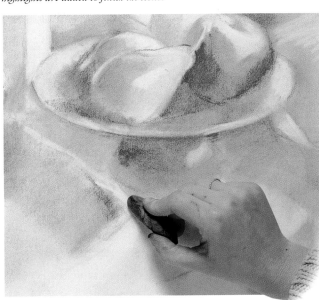

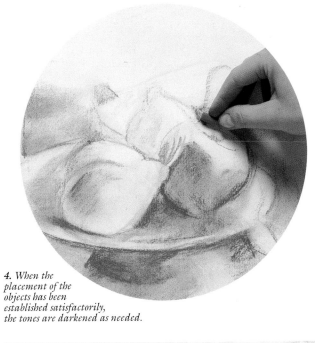

4. When the placement of the objects has been established satisfactorily, the tones are darkened as needed.

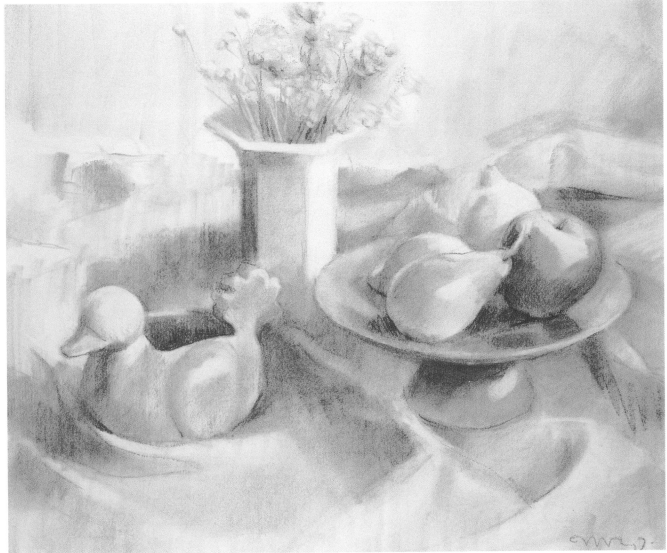

6. The potential for applying chiaroscuro with sanguine are visible in this drawing by Mercedes Gaspar.

Texture and Chiaroscuro with Sanguine

To enhance the chiaroscuro effect of the sanguine and to create a textured appearance, it is necessary to introduce the contrast of sepia and pencils. The objects immediately acquire richer depth, and the finest texture can be created in detail with ease. A medium-textured absorbent paper, your hands, sticks and pencils, sanguine and sepia, a cotton rag, a blending stick, and an eraser are all that is needed.

SEPIA TO DARKEN THE SANGUINE

The effect created by using the dark sanguine tone is very different from that created by using the dark sepia tone. Introducing sepia to darken the sanguine tones increases the color options in the darker range. The artist can use tonal gradations of both colors, which are incorporated in the background, that is, the contrasting atmosphere as a backdrop for the image of the cow.

Some areas are darkened with sepia by layering it over the sanguine used to represent the animal. This gives the scene a more realistic look against the backlit effect.

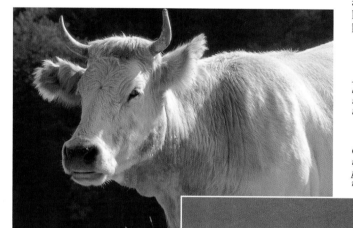

1. In the sketch, a very soft color defines the most important areas of shadow.

TEXTURE WITH PENCILS

The textured details of the hair are represented with thin lines using pencils and the sides of the stick. It is not necessary to draw it all, but only a few lines that indicate the direction and inflection of the hair. It is important to differentiate the hair from the ears, from the nape (it may fall in different directions depending on the hair's natural disposition), the neck, and so on.

The snout, the eye, and the horns require more contrast and good outlines. They are laid out with short expressive lines.

A more in-depth study can be achieved with an exercise that involves textures, like that of the hair.

Greater contrast is achieved by using sanguine and sepia, either in pencil or stick form. An eraser is required for making highlights.

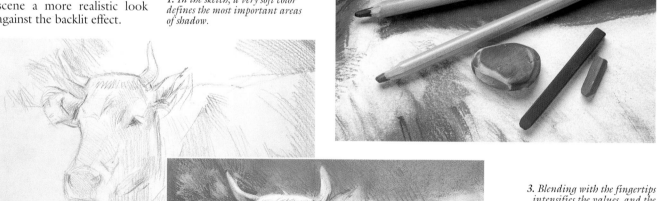

2. It is a good idea to begin highlighting the figure. To do this, the top area is darkened considerably using color gradations.

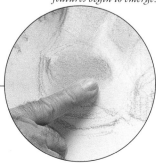

3. Blending with the fingertips intensifies the values, and the features begin to emerge.

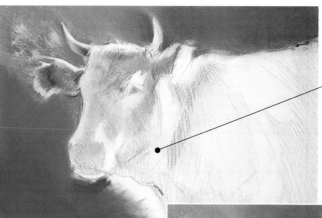

4. The background is finished by gradating the sanguine with the sepia, darkening it.

5. The shape of the nape and the texture of the hair are worked on carefully.

6. The body of the cow is modeled with lighter tones than those used in the background.

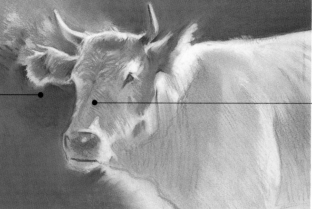

7. A cotton rag is used to soften the tones and to eliminate unwanted harshness.

8. A blending stick is used to blend some details that are hard to create with the fingers.

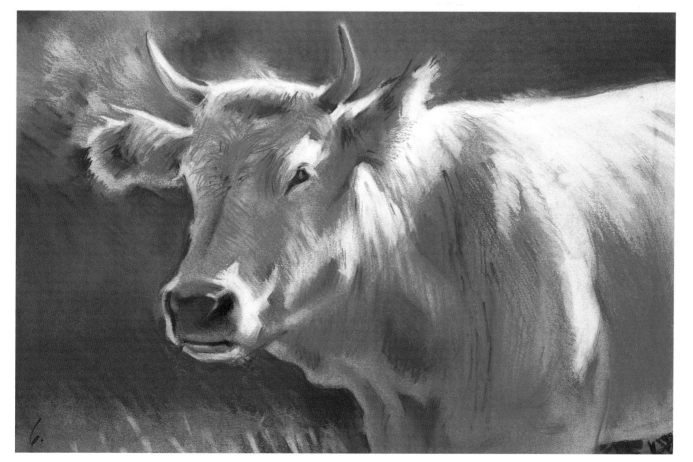

9. The last review to evaluate the overall feeling takes care of a few final touch-ups. The mastery of Vicenç Ballestar lays out everything with electrifying realism and a feeling of depth.

Modeling a Torso

The possibilities offered by the human figure for modeling with sanguine are well known. The basis of this exercise is drawing a torso with values using a stick of sanguine sepia, which can produce dark tones without difficulty. The same stick used for coloring can also be used for drawing the outline. The contour lines can be reinforced with tonal values that convey the feeling of volume.

The objective of this approach is to create a figure with a very light overall tone, devoid of harsh lines or colors.

1. The sketch is created by drawing a detailed outline of the shapes. The various planes that define their respective volumes are drawn using contour lines. These lines serve as guides for subsequent shading.

2. Shading and blending are applied with a cotton rag or with the fingertips.

A VALUE STUDY

A value-study approach is most effective in figure drawing. In fact, the representation of the flesh requires the application of delicate gradations without sudden tonal jumps, that is, without gaps. It is important to be aware of the darkest tone, which in this light drawing is not very dark, as well as the gradations created by progressing very gradually up to the medium or light tone.

With this model as a base, a drawing is created using only a stick of sanguine sepia.

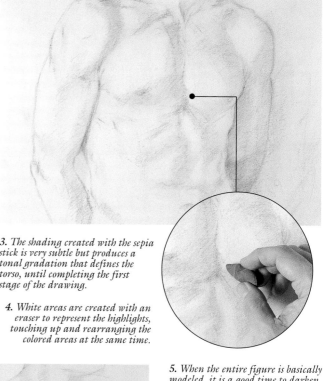

3. The shading created with the sepia stick is very subtle but produces a tonal gradation that defines the torso, until completing the first stage of the drawing.

4. White areas are created with an eraser to represent the highlights, touching up and rearranging the colored areas at the same time.

5. When the entire figure is basically modeled, it is a good time to darken the tones.

6. A few shadows are carefully darkened. It is better to not darken the shadows enough and have to go back over them than to make the tones too dark.

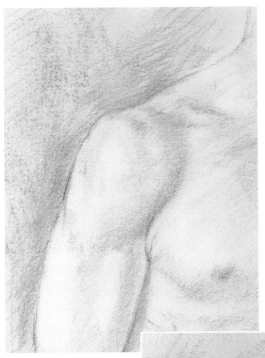

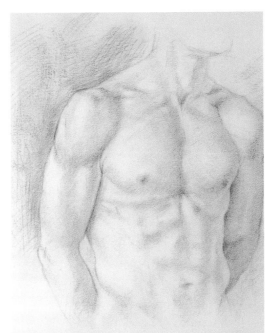

8. The background colors are worked on until the correct atmosphere has been achieved.

7. The background is darkened to make the figure stand out, without moving the focus away from the torso.

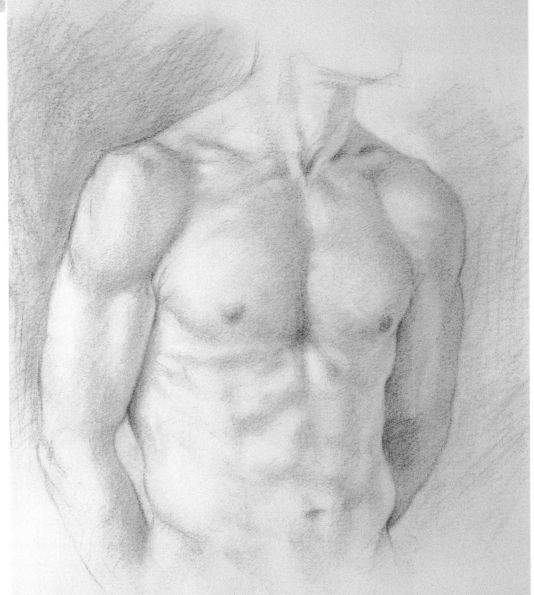

9. After a few final touches to even up the different tonal values, and darkening them where needed, this drawing by Josep Torres is considered finished.

An Atmospheric Background

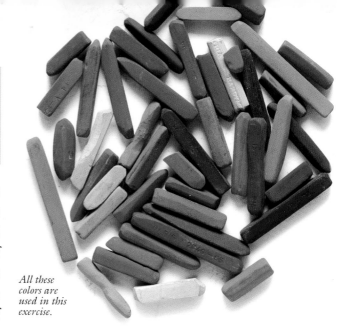

All these colors are used in this exercise.

Colored chalk allows drawing and painting at the same time. The impact of the colored areas intensifies the lines. A good background can add drama to the volumes and provide a feeling of depth. Chalk can be applied directly to create different colors and tones, or it can be built up in layers. Blending with the fingertip is the secret of chiaroscuro, which is used to represent the forms and the atmospheric effects.

THE COLOR OF THE PAPER AND LAYERING

A very light neutral colored paper is the perfect base for achieving good immediate results with chalk. The very first applications define the forms. It is especially important to focus on the main subject and to do the basic coloring with the lightest and darkest chalk. Evaluating each color and its effect after it has been applied, blending colors together, and touching up with the fingertips is how you create a composition that conveys the feeling of depth.

1. A loose sketch is drawn with a color that stands out on the paper and that can be easily integrated with the colors that are used later.

For practicing, it is not necessary to find a still life subject with many elements; however, if it is arranged naturally, a still life provides a good opportunity to make a loose freehand drawing.

2. Next, the light areas are defined.

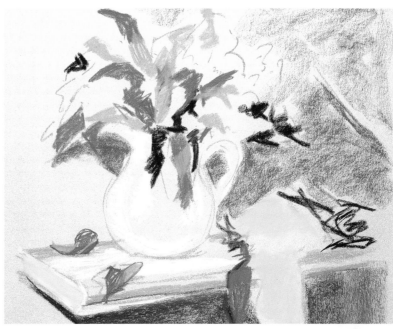

3. Shading is applied with confidence, intensifying the colors with sepia and burnt sienna.

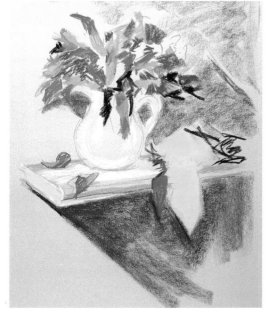

5. A range of pinks, some reds, carmine, and so on, is used to color the flowers.

4. Once the shadows are established, the greens are applied in an effort to approximate the different nuances of the colors and the tones.

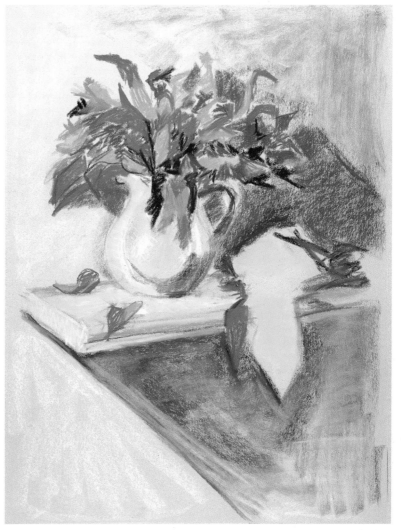

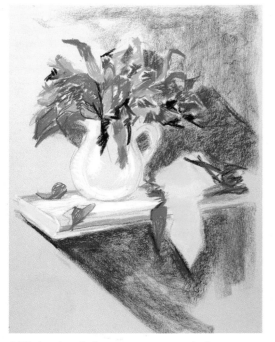

6. The layering of colors to create an atmospheric background is begun by applying violet.

7. A layer of white chalk adds to the atmospheric effect of the top right-hand side, which intensifies the colors of the flowers, and especially of the vase.

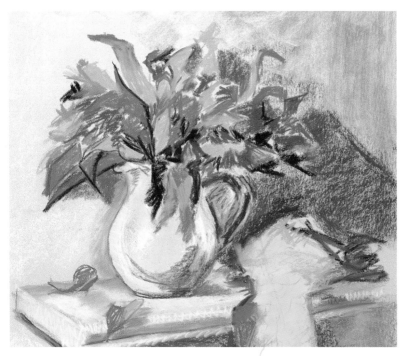

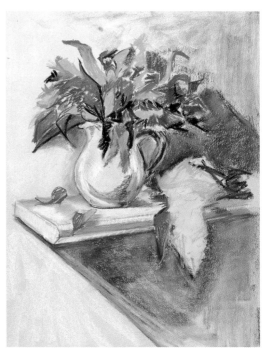

8. Now it is time to outline the vase and to define the shadows projected by the leaves.

9. The shadows are colored with ochre to lighten them.

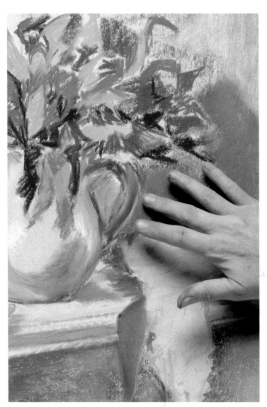

10. Blending the various layers of color with the fingertips creates a good base with different tonal hues.

11. The white chalk highlights the shadows projected on the wall (creating an atmospheric effect that enhances the feeling of depth) and the vase, giving them the importance that they deserve.

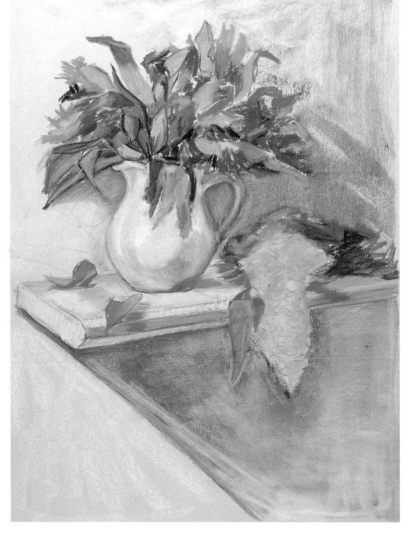

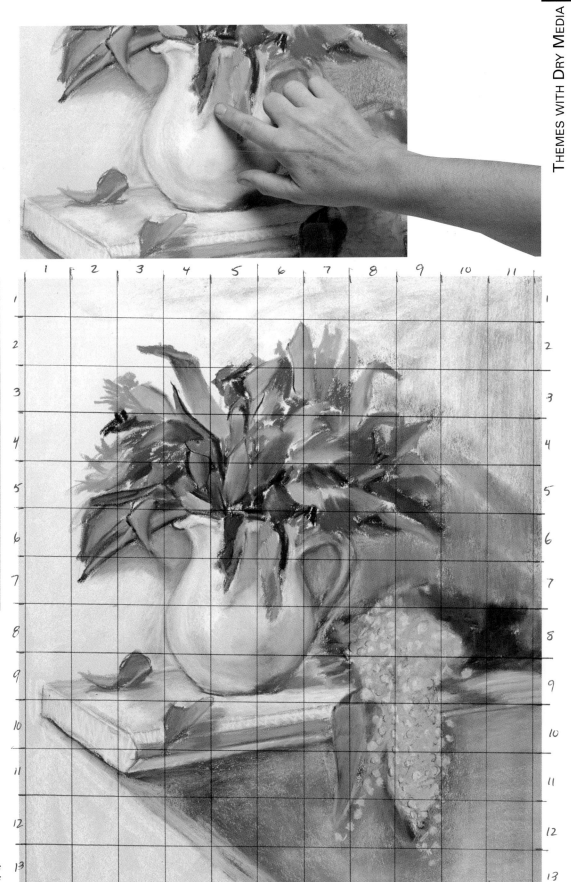

12. This step includes several applications, but the shape of the vase is modeled by softly blending them.

13. Now that the values have been created, only the necessary outlines are colored to represent the mimosa without clashing with the other objects. Then they are finished with touches of white, and light and medium yellow.

14. Thanks to the intensity of the shadows, interpreted in this exercise by M. Braunstein, the still life conveys a feeling of great depth.

Working with Pastel

Whether it is a sketch, a quick simple study, or a complete work of art, pastels provide the opportunity for enhancing the interpretation. There are two basic currents: the value-study approach and the colorist approach. The value-study approach is based on the creation of chiaroscuro using gradations, rubbing, and blending to achieve an effect that looks almost photographic. The colorist approach, on the other hand, represents volumes and areas of light using pure colors that are not rubbed or blended afterward.

Once acquainted with pastels, a person easily realizes that making light sketches is possible.

AN ARRAY OF POSSIBILITIES

The characteristics of pastels are evident, even on a simple sketch. Every work created with them is completely free of harshness. The quick sketches achieve an immediate feeling of depth when the colors that form the shaded areas are diffused. These first applications are an indication of the interpretative ability of the individual artist. Each artist would, without a doubt, provide his or her particular version. But if all the potential of pastels is put at the service of the artist, of his or her palette and special "touch," pastels can produce works of art of unimaginable visual impact, power, and subtlety.

A simple sketch displays the artist's individual approach.

The figure and the background are depicted using color contrast and other different techniques. In this drawing by Francesc Crespo, rubbing is used on the entire work; however, gradations are used to model the figure against a background of colors that have been rubbed.

A VALUE STUDY

To make a value study with a still life, it is necessary to analyze the light and the shadows carefully, and to study the colors and the tones that are needed. The palette is composed of pure colors that resemble those of the model. The artist must decide which colors are going to be applied for gradations and which will be used to darken the shadows.

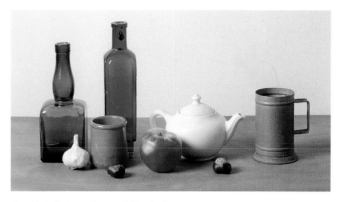

A subject that requires modeling is chosen.

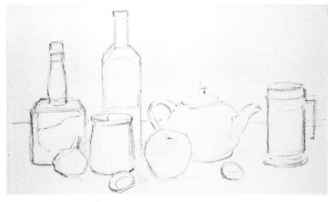

1. The sketch must place all the shapes, sketching them simply with an expressive line.

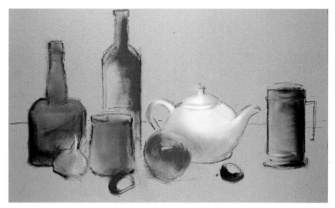

2. The first coloring and rubbing produce some chiaroscuro effects against the color of the paper.

3. The background: The table and atmospheric effect are worked on, using gradations to enhance the volume of the objects.

4. A few details are introduced: The shadows are defined and the outlines are reinforced, always modeling the forms with values.

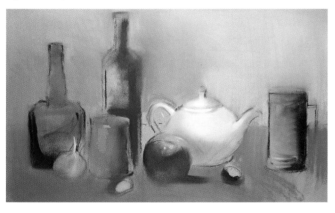

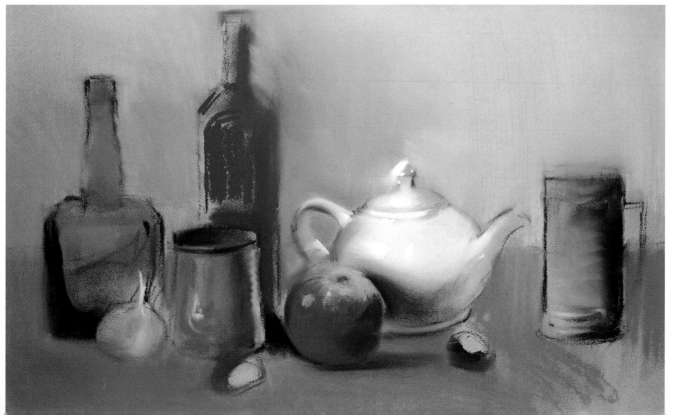

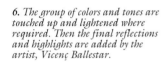

A TREND

Every artist develops a personal approach for his or her work. Some prefer dark tones while others use a light approach. But the value modeling technique can be equally appreciated in two such different trends. The artist can even modify the approach depending on his or her feelings and the motivation inspired by a particular model.

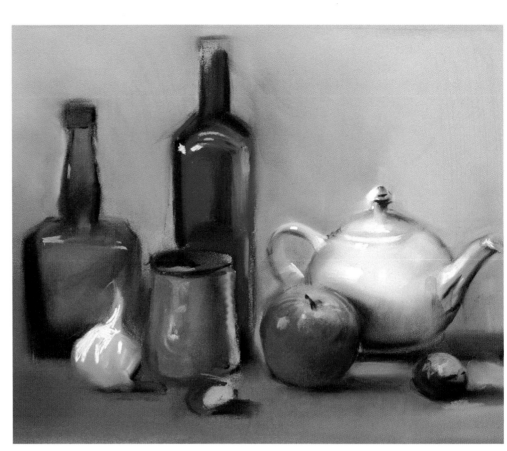

5. In this second to last stage of the painting, the artist shows a tendency to darken the work, using a value modeling approach.

6. The group of colors and tones are touched up and lightened where required. Then the final reflections and highlights are added by the artist, Vicenç Ballestar.

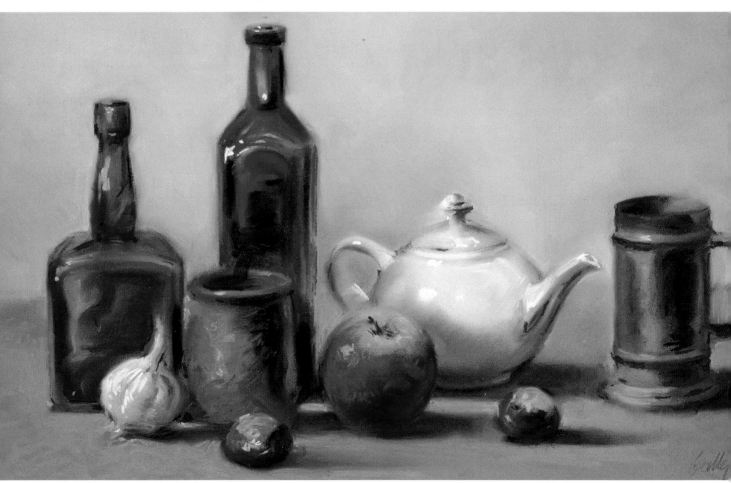

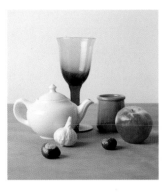

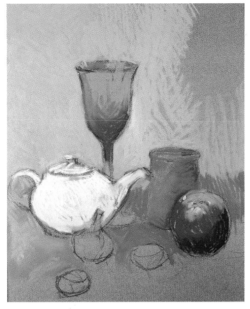

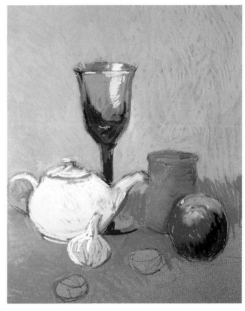

COLOR STUDIES VERSUS VALUE STUDIES

An alternative to the traditional value study is the colorist painting. Here the forms are modeled through the application of pure or neutral colors by painting them next to each other. To compare them, we draw a different still life containing the same elements as the first ones: the teapot, the apple, and so on. In all of them the difference between the value and color approaches is obvious.

1. The color is applied using several pure colors and tones.

2. The outlines and contrasts are created with bold applications of color without further manipulation.

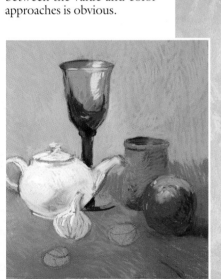

3. The colors and tones for the background and the more distant objects are chosen to create a solid and balanced reference.

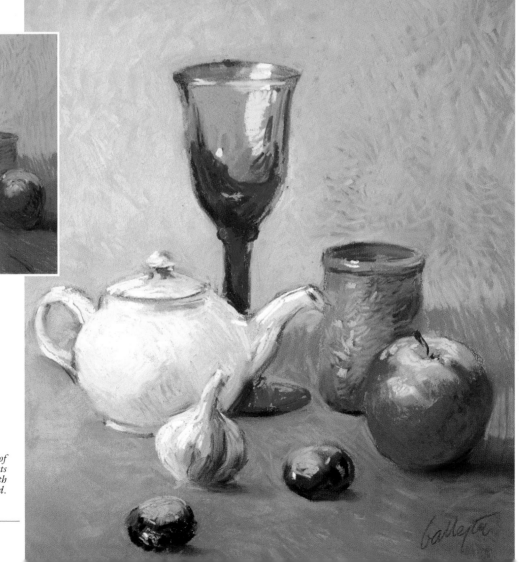

4. In the colorist approach of Vicenç Ballestar, the closest objects are those that contrast most with the more distant background.

Pastels Encourage Interpretation

Pastels offer many possibilities when it comes to interpretation. A colorist approach uses the striking characteristic of a flat painting, the darkening of the outlines, the synthesis of forms, and the trajectory of light. The impact is guaranteed when the model gives the artist the opportunity to use all these features at the same time.

The contrast between the colors of this still life guarantees a striking result.

PRELIMINARY STUDIES

Before starting to draw, it is very important to become familiar with the forms in the model, which in this case is a still life with flowers. The first step is to find the best way to frame it. It is a good idea to make some preliminary sketches, like those seen below. Next, it is important to try several color combinations to help choose the pastel crayons that will make up the painting's color palette. After some experimenting, you will discover a balanced solution that features the floral motif, which is the focus of the painting.

This first sketch to frame the subject seems less striking than the effect of the other study.

In this other sketch, the composition of the masses of color and shapes is successful because it reinforces the center of interest.

It is important to make pencil sketches to gain confidence at drawing and blocking in.

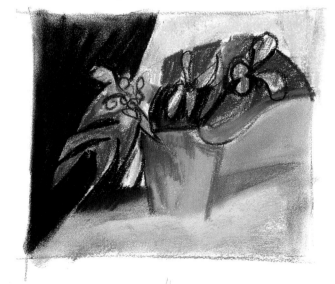

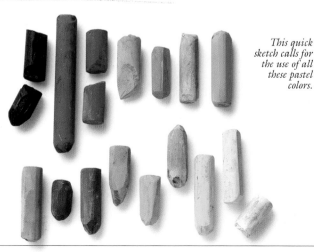

This quick sketch calls for the use of all these pastel colors.

1. When the placement and the palette have been determined, the sketch is drawn with light lines on special white paper for pastels.

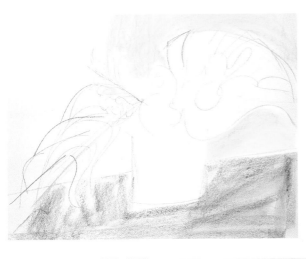

2. The first colors begin to delineate the floral motif.

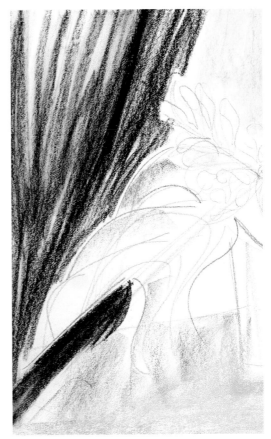

3. The drapery is intensified with a very dark, almost black, color.

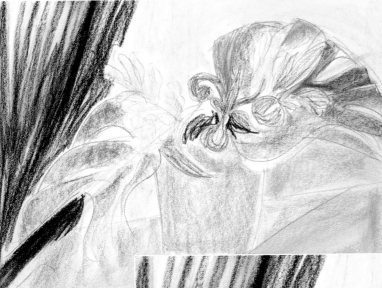

4. The coloring of the rest of the elements is completed, always very lightly.

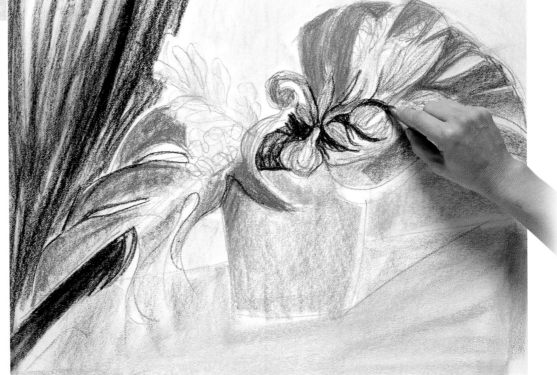

5. The color of each part is darkened by adding new layers of color. Expressive line work represents the contrasting outlines.

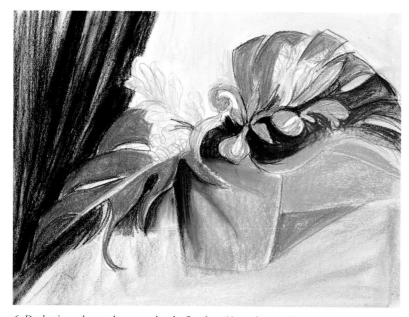

6. *Darkening colors and tones makes the floral motif stand out well. Notice now the dark green contrasts with the iris.*

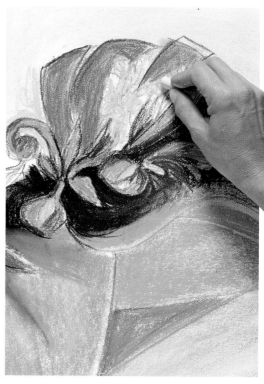

7. *The yellows are very bright. They are used to reinforce the background and to introduce some areas of light to represent one side of the flowers and the brightest part of the leaves.*

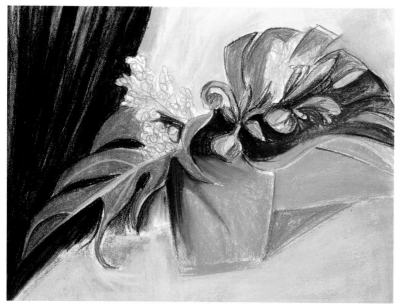

8. *In the first overall approach to the subject, everything is in place for later adjusting the volume.*

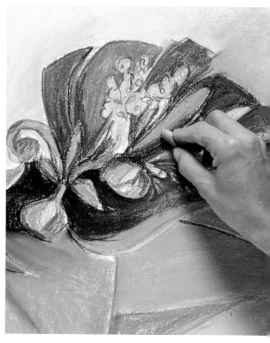

9. *The darker touches and lines solidify the shapes and the contrasts.*

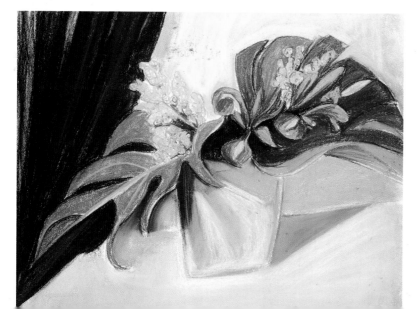

10. *The lightest value behind the bouquet is created with very light yellow and white. It will be the counterpoint that balances the harshness between complementary colors.*

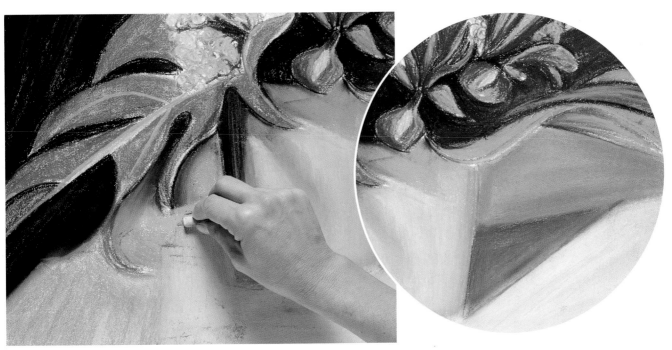

11. *The most appropriate shading is sought by superimposing colors, layer upon layer.*

12. *The shade projected by the vase is adjusted to achieve a greater feeling of depth.*

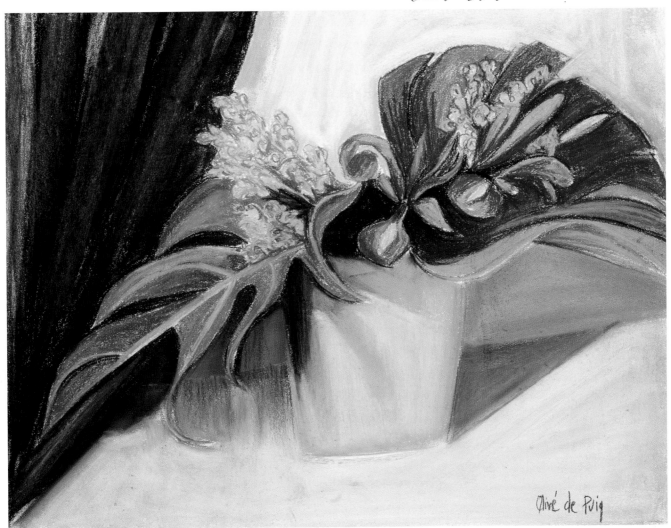

13. *After touching up the shadows on the left and the effects that focus the interest on this floral motif, Esther Olivé de Puig considers this drawing finished.*

Pastels and Contrasting Colored Paper

The artist can use a colored paper that vividly contrasts with the palette chosen. This drawing is based on the application of areas of color and a colorist approach. To confirm the possibilities for contrast afforded by this approach, a test is conducted first with a few colors on a piece of scrap paper. This is a way of verifying the contrast that can be created between different colored papers and the selected pastel colors. A good example of contrast is the one established between warm colors and a cool colored paper.

When the pastel colors have been chosen for the leaves (box on the left) and the tree trunks (box on the right), a test is conducted on both sides of two different blue papers. The smooth side is represented by the long strip, the coarser side by the short strip.

A colorful landscape will be the subject for this exercise in contrasts.

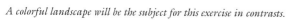

SELECTING PASTELS

Once a colored paper has been selected to produce a strong contrasting effect, the pastel colors must also be chosen to create the same kind of impact. Among the colors present in the subject, it is a good idea to select those varieties that can create very strong contrasts. It is interesting to test the effect of the contrast on a piece of blue paper. The sample on both sides of the paper (smooth and textured) will show the contrasting effect produced by the texture.

1. The sketch is drawn on the selected paper, a blue Canson Mi-Teintes, on the side with the heavier texture.

2. Yellow contrasts strongly with the blue paper.

3. Orange and red are used to represent the areas of shadow in this forest canopy. The contrast is strong, although the effect is less luminous.

5. Bright red and carmine are chosen for coloring the shaded area of the bright pinks.

4. Light pink is used to color the illuminated leaves of the second tree because it creates a good contrast with the blue of the paper.

6. Lightly applied colors create optical mixtures with the blue of the paper and its texture, producing intermediate tones and colors of different values.

7. The first stage includes the delineation of the branches and the tree trunk.

8. The branches are colored to look like a silhouette. The trunk on the other hand is modeled with the colors on the palette.

9. Now that the entire scene has been laid out, the colors are darkened, creating the highlights and the shadows of the treetops.

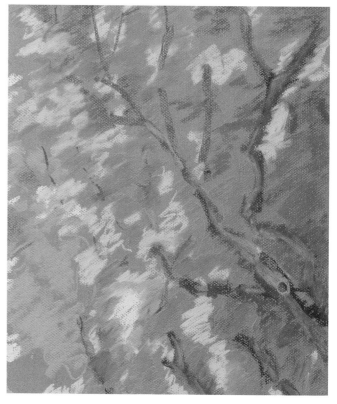

10. Now the branches and the trunk are modeled, superimposing colors that resemble the effect of the foliage.

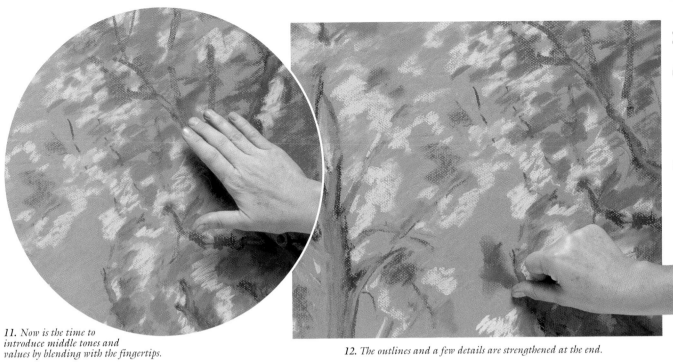

11. *Now is the time to introduce middle tones and values by blending with the fingertips.*

12. *The outlines and a few details are strengthened at the end.*

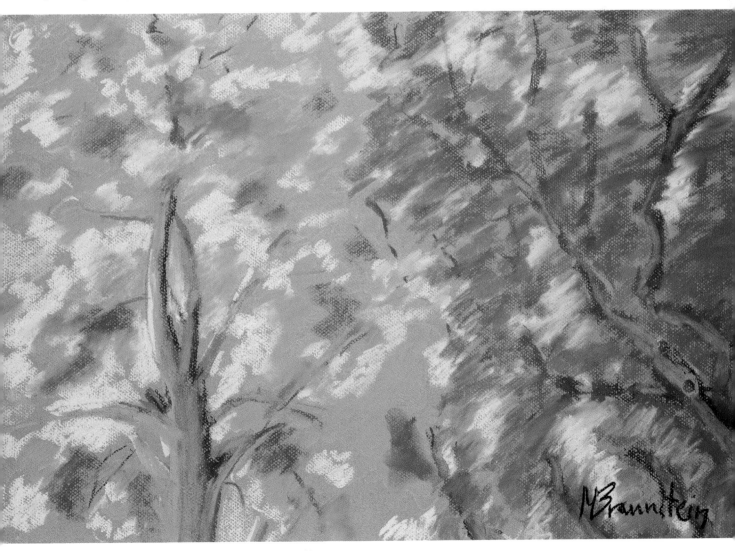

13. *The warm colors create a strong contrast with the blue paper in this exercise painted by M. Braunstein.*

Graphite Combinations

This exercise demonstrates a way of working with graphite that consists of alternating different grade pencils according to the effect desired. For example, a sketch can be done with an HB pencil, but then the artist may progressively switch to 2B, 5B, 8B, and a medium-hard graphite stick. The final result is an image that conveys a great feeling of depth and outstanding modeling.

This simple still life will serve to illustrate how a drawing can be executed with pencils and sticks of different hardnesses.

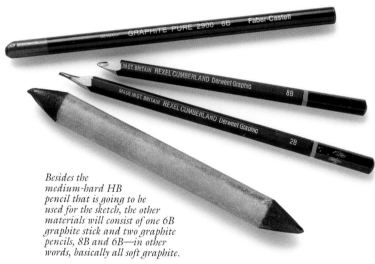

Besides the medium-hard HB pencil that is going to be used for the sketch, the other materials will consist of one 6B graphite stick and two graphite pencils, 8B and 6B—in other words, basically all soft graphite.

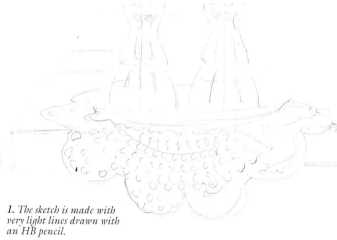

1. The sketch is made with very light lines drawn with an HB pencil.

DEPTH AND THE USE OF TONAL GRADATION

It is important to learn to observe the model and to identify the tonal values and gradations that will bring a feeling of great depth to the representation. The darkness that surrounds the shelf and the object itself is very intense in its lower part, but it dissipates progressively as it reaches the gray background of the upper part. Furthermore, the objects immersed in this type of atmosphere of tonal gradations are worked with more contrast and definition in the closest and most outstanding areas, which sets them apart from the most distant areas, which are executed with a lesser degree of contrast and definition.

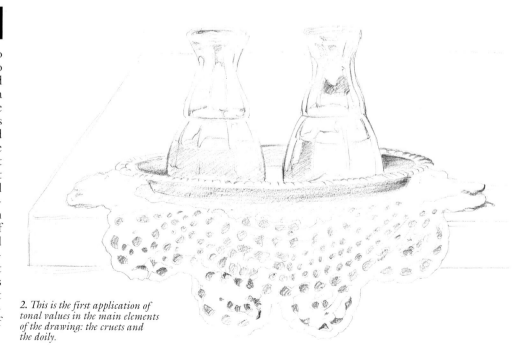

2. This is the first application of tonal values in the main elements of the drawing: the cruets and the doily.

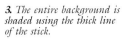

3. *The entire background is shaded using the thick line of the stick.*

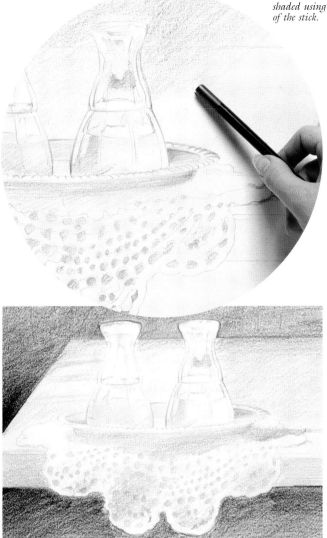

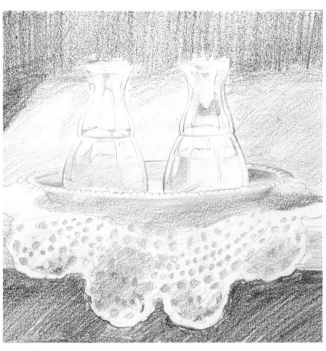

4. *Once the background has been created with the graphite stick, the shading is darkened with layers of vertical and oblique lines.*

5. *Tonal gradations are applied in successive layers to represent the atmospheric effect that surrounds the objects.*

7. *A piece of paper is placed under the hand so it will not drag across the paper when drawing detailed and specific lines and shadows.*

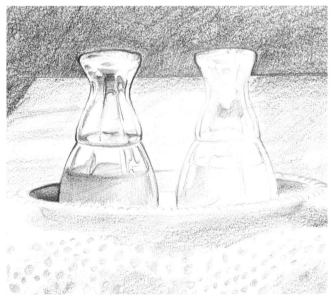

6. *The first cruet is defined with pencil lines. The hatch-shaded background contrasts with the shading without hatching of the cruet, surface, and doily.*

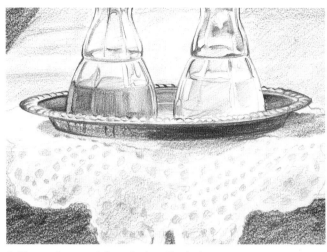

8. The metal tray and the projection of its shadow are developed by alternating the two pencils.

9. The blending stick is used to create the table's texture and to introduce a different range of tonal values.

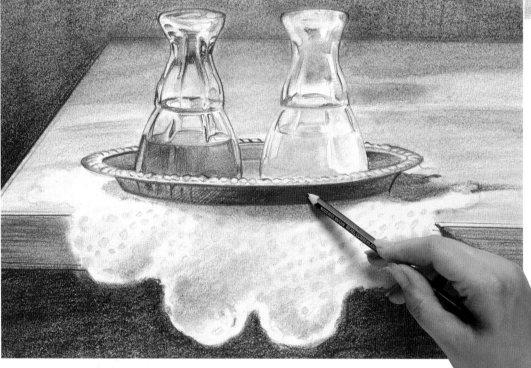

10. Drawing continues with an 8B pencil to darken the shadows of the foreground.

11. The same pencil is used to darken and adjust all the tonal values of the most distant plane, which increases the feeling of depth of the drawing.

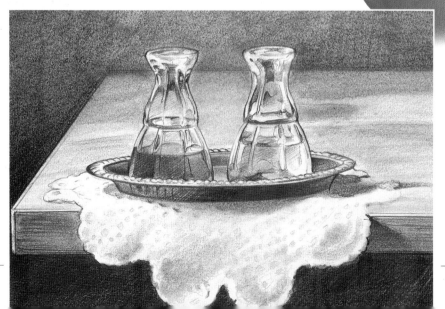

12. *The details of the doily are left until the end. To represent the holes, the artist locates the darkest shadow projected on the wood, and repeats this for practically every opening.*

13. *The doily is approached as a whole, creating all the shadows: those that represent the part that hangs over the table, its texture, and so forth.*

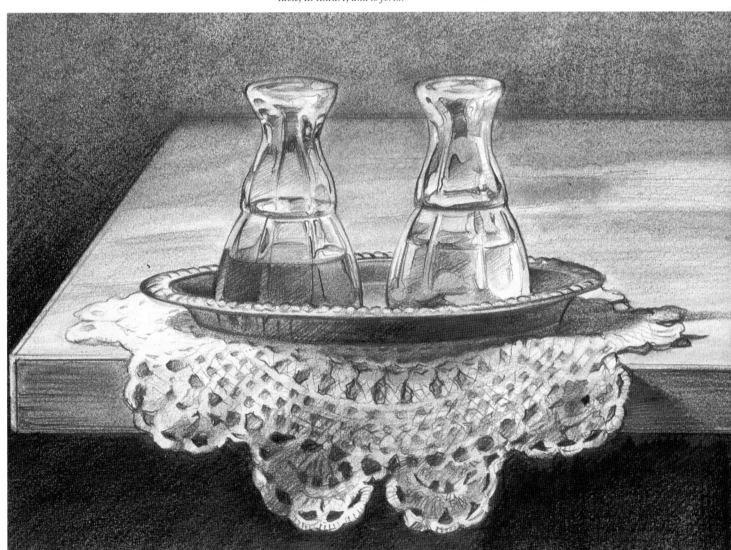

14. *The shadows of the doily look darker once the drawing of the tray and the cruet is made final. This is the last step of the excellent exercise, executed by Myriam Ferrón, in which the various planes are differentiated in this realistic interpretation.*

Landscape and Shading without Lines

A landscape is the ideal theme for illustrating the technique of shading without visible hatching. The different planes that are needed to convey the feeling of depth are created with the intensity of the shading and the intermediate values that result from using a blending stick. Thanks to the 8B graphite pencil, the results are immediate and convey incredible energy and harmony.

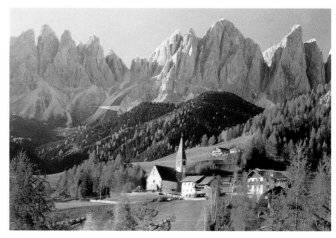

The artist will create a drawing that illustrates the technique of shading without visible lines, based on this landscape.

CONTROLLING THE LINE

For the technique of shading without hatch lines, mastery of the tool—in this case the pencil—is essential. It is important to create light shading that can be intensified by layering applications until the desired tone is achieved.

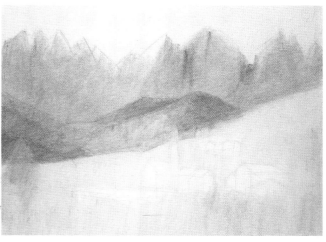

2. The definitive layout is executed on a different paper with an HB pencil. Graphite powder, scraped from a graphite stick, is used with the blending stick to apply the first shadows of the mountains.

1. On a piece of scrap paper, a preliminary sketch is created with a 6B pencil. It will include the most important lines of the landscape.

3. The outlining is done with an 8B pencil, resting the hand on a wooden platform to avoid smearing on the paper.

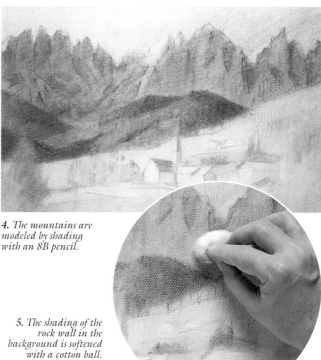

4. The mountains are modeled by shading with an 8B pencil.

5. The shading of the rock wall in the background is softened with a cotton ball.

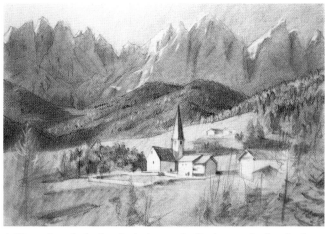

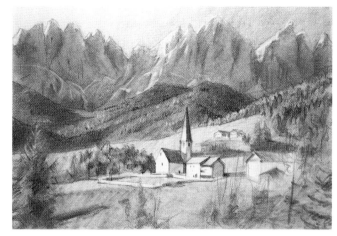

6. *We continue darkening the shadows and adjusting tonal values for the medium and distant planes with an 8B pencil.*

7. *To model the foreground, the artist must establish the best possible relationship between the central subject and its natural surroundings.*

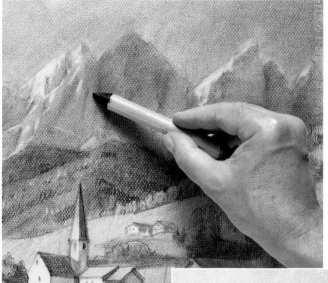

8. *The blending stick is used for softening and touching up.*

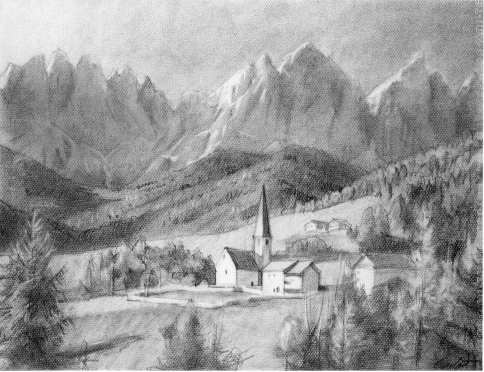

9. *A kneaded eraser, shaped appropriately, is used to create highlights.*

10. *The artist, Carlant, continues defining the tonal values and harmony until the very end. The result is a very light drawing, with no visible lines, that offers a representation at once realistic and bucolic.*

Coloring without Lines Using Colored Pencils

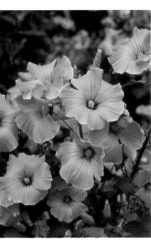

Coloring without visible lines using colored pencils is one of the most difficult procedures, although the results are so beautiful that the tedious work is well worth it. In the examples that follow, the line technique acts as the contrast and constitutes a very attractive counterpoint.

This very striking view of flowers in the foreground calls for a medium, in this case colored pencils, that allows the artist to draw in detail.

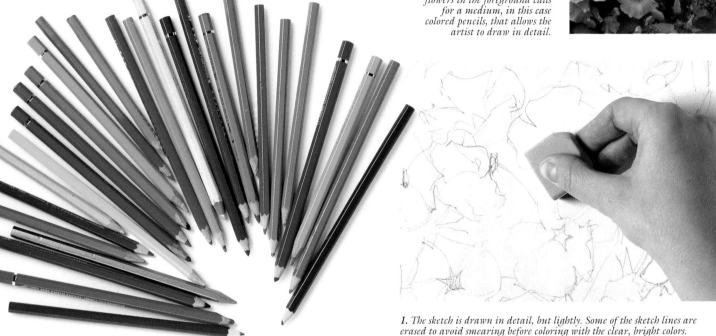

1. The sketch is drawn in detail, but lightly. Some of the sketch lines are erased to avoid smearing before coloring with the clear, bright colors.

A variety of colors and pencil hardnesses have been chosen for the following theme.

2. This first layer of color, which forms part of the background that helps define the space around the flowers, helps to lay out and to establish the location of the flowers.

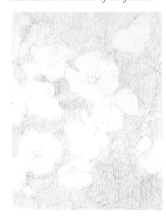

LAYERING COLORS

When the artist works with colored pencils, the strongest tonal values are created through several applications of color.

First, the background is applied very lightly until the main theme, the flowers, is well defined. Then the background is worked with darker tones until the desired color is achieved.

The artist does not begin to model the flowers until the background is completely finished. The successive layers of different colors ultimately represent the petals in a very realistic and, at the same time, delicate way.

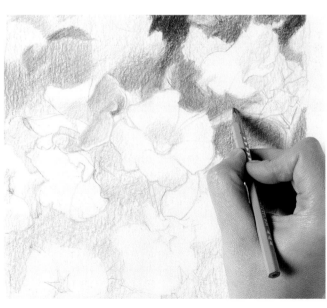

3. Any layer of the same color, or a darker one that is applied over the first one, immediately becomes more intense. The artist also introduces the highlighted areas of the vegetation using light greens on the clear paper.

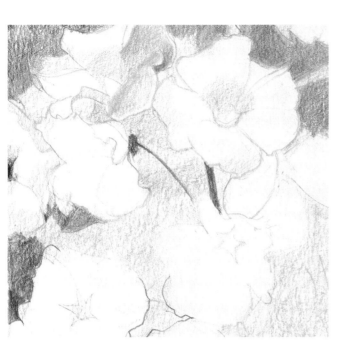

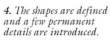

4. The shapes are defined and a few permanent details are introduced.

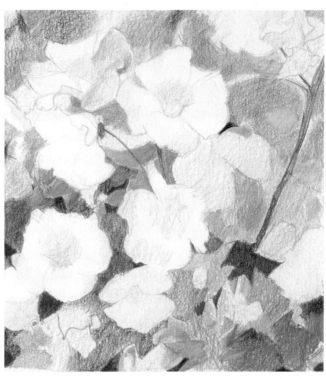

6. It is important to outline all the flowers because it is necessary to establish the drawing's value range before moving on.

5. Dark colors and tones are added over this base, indicating the background, which will highlight the group of flowers.

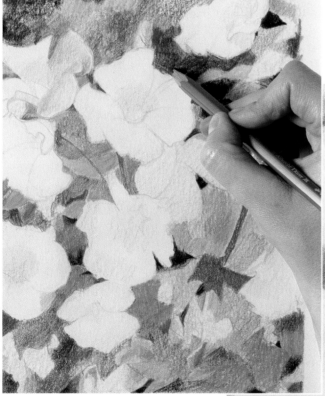

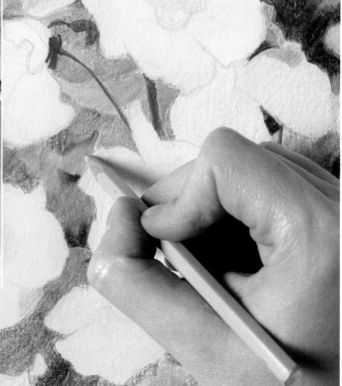

7. The final phase of the drawing involves adding nuances and softening the brightness of the colors with gray, a most important technique of this medium.

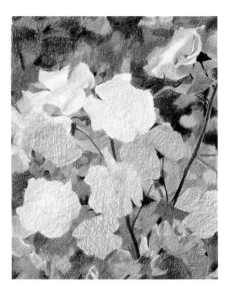

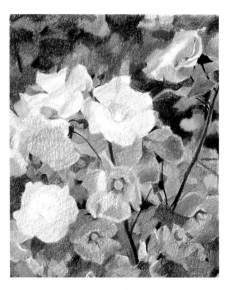

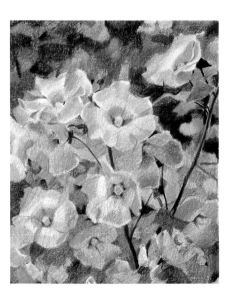

8. The modeling of the flowers is based on an overall coloring process from which several tonal values emerge.

9. The carmine and light violet tones of our color selection are used to define the shapes and the volume of the flowers.

10. The warm highlights are created with yellows, orange, and ochre.

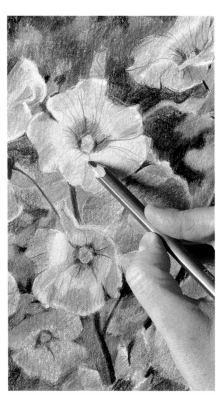

11. Now the appropriate texture is applied with a sharp pencil to define the structure of the petals. These lines contrast strongly with the color scheme of the drawing.

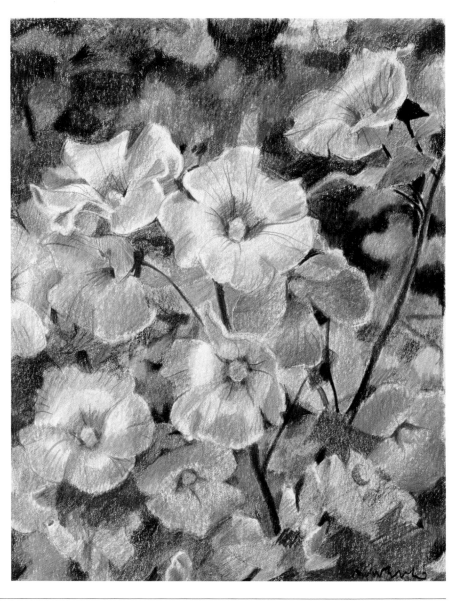

12. Mercedes Gaspar finishes a very colorful drawing, harmonizing it by darkening some of the tones that surround the flowers.

Colored Pencils and Hatching

T he direction of hatched lines created with colored pencils can be used to darken outlines, to define shapes, and to contrast different planes. It is important to establish the tonal values of the drawing and to plan the order of the successive coloring process. Light colors, for example, are reserved mentally and kept clean throughout the process, as are the white areas that require the paper to remain uncolored.

The shapes and tonal values of the model should be carefully studied.

THE DIRECTION OF THE HATCHING

It is a good idea to apply the hatching so it conforms to the curves of the objects. Modeling can be done by following the direction of the perspective lines. This enhances the volumes and conveys a strong sense of depth in the drawing.

1. Over the lightly drawn sketch, the artist begins to apply, also slightly, the first base colors.

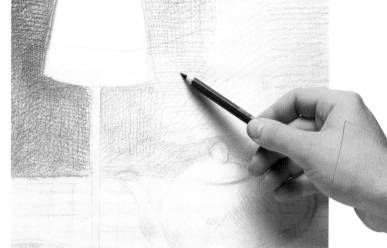

2. Hatching is drawn with dark gray to represent the background.

3. Placing colors against each other can enhance their intensity. Notice the horizontal direction of the colors of the table.

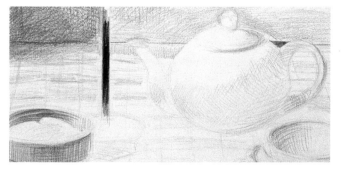

4. The modeling of the cup is done with curved strokes that attempt to describe its volume.

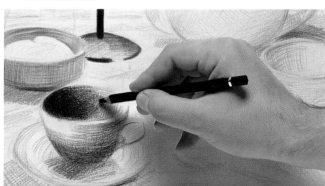

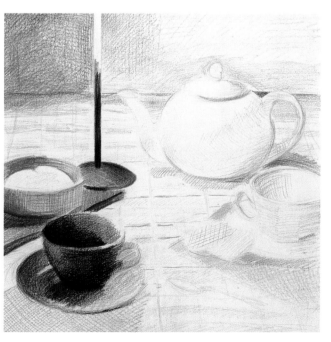

5. One by one, each shape is modeled using darker colored pencils.

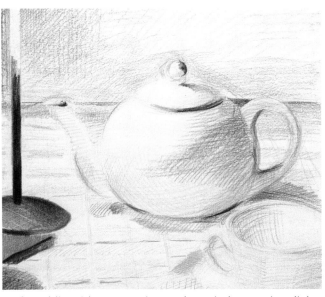

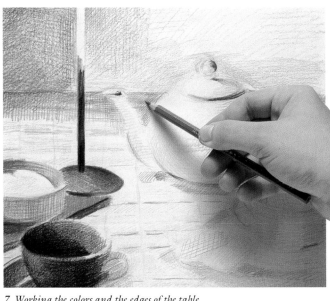

6. *The modeling of the teapot continues as the required contrast is applied. The light lines shade the volume without smearing the light colors.*

7. *Working the colors and the edges of the table automatically defines the outline of the teapot.*

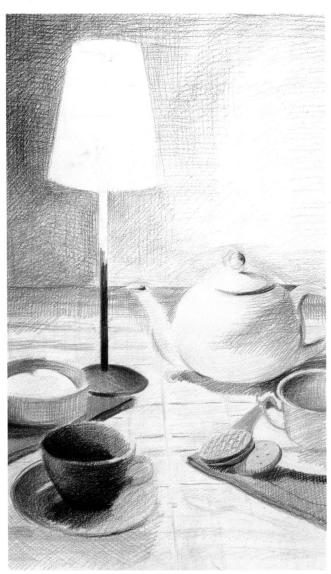

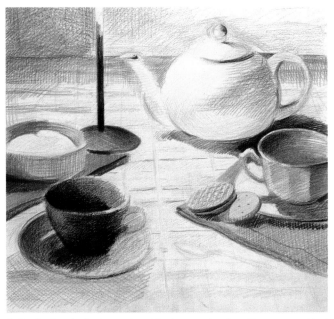

9. *Darkening the shadow projected by the teapot on the table creates an ideal background for the contrasting white cup in front of it.*

8. *Tonal gradation representing the values of the table's surface conveys a feeling of depth.*

10. *The reflections on the blue cup are applied with a white pencil.*

11. The spoon is carefully shaded with gray, and great care is taken not to distort its shape or proportions.

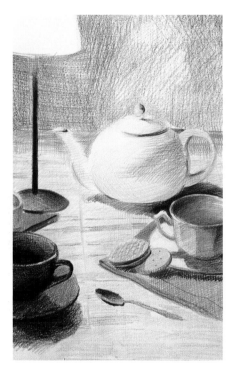

12. The main object is emphasized simply by darkening the tonal values of the background.

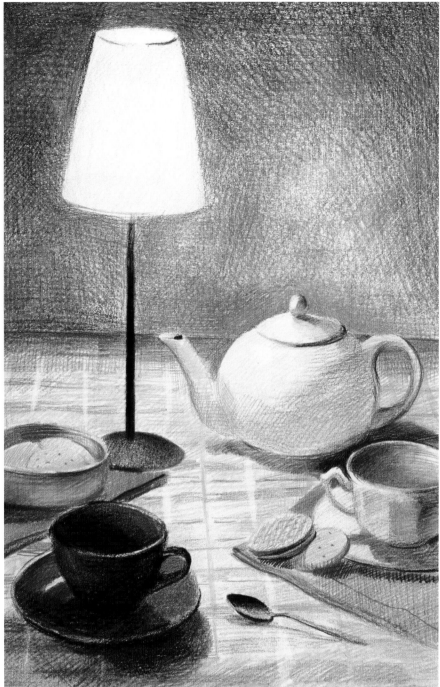

There is a wide range of grays and yellows. The blues are for the cup and the earth tones for the napkins. The neutral colors and the greens are used for darkening the yellows against the blue reflections.

13. David Sanmiguel darkens the colors and tones of each plane, object, and shadow to create balance, relating the tonal values until he achieves a perfect chiaroscuro representation.

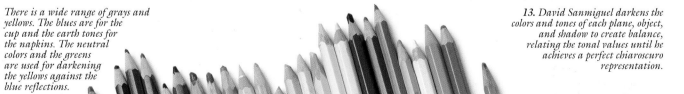

Colored Pencils and Complementary Colors

The most vibrant technique that can be used with colored pencils is that of color contrast. The shapes are described and outlined by superimposing hatched lines of complementary colors. The challenge in applying this technique lies in the synthesis of the shapes and the selection of the pairs of complementary colors.

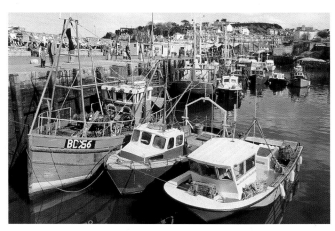

THE REASON BEHIND VERTICAL LINES

A vertical line applied next to other vertical lines of different colors produces an effect of simultaneous contrasts. This contrast is enhanced when the colors involved are the complements of each other. Therefore, the less complementary they are, the less contrast there will be. On the other hand, the vertical orientation of the characteristic lines of this technique creates an overall rhythm that is slightly interrupted by occasional lines drawn in other directions.

This seascape is a suggestive model for illustrating with colored pencils using the complementary color technique.

1. A sketch is created with red pencil on colored paper, a factor that will enhance the final contrast.

2. The outlines of the boats begin to emerge after applying red and blue.

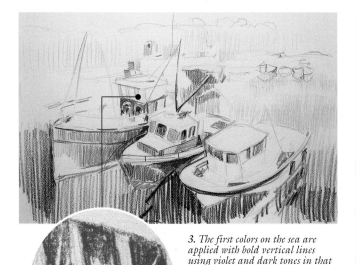

3. The first colors on the sea are applied with bold vertical lines using violet and dark tones in that color range.

4. The details of the boats in the foreground are darkened with several colors, brown tones among them.

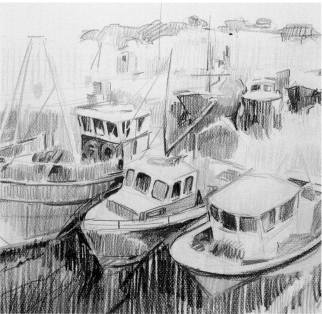

5. Vertical hatch lines using yellow and orange are overlaid to create the color of the water, to represent its reflections, and to provide continuity in the middle ground and background.

6. Additional overlaid vertical hatching (red, magenta, and blue) darkens the colors and tones and defines the forms in all three planes with more precision.

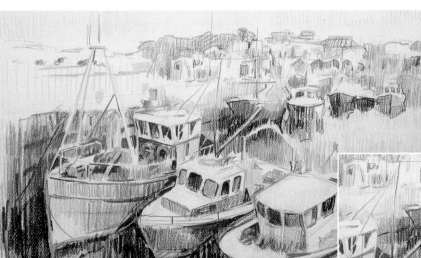

7. Horizontal hatch lines, drawn with a light blue pencil, contrast with the vertical lines in the rest of the drawing to represent the light on the water in the middle ground.

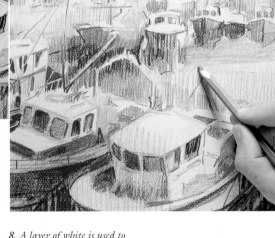

8. A layer of white is used to bring out the light tones and the highlights in general, wherever they are needed.

9. Óscar Sanchís has masterfully demonstrated the technique of contrasting colors using colored pencils.

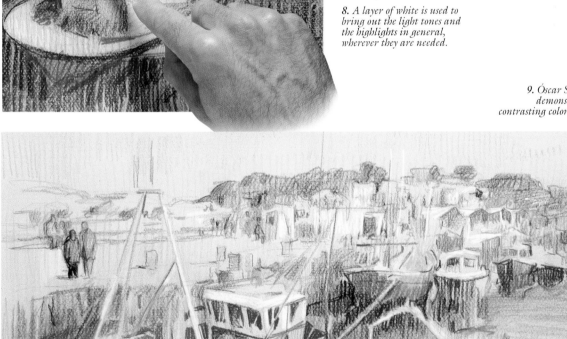

Wax Crayons and Areas of Color

To draw, it is not always necessary to begin with an elaborate sketch, especially if the artist intends to create the forms with blocks of color. Gradually building up wax colors will describe and darken the colors and tones of the various volumes that are to be represented. The same treatment is maintained throughout the work because the line technique is not used at all.

The texture of the support is one of the elements that enhances this painting. It enhances the effects of optical mixing.

DARKENING TONES BY RUBBING

All the color of the wax crayons applied on a rough textured canvas accumulates on the highest areas of the fabric. The low areas of the texture do not get any color at all when it is applied superficially. However, a bold and intense stroke covers the entire surface of the canvas. This can be used by the artist to create optical mixtures and rubbing that covers the entire surface. To illustrate this point, we are going to develop a still life with lemons that will be very expressive.

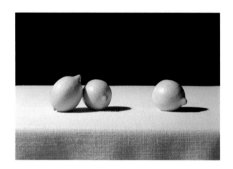

1. The three objects are drawn directly with the appropriate colors.

2. The entire scene is situated by lightly coloring in the background (black crayon) and the shadows projected by the lemons (with sepia and yellow) on the tablecloth.

3. The colors of the background are darkened with black. The lemons are also colored with yellow, with care taken to leave the lighter areas unpainted.

4. *The folds of the cloth that hang over the table are suggested with a light gray color.*

5. *The modeling of the lemons is intensified with a darker yellow and ochre. A darker tone of gray is used to define the tablecloth's folds. The shadows projected by the lemons are also darkened.*

6. *The same crayon is used to soften the tablecloth's shadows and to create an overall harmony.*

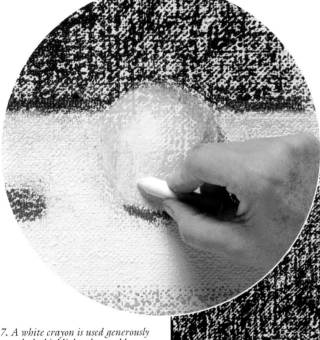

7. *A white crayon is used generously to rub the highlights thoroughly.*

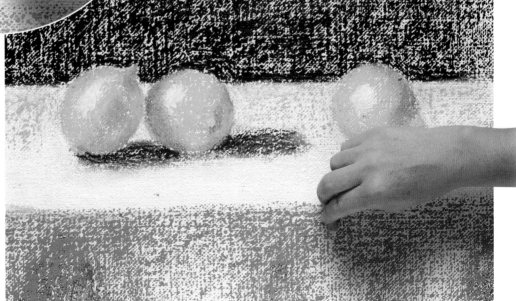

8. *The background is darkened with more black, and the tablecloth is lightened with additional white.*

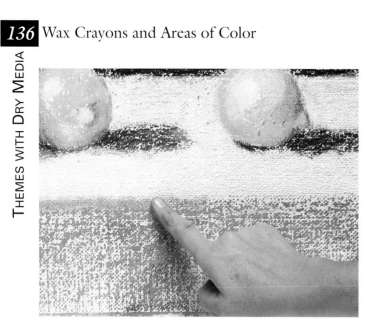

9. Rubbing is done only on the representation of the tablecloth. In this instance, the line that represents the corner of the table is rubbed.

10. The effect of the rubbing is visible. The texture of the background created by optical mixing strongly contrasts with the rubbed part: The tablecloth begins to acquire the look of true fabric.

11. A last application of white crayon balances the values of the tablecloth.

12. With a little rubbing and a few final touches, M. Braunstein concludes this still life with lemons.

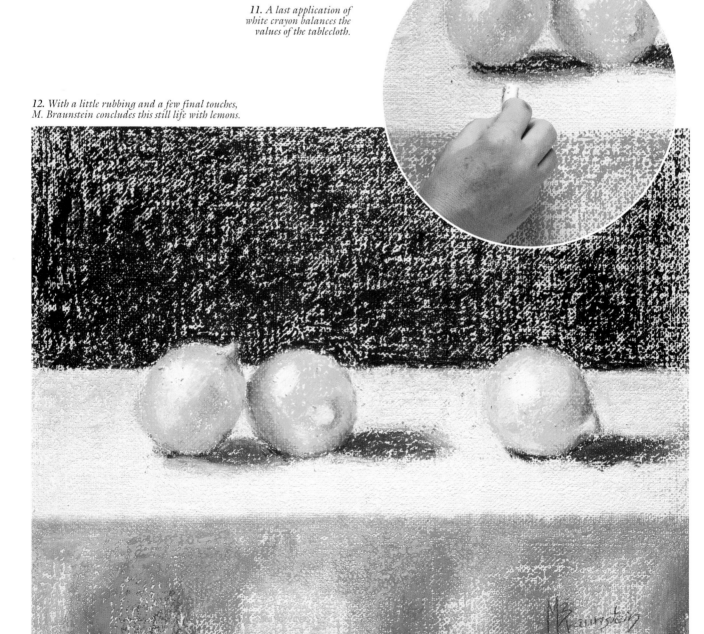

Wax Crayon Lines for Texture

A large surface area can be colored by placing one line next to another, and a texture can be applied to create an atmospheric effect, modeling, or anything else that the artist wishes. As a group, these lines create optical mixtures.

SHORT LINES TO CREATE TEXTURE

Many short lines end up creating an optical mixture. The richness of execution of the type of texture created with this unique method is obvious. It is very common to choose a specific direction for the lines, as in this case. The vertical stroke is easily seen in the sky, the buildings, the reflections, and so forth. This verticality is only interrupted by the few horizontal lines of the buildings.

This urban landscape of Bilbao (Spain), with reflections over the Nervión River, will serve to illustrate the technique of coloring with short strokes.

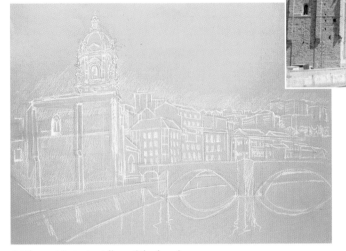

1. The most important lines of the drawing are made with white crayon on colored paper.

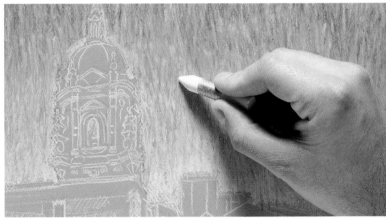

2. The sky is represented with a combination of short lines using an assortment of blue and white crayons. A general gradation is achieved through optical mixing: darker above and lighter below.

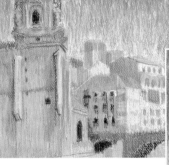

3. The same line-texture technique is applied to represent each structure with its own colors.

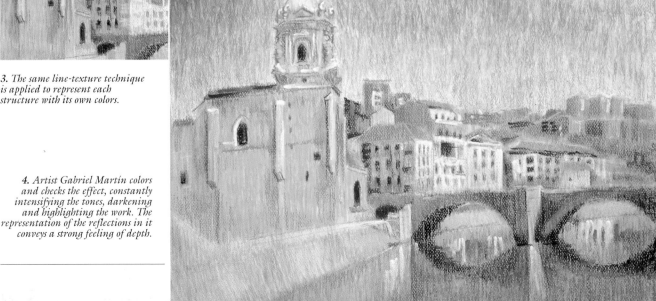

4. Artist Gabriel Martín colors and checks the effect, constantly intensifying the tones, darkening and highlighting the work. The representation of the reflections in it conveys a strong feeling of depth.

The Special Touch of Wax Crayons

Crayons, despite their transparency, can also be used to create more opaque effects. An exercise that illustrates this consists of painting heavy black paper. The final result is very unique. When the crayon is white, it must be applied thickly so the colors that are painted over it stand out. The stained glass effect produced by this will inspire many to paint pictures.

THICKLY APPLIED CRAYONS

Applying crayon colors in thick layers presents some difficulty. It is important to practice with different papers and to study the results for each color. The artist may discover that some papers accept this thick layer better than others and that there are color crayons that offer more covering power than others. Another difficulty stems from the fact that the crayon fuses when it is applied in layers, and rather than intensifying the effect, does the opposite. This problem can be solved by using fixative for the layer underneath.

This view of Lisbon offers a very complex urban landscape, which is approached as a color exercise of great synthesis.

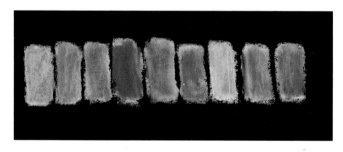

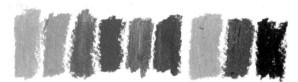

If we compare the effect of a set of colors on white paper and another on black paper applied over a layer of white crayon, we can see how they resemble stained glass, which creates a very special look.

It is a good idea to practice the techniques that are going to be used.

A cardboard frame is created on which to rest the hand when drawing, enabling the artist to work without having to worry about smearing on the paper.

It is necessary to attach the frame to the paper with masking tape.

1. The entire surface of the paper is painted with white crayon.

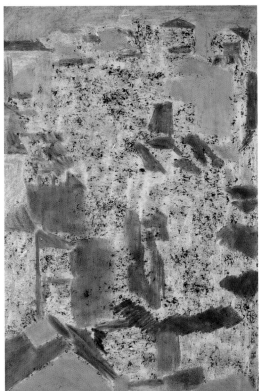

2. Blocks of bold colors are created, beginning with the sky. The drawing progresses as the colors are applied.

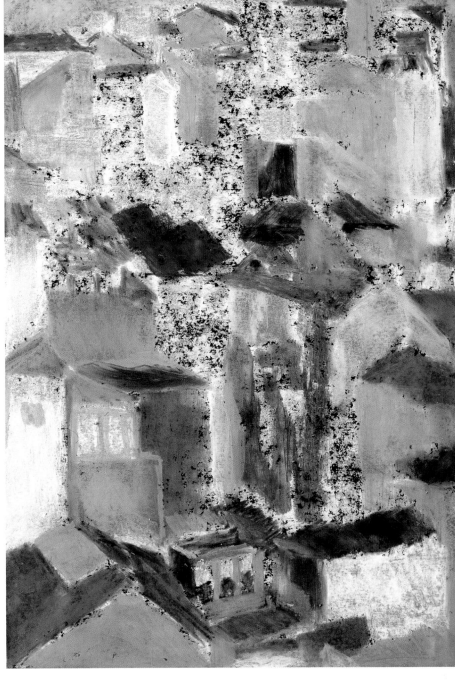

3. The areas of light are applied at the same time as the shadows.

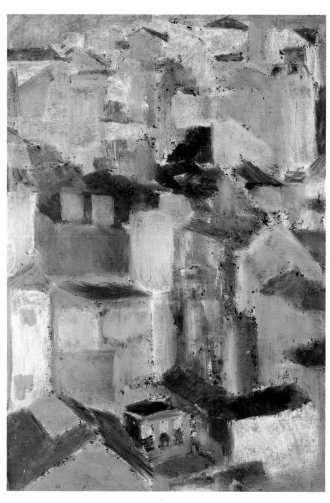

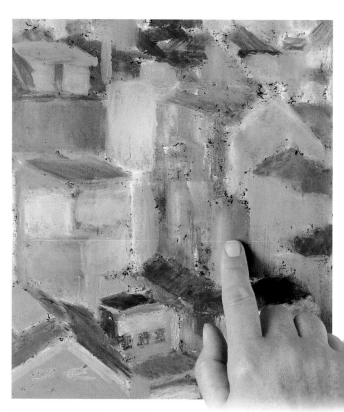

5. Rubbed with the fingertips, the textures become more defined and representative of the shapes and the perspective.

4. All the buildings are painted, always with an effort to synthesize the colors.

6. A sgraffito tool is used to describe the outline and the dark areas more precisely.

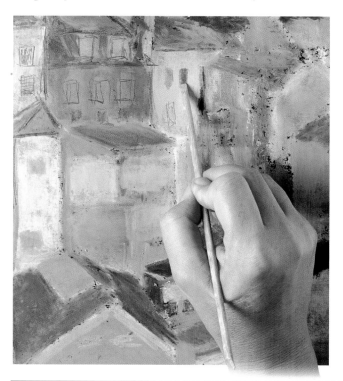

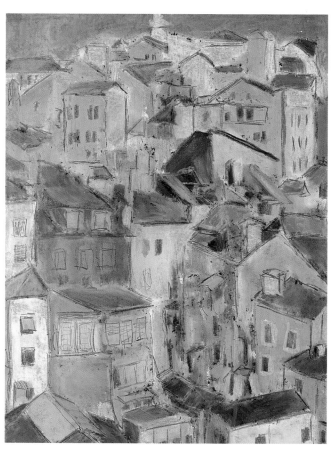

7. Not all the details are outlined with sgraffito, only those required to convey the feeling of an urban landscape.

8. Then, the artist can color over the painting to lighten or darken it as needed, "forgetting" about the original color of the paper.

10. M. Braunstein leaves the sgraffito effects for the end, along with the redrawing of a window or two and the recovery of some of the details hidden by the rubbing of the colors.

9. When color has been applied repeatedly over the same area, it begins to resist adhesion. To solve this problem, a thin layer of latex can be applied and allowed to dry completely.

Index

Original title of the book in Spanish: *Todo sobre las técnicas secas*

© Copyright Parramón Ediciones, S.A., 2004 World Rights
Published by Parramón Ediciones, S.A., Barcelona, Spain

Author: Parramón's Editorial Team
Designed and produced by Parramón Ediciones, S.A.
Exercises: Vicenç Ballestar, Mercedes Braunstein, Carlant, Myriam Ferrón, Mercedes
Gaspar, Esther Olivé de Puig, Óscar Sanchís, David Sanmiguel
Graphic Design of the Collection: Toni Inglés
Photography: Estudi Nos & Soto, Gabriel Martín

Translated by Michael Brunelle and Beatriz Cortabarria

© Copyright 2005 of English language translation by Barron's Educational Series, Inc.

All inquiries should be addressed to:
Barron's Educational Series, Inc.
250 Wireless Boulevard
Hauppauge, New York 11788
www.barronseduc.com

International Standard Book No. 0-7641-5860-0

Library of Congress Catalog Card No. 2004065777

Library of Congress Cataloging-in-Publication Data

Todo sobre las técnicas secas. English
 All about dry techniques / author, Parramón's Editorial Team ; exercises,
 Vicenç Ballestar ... [et al.] ; translated by Michael Brunelle and Beatriz Cortabarria.
 p. cm. — (All about techniques)
 Translated from Spanish.
 Includes index.
 ISBN 0-7641-5860-0
 1. Drawing—Technique. I. Ballestar, Vicenç. II. Parramón Ediciones. Editorial
Team. III. Title. IV. Series.

NC730.T58513 2005
741.2—dc22 2004065777

Printed in Spain
9 8 7 6 5 4 3 2 1